MASTERPIECES OF WESTERN PAINTING

This series serves as a forum for the reassessment of several important paintings in the Western tradition that span a period from the Renaissance to the twentieth century. Each volume focuses on a single work and includes an introduction outlining its general history, as well as a selection of essays that examine the work from a variety of methodological perspectives. Demonstrating how and why these paintings have such enduring value, the volumes also offer new insight into their meaning for contemporaries and their subsequent reception.

VOLUMES IN THE SERIES

MICHELANGELO'S
LAST JUDGMENT

Edited by

MARCIA B. HALL

Temple University

CAMBRIDGE
UNIVERSITY PRESS

PUBLISHED BY THE PRESS SYNDICATE OF THE UNIVERSITY OF CAMBRIDGE
The Pitt Building, Trumpington Street, Cambridge, United Kingdom

CAMBRIDGE UNIVERSITY PRESS
The Edinburgh Building, Cambridge CB2 2RU, UK
40 West 20th Street, New York, NY 10011-4211, USA
477 Williamstown Road, Port Melbourne, VIC 3207, Australia
Ruiz de Alarcón 13, 28014 Madrid, Spain
Dock House, The Waterfront, Cape Town 8001, South Africa

http://www.cambridge.org

First published 2005

Printed in the United States of America

Typeface Bembo 11/13.5 pt. *System* LATEX 2ε [TB]

A catalog record for this book is available from the British Library.

Library of Congress Cataloging in Publication Data
Michelangelo's "Last Judgment" / edited by Marcia B. Hall.
p. cm. – (Masterpieces of Western painting)
Includes bibliographical references and index.
ISBN 0-521-78002-0 – ISBN 0-521-78368-2 (pb.)
1. Michelangelo Buonarroti, 1475–1564. Last Judgment 2. Art and religion –
Italy – History – 16th century. I. Hall, Marcia B. II. Series.
ND623.B9A69 2004
759.5–dc22 2004051846

ISBN 0 521 78002 0 hardback
ISBN 0 521 78368 2 paperback

CONTENTS

ILLUSTRATIONS

CONTRIBUTORS

MARCIA B. HALL (Temple University, Philadelphia, Pennsylvania) is the author of several books including *After Raphael: Painting in Central Italy in the Sixteenth Century; Michelangelo: The Frescoes of the Sistine Chapel;* and *Color and Meaning: Practice and Theory in Renaissance Painting.* She has edited *Raphael's School of Athens* and *The Cambridge Companion to Raphael,* and she is the series editor of *Artistic Centers of the Italian Renaissance,* currently in preparation at Cambridge University Press.

MARGARET A. KUNTZ is currently Assistant Professor of Art History at Drew University, Madison, New Jersey. Her most recent publication on the design and function of the Cappella Paolina appeared in the *Journal of the Society of Architectural Historians.* She has written articles on the Cappella Paolina, the Vatican Palace, and New Saint Peter's.

THOMAS F. MAYER (Augustana College, Rock Island, Illinois) has written extensively on the religion and politics of sixteenth-century Europe, particularly Italy and England. Among his recent publications are *Reginald Pole, Prince and Prophet* (New York: Cambridge University Press, 2000) and the first two of five projected volumes of Pole's correspondence (Ashgate). He is editor of the monograph series "Catholic Christendom 1300–1700," also published by Ashgate.

MELINDA SCHLITT (Dickinson College, Carlisle, Pennsylvania) is the author of several articles on Francesco Salviati and recently compiled and edited a collection of new essays with Joseph Marino, *Perspectives*

on Early Modern and Modern Intellectual History – Essays in Honor of Nancy S. Struever (University of Rochester Press, 2001).

WILLIAM E. WALLACE (Washington University in Saint Louis) is the author and editor of four books on Michelangelo, including *Michelangelo at San Lorenzo: The Genius as Entrepreneur* (Cambridge University Press, 1994) and *Michelangelo: Complete Sculpture, Painting, Architecture* (Hugh Levin, 1998). In addition, he has published more than fifty articles and chapters on various aspects of Renaissance art.

ACKNOWLEDGMENTS

My part of this book has been a long time in the making. I first started thinking about the fresco in 1972. That research resulted in my 1976 *Art Bulletin* article, "Michelangelo's *Last Judgment*: Resurrection of the Body and Predestination." A paper delivered at the conference in 1996 in Santa Barbara on the conservation of the Sistine frescoes and another the following year at the annual meeting of the College Art Association in New York brought my thinking to a new stage, which I presented in *Michelangelo, The Sistine Chapel Frescoes* (contracted by Ultreya Press in Milan and published in English by Abrams, 2002). Since then I have pursued the reception of the fresco in the context of the emerging Counter-Reformation and discovered some fascinating new material on the meaning that the *Last Judgment* would have had to the Church, challenged to staunch the hemorrhage of the faithful to the Lutheran and Reformed churches.

So many people have contributed to my research over this long trajectory that it would be difficult to catalogue them. Recently they include Nicholas Horsfall, who generously aided me in translating and interpreting Cajetan's Latin. Dana Prescott and William Wallace read earlier versions of the text. I have continued to receive kind help from Sandro Chierici and Massimo Giocometti of Ultreya Press. Libraries from the University of Arizona to the American Academy in Rome have welcomed me and aided my research. Temple University has supported me with Study Leaves, Summer Research Grants, and Grants in Aid. Students in my graduate seminar in 2001 read the papers

and commented on them from the perspective of those for whom the book is intended.

John Shearman generously agreed to prepare his material on Pope Julius's intention to commission *Last Judgment* and *Fall of the Rebel Angels* for the Sistine Chapel – material that I and many others had heard him present in lecture and that I consider of great importance. Unfortunately, John died before he could write his contribution.

My primary gratitude is reserved for my patient authors, who have endured delay and who have willingly presented their important contributions in the modest format of a book intended to be accessible to students.

Beatrice Rehl and I continue our relationship and friendship, now longstanding, and I continue to rely on her quick and accurate judgment and to be grateful for her toughmindedness. I used to think wistfully that Thomas Wolfe's legendary relationship with his editor was something I coveted, but I now feel I am as fortunate in my editor as he was in his.

INTRODUCTION

HISTORY OF THE COMMISSION

The Sistine Chapel takes its name from its founder, Pope Sixtus IV, who demolished the medieval Great Chapel and replaced it, beginning in 1477 (Fig. 1).[1] In remarkably short time it was ready for decoration. In 1481 Sixtus brought to Rome the best painters from Tuscany and Umbria to fresco the walls with the lives of Moses and Christ and a series of portraits of popes, as well as to cover the ceiling with a blue sky studded with gold stars. The lowest zone of the walls was frescoed with fictive tapestries containing the arms of Pope Sixtus. The decoration was considered complete and would probably have remained untouched had an enormous crack not appeared in the vault in 1504, forcing the closing of the chapel for six months while necessary structural work could be done, which required the repainting of the ceiling.[2] Julius II, nephew of Sixtus, commissioned Michelangelo to fresco the new ceiling. The painter worked on the vault over a period of four years; it was unveiled at the end of October 1512.

Clement VII (de'Medici, 1523–34) conferred with Michelangelo in the fall of 1533 about commissioning him to paint the altar wall (Fig. 2). We do not know what motivated his decision. Vasari reported that Pope Julius had intended to have Michelangelo paint a *Last Judgment* over the altar and the *Fall of the Rebel Angels* on the entrance wall, but nothing had come of it.[3]

The artist had been residing in his native Florence since Pope Leo X (de'Medici, 1513–21) had dispatched him there to work on Medici

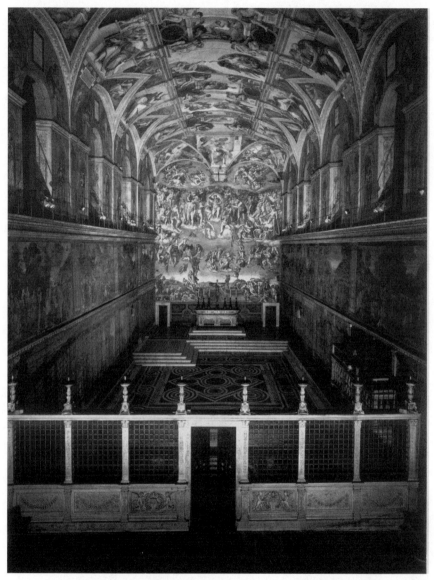

FIGURE 1. View of the Sistine Chapel, Vatican (Photo: Vatican Museums).

family commissions in 1516. Florence chafed under papal rule, so in 1527, when imperial troops sacked Rome and forced Pope Clement to take refuge in the fortified Castel Sant'Angelo and become a virtual prisoner there, Florence seized the opportunity to reestablish its

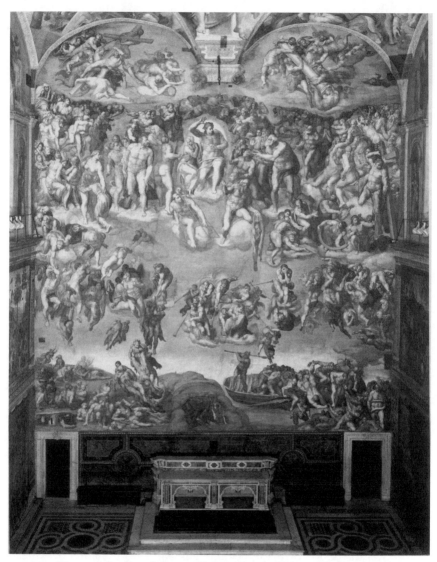

FIGURE 2. View of the *Last Judgment*, Sistine Chapel, Vatican (Photo: Vatican Museums).

republic. Michelangelo, an avid supporter of the Florentine Republic, abandoned the Medici Chapel in San Lorenzo and transferred his energies to designing fortifications for the city. When the ensuing war ended with the defeat of the fledgling Florentine Republic and the

reimposition of Medici rule in 1530, Michelangelo found himself in a difficult position, alienated from the papal patron he had deserted and residing in a city ruled by the young Duke Alessandro de'Medici whom he feared and hated. Furthermore, his obligation to finish the tomb for Pope Julius II, dead since 1513, weighed heavily on him, for he had signed contracts and received some payment for the project.

As had happened in the past, the ruling pope's demands interfered with the artist's attempt to complete the tomb for Pope Julius. Such was Clement's desire to have Michelangelo serve him that he pardoned him and directed him to continue work at San Lorenzo. In 1532 a compromise was reached and a new contract negotiated with the heirs of Julius II, reducing the scale of the tomb and dividing Michelangelo's time between Medici commissions in Florence and the Julius tomb in Rome. Hardly had this new agreement been settled, however, when Clement placed the commission for the *Last Judgment* before the artist. If Michelangelo was reluctant, as seems to have been the case, it must have been due to his unwillingness to take on another enormous task with both the tomb and the projects at San Lorenzo still unfinished.

Michelangelo transferred his residence to Rome in September 1534. When, only a few days later, Pope Clement died, Michelangelo thought that he would be relieved of the Sistine fresco and free at last to complete the Julius tomb. Such was not to be. Clement's successor, Pope Paul III (Farnese, 1534–49), already an old man, greeted Michelangelo's excuses with the following exclamation: "For thirty years I have had the wish that Michelangelo serve me. Now that I am Pope, can I not gratify it? Where is this contract? I want to tear it up" (according to Michelangelo's contemporary biographer, Condivi). Again the tomb was discussed and Michelangelo's obligation reduced still further.

The preparation of the wall in the Sistine Chapel was protracted over the period of a year, beginning in April 1535. Painter Sebastiano del Piombo, Michelangelo's friend, had the wall prepared for an oil mural, a technique that Sebastiano had developed and practiced with success. Michelangelo allowed the work to proceed for almost nine months, during part of which he worked on his cartoon for the *Judgment*, before declaring the surface unsuitable and requiring that it be remade (25 January 1536). No explanation for this curious behavior is offered by documents or contemporary sources; it may have been that he was stalling to gain precious time to complete statues for the

Julius tomb, for the contract he had signed in 1532 expired in 1535. His biographer Condivi tells of other ruses the artist devised to keep the pope at bay, and says that "he procrastinated and, while pretending to be at work, as he partly was, on the cartoon, he worked in secret on the statues that were to go on the tomb." The wall was at last ready in April 1536, and Michelangelo set to work painting before 18 May, when the first of many payments for pigments was made.

The project necessitated bricking up the two clerestory windows and destroying the quattrocento decoration of the altar wall, Pietro Perugino's frescoes of the *Finding of Moses* and the *Adoration of the Shepherds* that had opened the cycles, and the portraits of the popes, all of which had encircled the chapel and continued across this wall. It was also eventually decided that Perugino's altarpiece and its frame had to be removed and Michelangelo's own *Ancestors of Christ* in the two lunettes destroyed, although the original plan had been to preserve both.

The painter's final solution to utilize the entire wall, without even a frame, radically changed the appearance of the chapel, overriding the horizontal accent, which the continuous bands of windows and frescoes across the altar wall and circling the chapel gave it, and introducing a strong vertical element. With the *Last Judgment* in place the chapel now has a focus toward which the space seems to process, just as the papal entourage would process from the entrance opposite to the altar.

COMPARING THE DRAWINGS TO THE FRESCO[4]

The medieval composition of the *Last Judgment*, which can be represented by Giotto's monumental fresco in the Arena Chapel (Fig. 3), was rigidly organized to convey God's central place in the ordered cosmos and his control of man's final destiny. The composition was divided into two tiers. In the celestial zone, Christ the Judge was flanked by the choirs of apostles, angels, saints, martyrs, and patriarchs. In the terrestrial zone below, corresponding to the Resurrection of the Dead on the left, were the Damned in Hell on the right. Each obedient population, assembled in its designated place, performed its roles with predictable emotion – the Elect joyful, the Damned in torment. The ranks were fixed and closed. The composition attained its order from the ordering of the static units.

Changes from the preparatory to the final design show that Michelangelo's conception evolved from the medieval view of the subject to one reflecting Renaissance ideas of human individuality and responsibility. He revised the traditional static composition to conform to sixteenth-century artistic taste for a dramatic presentation unfolding before the viewer. This comparison, which reflects Michelangelo's thinking over a period of nearly three years, can provide hints of his ultimate interpretation.[5]

When he set about designing the fresco, Michelangelo at first intended to preserve the existing altarpiece by Perugino and his own lunettes. This much can be deduced from his studies, particularly the sheet in the Casa Buonarroti, Florence (Fig. 4), where the top of that altarpiece has been drawn in and space left for it and the area of the lunettes is not included in the field. We can see that, from the start, he envisioned abandoning the tradition composition, breaking down the rigid compartmentalization and arrangement in tiers, such as we see in Giotto's *Last Judgment*. The Elect flanking Christ are already conceived more in terms of an animated chain of intertwining figures than as the conventional row of dignitaries seated on the clouds. In fact, in what is presumably an even earlier study (Bayonne, Musée Bonnat; Fig. 5), we already see a figure who turns to look down at those descending, an idea elaborated in the Casa Buonarroti drawing and used to great effect in the fresco. Between these two studies the figure of Christ has evolved away from the seated judge to a standing, even striding, figure whose arrival sets the whole event in motion. Even Michelangelo's seated Christ twists in a dynamic *contrapposto*, banishing the traditional static icon of the Judge in his mandorla.

The designing of the fresco appears to have taken place in two phases. We know that Michelangelo presented Pope Clement with a *modello*, that is, a large finished drawing of the composition, presumably in the summer of 1534. Although this *modello* is lost, two copies survive. One in the Metropolitan Museum in New York shows the upper portion only, but a second copy in the Courtauld Institute, London (Fig. 6), although reworked, shows the whole composition. An especially important change the copyist made was to the pose of Christ, whom he shows with arms outstretched. There is no evidence that the artist ever considered such a pose. The rectangle for Perugino's altarpiece is reserved at the bottom center. Saint Michael, who did not

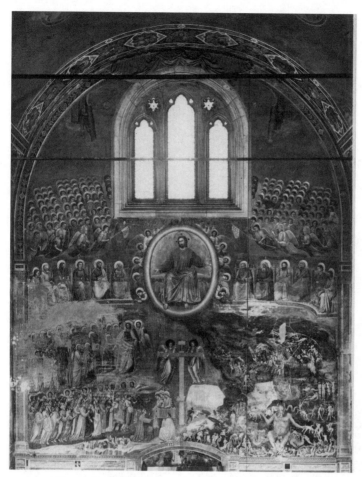

FIGURE 3. Giotto, *Last Judgment*, Arena Chapel, Padua (Photo: Alinari/Art Resource, NY).

ultimately appear in the fresco, stands on top of the frame, the symbol of judgment in medieval Last Judgments, where he usually holds his scale and weighs the souls to determine the balance of good and evil in each of them. Many of the figures of the fresco already appear, but their groupings would undergo significant development. They are sparsely spread about the sheet, not yet conceived in terms of the dense packing and overlapping that gives the final version the depth otherwise lacking because the painter has eschewed perspective renderings of choirs of similar figures.

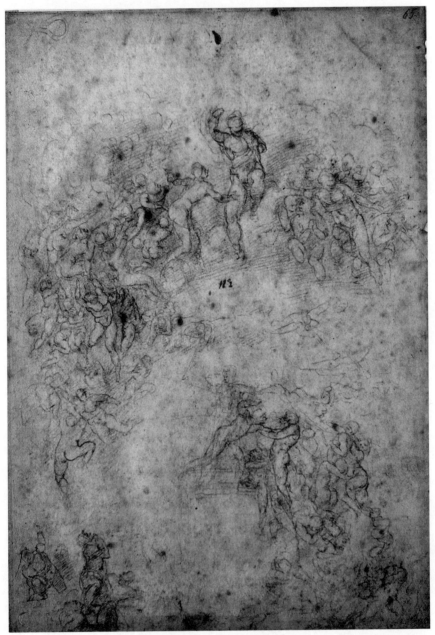

FIGURE 4. Michelangelo, sketch for the *Last Judgment*, c. 1534, black chalk, retouched later in pen. Casa Buonarroti, Florence, inv. no. 65 F recto (Photo: Scala/Art Resource, NY).

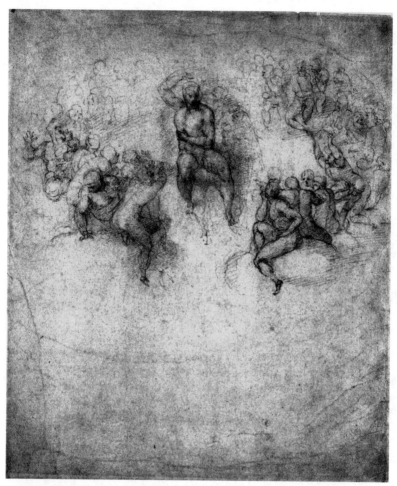

FIGURE 5. Michelangelo, sketch for Christ and saints, c. 1534, black chalk. Musée Bonnat, Bayonne inv. no. 1217 (Photo: Réunion des Musées Nationaux/Art Resource).

The drawings in Casa Buonarroti and Bayonne (Figs. 4, 5) must have been preparatory to the *modello*. The second stage of design would have occupied the artist as he prepared the actual cartoons during the prolonged preparation of the wall in the fall of 1535 and in early 1536. The large sheet now at Windsor of the Resurrection of the Dead shows many of the principal figures already invented, but their placement has not yet been determined. The sheet is a series of individual fig-ure studies rather than a compositional sketch, but Michelangelo is also

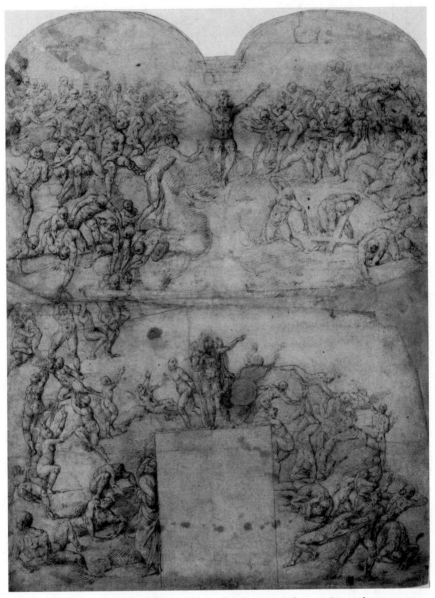

FIGURE 6. Copy after the lost design for the *Last Judgment*, sixteenth century, pen with traces of black chalk or lead pencil. Witt Library, Courtauld Institute Galleries, London (Photo: Courtauld Institute). Courtesy of Ultreya Archives, Milan.

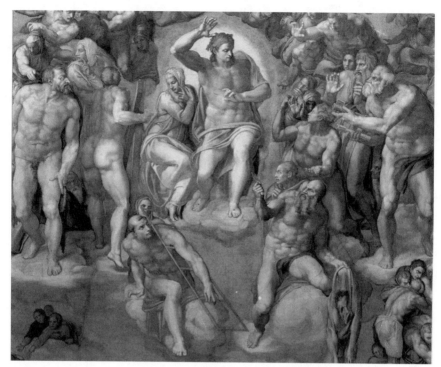

FIGURE 7. Detail from the *Last Judgment*, Christ and surrounding Elect (Photo: Vatican Museums).

interested here in establishing the currents of motion: the pull to the right, where the cave will be, is clearly announced, as is the upward movement. Details such as the skeletons and shrouds do not yet appear, and the figures will be rearranged.

In the fresco, even more than in the drawings, the commanding figure of Christ dominates (Fig. 7). He is set off against a golden aureole, which includes his mother, who cleaves to his side. In the early sketches Michelangelo had drawn Christ seated in the traditional manner, but in the painting he seems rather to be striding forward, perhaps shown rising to his feet. His stance reminds us of images of Christ at his resurrection, bursting from the tomb, even specifically of Michelangelo's drawings for such a figure.[6] This is indeed the risen Christ, for it was his resurrection that makes possible the resurrection of the dead (Fig. 8) on the final day. As Saint Paul stated it: "For as in Adam all die, so also in Christ shall all be made alive" (1 Cor. 15:22).

Vasari and Condivi describe Christ's gesture as angry, but his impassive face contradicts this interpretation. His raised arm should rather be understood as one of command, setting into action the events we see unfolding before us: the angels sound the trumpets, the dead are raised and proceed to their appointed places, either rising to be with Christ in Heaven or falling into the abyss of Hell. He displays the wounds on his hands and feet and his side, reminding us of his suffering and at what cost eternal life was won for us.

The Virgin's pose has been changed from her pleading posture in the drawings to a passive one, arms folded, as if to say that the time for her merciful intercession has passed. Any semblance of judgment and intercession that was to be seen in the drawings has been removed. An attractive interpretation sees the closeness of Christ and Mary as indicating that Justice has already been tempered with Mercy, so the two have become one.[7]

Some of Michelangelo's contemporaries criticized his unconventional beardless Christ. His resemblance to Apollo, the god of the sun in classical myth, was recently linked to the revolutionary Copernican discovery that the planets revolved around the sun, not vice versa. Although Copernicus's book was not published until 1540 when the fresco was almost finished, Clement VII was briefed on the Copernican discovery at the Vatican in 1533, just around the time the pope first discussed the commission with the artist.[8] The golden light behind Christ/Apollo, which Michelangelo went to the trouble of painting *a secco* in brilliant yellow pigments that he used nowhere else in the fresco, becomes the sun around which the whole event moves in an ineluctable and unperceived rotation. Quite the opposite to the condemnation the Church would later impose on Copernicus's theory, Clement and Michelangelo appear to have embraced it, finding no conflict between it and Church doctrine. This association with Apollo can be seen to weaken further the identification of Christ as judge, for Apollo carried no such connotation.

A number of additions were made to the fresco once the decision to use the entire wall had been made. Around the space opened up when the decision was made to destroy Perugino's altarpiece, we find that Saint Michael, who appeared in the *modello*, was eliminated. In his place and in the area above left open in the *modello*, we find now another group of angels (Fig. 9). In response to Christ's command they

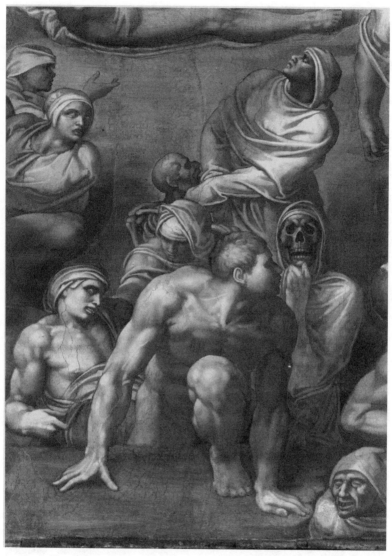

FIGURE 8. Detail from the *Last Judgment*, Resurrection of the Dead (Photo: Vatican Museums).

blow their trumpets to announce the Second Coming, as they appear in Giotto's fresco at the bottom of the circling angel around Christ's mandorla. "They will see the Son of man coming on the clouds of heaven with power and great glory; and he will send out his angels with

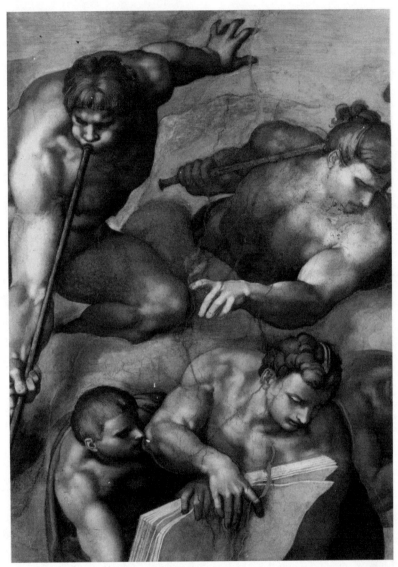

FIGURE 9. Detail from the *Last Judgment*, Angels with trumpets and books (Photo: Vatican Museums).

a loud trumpet call, and they will gather his elect from the four winds" (Matt. 24:30–1). The four angels on the left have their cheeks puffed out in the manner of the ancient wind gods. Two of the angels hold up and consult books in which the judgment concerning each life has

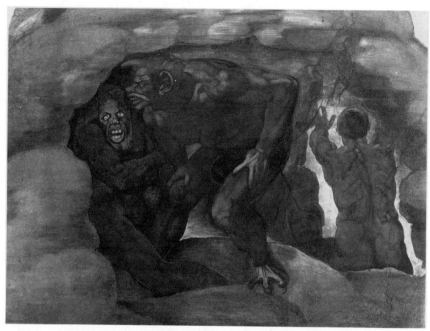

FIGURE 10. Detail from the *Last Judgment*, the Cave (Photo: Vatican Museums).

been written at the time of death. These judgments, long since recorded, determine whether one will rise to Heaven or descend to Hell.[9]

Directly behind the altar, placed so that the celebrating pope or priest would look directly into it, is a black cavern filled with demons and a single figure, seen from the back, silhouetted by a fiery glow (Fig. 10). The left wall of the cave has been breached where we see angels and demons battling over bodies. Scholars have differed over whether these are escaping or being nabbed by malignant demons as they awaken from the dead. There is even less certainty over what this cavern represents, but the arguments in favor of Purgatory are the most convincing.[10] It is only from Purgatory that one can escape, and in fact the priest at the altar would have in his mind that his celebration of the Mass helped the souls suffering in Purgatory. (The Council of Trent, after it began meeting in 1546, was quick to confirm the existence of Purgatory in the face of the Protestant claim that it was a fraud that benefited the Church through the sale of indulgences.) The fiery hole that descends at the rear appears to connect to Hell, which is adjacent and below. The anecdote concerning

Biagio, the master of ceremonies,[11] appears to confirm that Purgatory was included in the fresco. When Biagio complained to Pope Paul of Michelangelo's portrayal of him, the pope is alleged to have responded that if Michelangelo had consigned him to Purgatory he could have helped, but over Hell he had no power. This part of the fresco was damaged because the *baldacchino*, or canopy, installed until the middle of the twentieth century for solemn occasions, was hung from the two hooks still in place on either side. Thus the angels disappeared from view, together with the cave below it, whenever the *baldacchino* was used.[12]

Michelangelo had painted the topmost area of the wall twenty-four years earlier as part of the series of *Ancestors of Christ* in the ceiling decoration. As we saw in the drawings, he initially intended to save his own work and allow the Ancestors to continue across the altar wall. Instead, in these spaces he depicted the symbols of Christ's Passion: the cross, the column against which he was scourged, the ladder, the sponge, the crown of thorns, all carried by wingless angels. The choice to fill the lunettes with symbols of the Passion is significant in terms of the focus ultimately selected for the fresco. They give prominence to the theme of the Resurrection by making it clear that the final resurrection depicted below was made possible by the sacrificial death of Christ and his resurrection.

The lunette at the left (Fig. 11) carries upward the movement of the ascending bodies with the oblique line of the cross, symbol of redemption, and the lunette on the right begins the downward movement of the Damned with the corresponding line of the column, emblem of the cruelty of humankind. The angels cling to cross and column, lifting or lowering, in a maelstrom of energy.

Michelangelo's interpretation evolved as he prepared the design. It gradually shifted from one containing traditional medieval elements emphasizing judgment to one that expressed a modern, Renaissance view of the Final Day. He conceived his *Judgment* as a swirl of bodies around the dynamic center of Christ, with every figure either in motion or tense with emotion. The predictability has been swept away, replaced by anxious uncertainty. Whereas the traditional iconography was static and hierarchical, Michelangelo's vision is of a dynamic, explosive event. Flowing robes have been put aside, for Michelangelo recognized that we will all meet the Lord stripped of rank and emblems of our earthly status. Instead of giving a sense that everyone has their

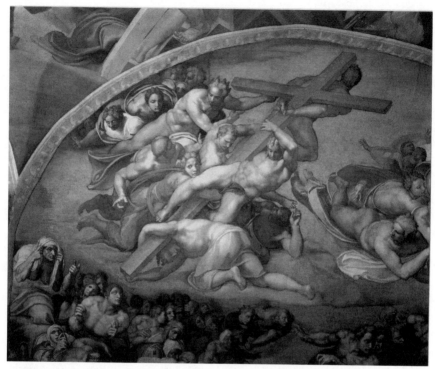

FIGURE 11. Detail from the *Last Judgment*, lunette with cross (Photo: Vatican Museums).

place here and knows what it is, Michelangelo shows the uncertainty of men and women who are being moved by a force outside themselves, sometimes to a fate still unknown to them. Or when they discover their destinations, he shows their explosions of surprise, joy, or horror. There is an ineluctable rotation, not perceivable to those being moved by it but visible to the viewer, rising from lower left, circling around Christ, and descending on the right to Hell.

Although Michelangelo avoided the sharply divided bands of earlier artists' versions, he subtly introduced zones that correspond to the divisions of the side-wall frescoes to give order to his composition. Below the area of the lunettes at the top with the angels and the implements of the Passion, there is a break, a bit of sky, and then the densely massed figures of the Elect begin. Further down, the cornice at the bottom of the window zone marks the transition between those who are already among the Elect surrounding Christ and those who are rising or descending. The line continues across the fresco, and there

is suddenly an unimpeded glimpse of blue sky. At the extreme right of this zone, Simon of Cyrene appears to place his cross on the ledge of the cornice. The Resurrection of the Body on the left and Hell on the right correspond to the lowest zone of the side walls where the fictive tapestries were painted.

Some earlier painters, such as Giotto, achieved the appearance of a fictive depth by rendering the choirs of similarly posed figures receding in perspective. Depriving himself of this device, Michelangelo resorted to overlapping his figures in densely packed groups, forming chains to carry the current of movement. Where he overlaps figures, he renders those behind with thin paint, soft-edged and out of focus, a device he had sometimes used on the vault and particularly in the Ancestors of Christ.

One of Michelangelo's most remarkable innovations is his elimination of a frame. Figures are cut off at the edges, as if to imply that we are seeing only a portion, and the scene continues in all directions, laterally and below as well. There is no guessing how extensive Hell actually is, for it disappears at the lower right corner, nor can we know how many more Elect extend beyond our curtailed view.

The subject of the Last Judgment had not been favored in the Renaissance compared with the Middle Ages, when it frequently adorned the portals of churches or covered the inside of the entrance wall, so that it was what worshipers had before them as they left the church and reentered the world. The apocalypticism accompanying the turn of the half millennium in 1500 had perhaps been responsible for the major example to be commissioned in these years: Luca Signorelli's frescoes around the walls of a chapel in the Orvieto Cathedral. He divided up the traditional sections, so that the Blessed, the Damned, and the Resurrection of the Body (Fig. 12) were each assigned to a separate frame, and Christ and the angels with trumpets appear above the Blessed in paradise.[13] According to Vasari, writing soon after Michelangelo's fresco was unveiled in 1541, Signorelli's work had been much admired and studied by Michelangelo.

Throughout its history the Church had held in tension the two polar views of the Final Day, either as the visitation of eternal punishment or the inauguration of eternal bliss. Depending on conditions, one gained ascendancy over the other, as in the surge of pessimism following the disasters of the 1340s, which included the Black Death.[14]

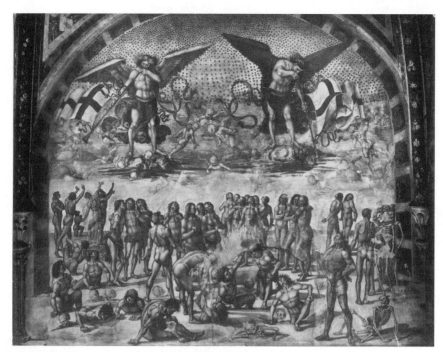

FIGURE 12. Luca Signorelli, *Resurrection of the Dead*, San Brizio Chapel, Cathedral, Orvieto (Photo: Art Resource).

Depictions of the Last Judgment are a sensitive seismograph of shifts in cultural mood. The balance shifts between admonition and promise, reflecting the degree to which people collectively feel threatened or confident. At times of cultural expansion, such as the early Renaissance, when optimism prevailed, the Last Judgment all but disappeared as a subject for decoration. If it was depicted, it was as Fra Angelico rendered it: a time of blissful reunion between those parted by death, in which the demons and Damned are scarcely plausible (Florence, Museo di San Marco). Much has been written about the revival of the subject in the 1530s. It has been connected with the Sack of Rome and interpreted as an acknowledgment of God's judgment on corrupt Rome.[15] This was certainly the view of some – and in particular of dissident Protestants. It seems clear to me, however, that the original patron, Clement VII, or his theological adviser, directed Michelangelo to Paul's first letter to the Corinthians, the only scriptural text other than Revelation that gives an extended description

of the Last Judgment. The weight of Paul's message is on the side of optimism: Christ's resurrection is the proof and prototype of our redemption and resurrection. Thus we find Michelangelo making every possible link to Christ's death and resurrection, from the symbols of the Passion in the lunettes, to the presence of crosses among the martyrs, to the depiction of Christ as the Resurrected Lord. That this was the paradigmatic text for the Renaissance is indicated by the Signorelli fresco cycle, which is also based on it.

Dissention developed within the Church in the mid–sixteenth century – after the fresco had been painted – over the proper emphasis of a Last Judgment. As scholars have pointed out, it is not possible to define a single orthodox position on the Last Judgment in the sixteenth century.[16] Because none of the scriptural texts on the Last Judgment is definitive, and they are in fact difficult to reconcile, even the Church Fathers disagreed on some key points. In this period of crisis there was a move away from humanism and optimism on any number of issues. Michelangelo's fresco was founded on what in the 1530s seemed solid humanist ground, but when schism in the Church became a certainty following the failure to gain acceptance of the accord achieved at the Colloquy at Ratisbon in 1541,[17] fear of moral anarchy began to grow. The Church, which had always recognized that threat of damnation is the ultimate weapon to enforce discipline, rediscovered the power of the message of retributive justice.

By the 1550s the ground had shifted, and the pessimists held sway. Michelangelo's fresco, created in a spirit of tolerance, was now being examined in a spirit of apprehension. The shift is comparable to the one we have recently experience in the wake of 9/11. The Homeland Security Act was promulgated in response to a sense of threat like that felt in the Church at midcentury. We can see evidence of discomfort among the midcentury commentators on the fresco. Don Miniato Pitti makes a reference to a thousand heresies in the fresco,[18] and Vasari and Condivi describe Christ's gesture as angry – a willful misreading of Michelangelo's impassive Christ.[19] As we will see, there is a curious lack of recognition, or at least acknowledgment, among contemporaries that what Michelangelo has represented is not simply judgment, but the Second Coming of Christ when everyone will be issued a new spiritual body to replace the worn-out physical body of earthly life, as described by Saint Paul (1 Cor. 15). Objections to

the nudity were also objections to the corporeality of Michelangelo's figures, corporeality that was indispensable to the message of bodily resurrection.

The earliest reference to Michelangelo's commission is a letter of 2 March 1534, which described it as a "resurrectione." This has been misinterpreted as proof that there was a change of subject: Michelangelo was originally commissioned to paint a Resurrection of Christ that was then enlarged to the Last Judgment. In fact the reference should be understood as a shorthand for the Final Resurrection, or the Universal Resurrection, or the Resurrection of the Body.[20]

Michelangelo was following Augustine[21] in representing the Last Judgment not as a judgment but as the time when everyone assumes a new spiritual body. Augustine talked about the first and second resurrections.[22] The first resurrection is when the individual makes the choice to lead a life of sin or a life of righteousness. The preservation of free will that Augustine so carefully incorporated would have appealed to Michelangelo and to Renaissance thinkers. According to Augustine, only those who choose the righteous life will join the Elect at the second, final resurrection. Thus, *the judgment of each soul has been made before the final day.* At the time of the Second Coming, Christ's appearance inaugurates the action, and all are propelled to their appointed places by a force exterior to themselves.

Yet a problem remained unresolved by the theologians. Augustine did not discuss the interval between death and the second resurrection. It was Thomas Aquinas who established the now-orthodox position that souls are delivered to hell and heaven immediately after death.[23] It seems to me that Michelangelo took the position that delivery was delayed, because many of his figures show anxiety and uncertainty, as though the judgment has not been revealed to them and they are not sure where they are being conveyed. Perhaps he intended us to understand that these people he represented are either those who are still alive at the Second Coming and therefore do not know how they have been judged, or else souls who have been in Purgatory and do not know yet whether they have fulfilled their sentence or whether they will have to return. There was not a single orthodox position of the Church on this point in the sixteenth century, although Aquinas would have weighted opinion heavily in favor of immediate delivery. Those who took the view that the fear of hell was the principal deterrent to

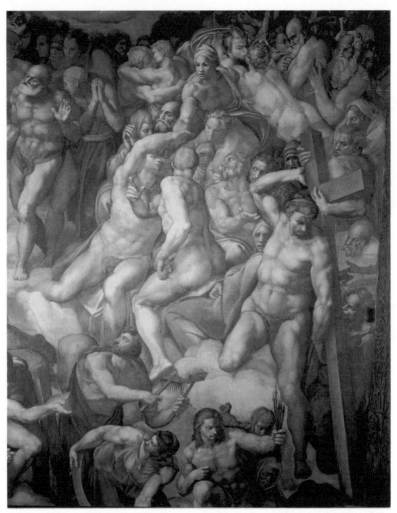

FIGURE 13. Detail from the *Last Judgment*, the Elect (Photo: Vatican Museums).

sin would have preferred direct delivery, because the more immediate the punishment the more effective the threat. Michelangelo, however, would have preferred the emotional tension that uncertainty would provide. It is also clear from his writings that he was personally haunted by the uncertainty of his own salvation and the recognition that no one is assured of it. A difference of opinion on this point, however, could have alienated some sixteenth-century critics from Michelangelo's

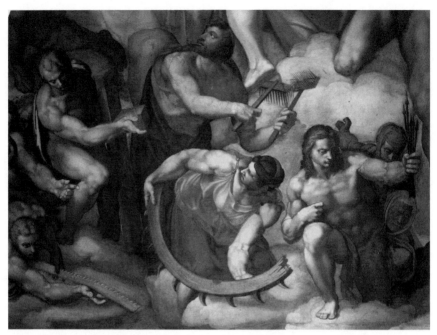

FIGURE 14. Detail from the *Last Judgment*, the Martrys (Photo: Vatican Museums).

fresco, namely, those conservatives who most frequently found fault with it.

THE ELECT

Surrounding Christ and the Madonna, crowded in the zone corresponding to the windows, are the Elect – the saints and martyrs and others who have risen to Paradise (Fig. 13). Some few have attributes and can be identified, but most cannot. We recognize Saints Lawrence with his grate (Fig. 7) and Bartholomew with his knife and flayed skin (see also Fig. 28), Saint Peter holding the keys (see Fig. 15), Saint Andrew with his cross, Saint Sebastian holding up the arrows with which he was shot, Saint Simon with his saw, Saint Blaise with his wool combs, and Saint Catherine with her wheel (Fig. 14). Two from the Crucifixion – the Good Thief, Dismas, and Simon of Cyrene, who carried Christ's cross for him – remind us again of the importance of Christ's sacrificial death and resurrection as necessary precursors to the event represented. Some figures we can only guess at, and there

was not even unanimity among Michelangelo's friends and contemporaries. The painter gave us only enough specifics to whet the appetite and stimulate the imagination. In the nineteenth century there were attempts to find an order here: "Choirs" of Prophets, of Apostles, of Sibyls, of Confessors, of Patriarchs, of Martyrs, and so forth, were identified, but all such efforts fail under examination. One scholar gave a name to every one of the 391 figures, an extreme example of exercising the imagination. The closest we can come to such choirs is the grouping of women at the left, balanced by a group made up largely of men in the corresponding position opposite. Because women were rare in traditional *Last Judgments*, Michelangelo's creation of this group is an innovation of considerable interest.[24]

The Elect respond with a whole range of emotions. Some embrace loved ones from whom they have been long separated. Many look toward Christ with intense scrutiny, some raise their hands as if to ward off what they are expecting. Many look anxious, some even terrified. As we have seen, they are quite unlike the traditional Blessed in their lack of complacency. Are they awed by the splendor of the Risen Christ, or is the painter saying there no such thing as certainty of election? To judge from Michelangelo's writings, he was much troubled by the realization that no one is truly worthy and that we can be saved only by God's grace and mercy.

Peter, the Prince of Apostles (Fig. 15), brandishes his attribute, the gold and silver keys, but they are more than an attribute, for he is returning the Keys of the Kingdom to Christ, who had entrusted them to Peter and to his successors the popes, as his Vicar on Earth. Some critics have seen in this head the features of Paul III, the incumbent pope, a not illogical identification. Yet what is the meaning of Peter's gesture? Is it a demand for justice, or is it a timorous proffering of the proof of his stewardship, tinged with doubt that he has adequately fulfilled his charge? Heinrich Wölfflin, recognizing the insistence of their gestures, saw these martyrs as seeking vengeance on those who had caused their suffering, an interpretation that may strike us as strangely off the mark.[25] Could it be that not even Peter is assured of his reception?

Vasari identified the figure striding forward on the left of Christ as Adam, but Condivi, who was writing a few years after Vasari and,

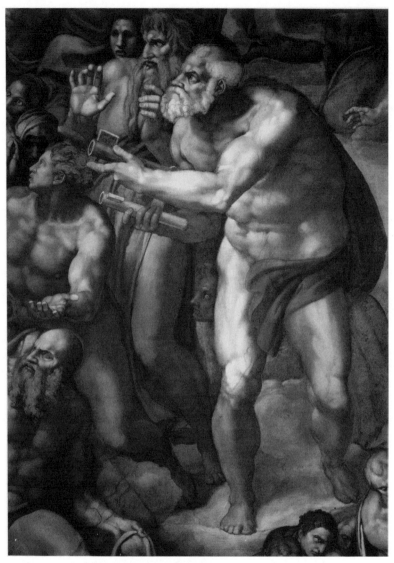

FIGURE 15. Detail from the *Last Judgment*, Peter (Photo: Vatican Museums).

under Michelangelo's guidance, corrected him, identifying him as John the Baptist. This would make sense, for he is pendant to Saint Peter opposite who also looks inward to Christ: John represents the end of the tradition of Old Testament prophets and Peter the beginning

of the era of Christianity, headed by the popes. There may be another level of allegory intended, for Christ reminds us not only of his Resurrection but also of his Transfiguration, in which he appeared to three of his Apostles in a blaze of light, flanked by the Old Testament figures of Elijah and Moses. According to the Gospels, Christ himself identified John the Baptist as a second Elijah to these Apostles in the context of the vision they had just witnessed (Matt. 17:9–13). Whereas Elijah was traditionally represented on the left, Moses was placed on the right, where here we see Peter. The frescoes of the Sistine Chapel were among many instances in which Moses was shown as an archetype of Peter: Botticelli's fresco of the *Punishment of Corah*, showing the passing of priestly powers from Moses to Aaron, was paired with Perugino's scene on the wall opposite depicting *Christ Bestowing the Keys on Peter*, the event understood as the institution of the papacy.

The Transfiguration was itself a prefiguration of the Resurrection and was interpreted as an anticipation of the Final Resurrection in the theological literature. Thus all three events are linked by the imagery: Christ's Transfiguration, his Resurrection, and the Final Resurrection. Thus the symmetry of the Baptist and Peter would appear to have been carefully calculated to give added theological depth. The layman-painter could not be expected to have invented such a conceit as this. It is the kind of refinement the theological advisers to the painter would have suggested or required.[26]

From the lower left where the graves are giving up the dead (Fig. 8), bodies are rising toward the Elect (Fig. 16). They are shown in all stages of acquiring their new spiritual bodies before they ascend. Some are taking flight, some are carried by angels, although they may be assisted by other Elect – we cannot distinguish because the angels have no wings. This could be a way of crediting Justification by Good Works, a doctrine under attack by the Protestants.[27] One pair grasping hold of a rosary are being hoisted by a muscular angel, apparently a demonstration of the power of Faith. The other cardinal Virtues may be recognized in other figures: the woman with eyes still closed, her shroud falling away, her hands raised, could be the embodiment of Hope, and those Blessed who lean over the clouds to offer a helping hand, Charity.[28] Some may be those who are still alive at the Second Coming of Christ, for Saint Paul assured that "The Lord himself will

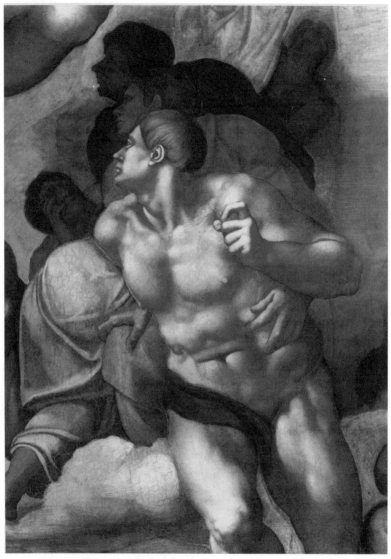

FIGURE 16. Detail from the *Last Judgment*, the Elect rising (Photo: Vatican Museums).

descend from heaven with a cry of command, with the archangel's call, and with the sound of the trumpet of God. And the dead in Christ will rise first; then we who are alive, who are left, shall be caught up together with them in the clouds to meet the Lord in the air" (1 Thess. 4:16–17).

THE DAMNED

Opposite those who are rising on the left toward the Elect are those who are descending into Hell on the right (Christ's left, Fig. 17). Battered down by angels who thwart their frantic attempts to ascend, some are cast down headlong, while others are dragged by demons. According to Condivi, sinners are hauled down by the part of the body with which they sinned, the proud by their hair, the lascivious by their pudenda. In fact, these figures seem to be allegories of the Vices, some even with attributes, like the money purse, which identifies Avarice. The spiritual bodies of the sinners are no less powerful or beautiful than those of the Elect, but suffering and torment, to which they are susceptible, distort their faces and contort their bodies. They are still vigorous, in contrast to the Damned depicted by many of Michelangelo's predecessors in their *Last Judgments*, where they are reduced to wasted, cadaverous creatures, as if malnutrition were the price of sin to be paid in the afterlife. Often the Damned and their sufferings had been on the threshold of the comical, reduced to implausible caricature. Before Michelangelo, only Signorelli had shown the Reprobates as still robust, preserving thereby their ability truly to inspire horror.

The despair of the Damned is embodied in a single titanic man, whose isolation enhances the horror (Fig. 18). His legs wrapped by a demon, another pulling on his feet, he plummets toward the abyss of Hell below. His face half covered with his hand, his shoulders humped, with his one staring eye he conveys vividly the dawning realization of his fate. Michelangelo wisely distilled into a single portrait of psychic despair the wages of an unredeemed life. His lonely figure anticipating eternal damnation is a far more effective admonition than the graphic images of physical torture that mark the depictions of Hell in earlier *Last Judgments*.

The Damned are being pulled inexorably toward the lower right corner, where they will be ferried by Charon across the river Styx (or Acheron) to the underworld (Fig. 19). Charon has been borrowed from classical mythology, and he, like Minos, figured in Dante's *Divine Comedy*, where he is described as a demon who torments the Damned with their hopeless plight and urges along the reluctant with blows from his oar. There is very little in the scripture that describes the

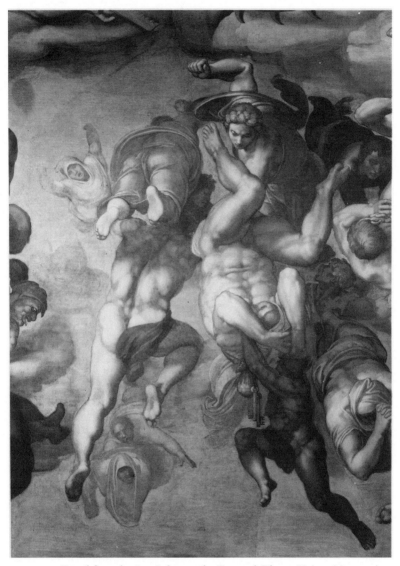

FIGURE 17. Detail from the *Last Judgment*, the Damned (Photo: Vatican Museums).

afterlife, so Dante's vivid imagery filled the gap for Michelangelo, who knew his Dante so well, we are told by his contemporaries, that he could recite much of it from memory.

In the lowermost corner is Minos (Fig. 20), the judge of the Underworld in Greek mythology, who appeared to Dante at the entrance

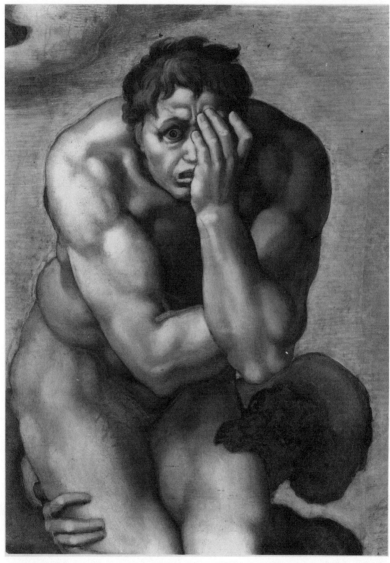

FIGURE 18. Detail from the *Last Judgment*, the anguished reprobate (Photo: Vatican Museums).

to the second circle of Hell in his *Inferno*. Vasari relates how Pope Paul brought his master of ceremonies, Biagio da Cesena, with him when he inspected Michelangelo's still unfinished fresco. Asked his opinion, Biagio replied that it was disgraceful to represent so many nudes in

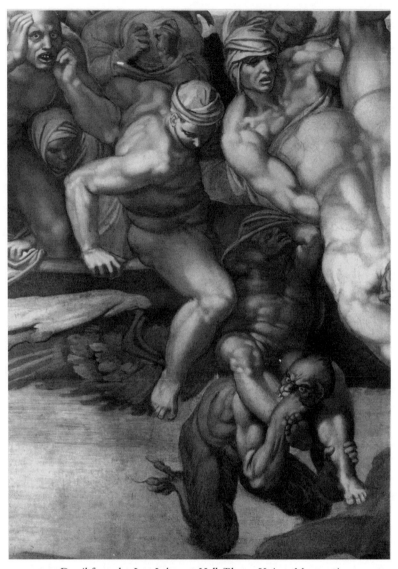

FIGURE 19. Detail from the *Last Judgment*, Hell (Photo: Vatican Museums).

such a place and that the work was better suited to a public bath than a chapel. As the story goes, no sooner had they left than Michelangelo took his revenge by giving to Minos the features of the master of ceremonies and wrapping an enormous serpent around his torso with its mouth sucking his penis. Another figure has been more convincingly

identified as the portrait of Biagio,[29] but Minos is the consummate emblem of evil and of abuse of the body, for his right hand gently supports the friendly serpent in her fellation of him.

THE RESPONSE: ARTISTS AND CRITICS

The reception of the fresco should be considered from the point of view of both the artists and the critics, and critics both inside and outside the church.[30] The issues are of course linked, because the enormous impact the fresco made on the painters was then reflected in their imitations of it. In the hands of lesser artists, and less pious artists, these imitations were often out of context and incongruous, as the critics pointed out. Although it is not difficult to defend Michelangelo's use of nudity and exaggerated musculature for the subject he was depicting, the use to which some painters put his innovations was indecorous, as even secular critics of the later cinquecento admitted. Raffaello Borghini, writing in Michelangelo's native town of Florence (1584), where Il Divino continued to be regarded as the greatest of the great, warned artists against the excesses deriving from copying Michelangelo's anatomy. Do not give a delicate woman the limbs and muscles of a ferocious man, the painter is told. The modeling of muscles should not be exaggerated.[31] Although it is never stated, these faults resulted from uncritical imitation of Michelangelo.

As soon as the fresco was unveiled in 1541 it became a new model and a source of poses for the artists. The painter and writer Armenini (1586) recollected how as a young man, when he was in the chapel drawing, he would be among many others, and he would overhear discussions and disputes about minute details of the work. It became a kind of school of anatomy, the best place in Rome – or anywhere – to study the nude figure. This created its own set of problems, as Armenini noted. The obsessive and slavish imitation practiced by some artists led to their loss of good judgment, so that they would fail to integrate the imitated parts into the whole: "Some painters are so blind they place in their works some ridiculous nudes made with graceful heads and soft arms, but with muscular body and loins, while the rest of the work is in soft contours and light shadows."[32] Michelangelo himself was aware of the danger this wholesale imitation offered to young artists if they did not take into account the context and subject

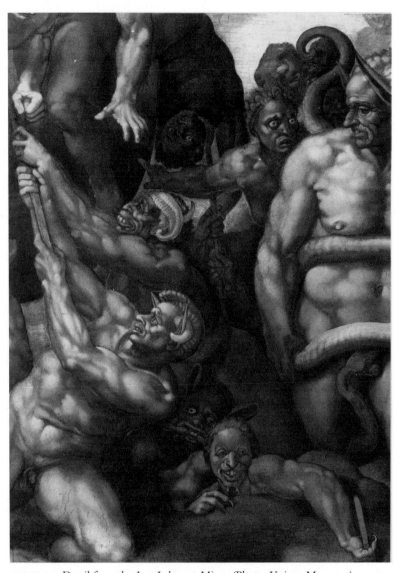

FIGURE 20. Detail from the *Last Judgment*, Minos (Photo: Vatican Museums).

of his fresco. Armenini tells of Michelangelo visiting the chapel on some sort of business in the company of a bishop and, seeing the copyists, remarking, "Oh, how many men this work of mine wishes to destroy."[33] Nevertheless, many experienced artists and some brilliant ones learned from the *Last Judgment*, assimilating what they learned and

making it part of their own styles – for example, Agnolo Bronzino, the principal painter in Florence at midcentury, and Francesco Salviati, who deserted the model of Raphael after the *Last Judgment* and took up a Michelangelesque sculptural style in his painting.[34]

Amid the chorus of praise reporting on the fresco when it was first viewed, we hear a disturbing undercurrent criticizing the nudity, as Melinda Schlitt shows in her essay in this volume. Even in 1541 there were already those who felt that such a display was indecorous on the altar of the papal chapel. This became part of a reaction that was building within the Church against the prevailing artistic style, regarding it as inappropriate for sacred images. The fashion for contorted nudes imitated from Michelangelo's fresco exacerbated the situation and added fuel to the critics' fire. Armenini addressed himself to the artists when he gave this advice to the painter of devotional images: "When paintings are in a sacred place, they must be such that they draw men's thoughts as much as possible toward purity and honesty. Certainly, it is very unsuitable to see in holy places paintings of such a nature that they turn the minds of men away from religious thought and towards the pleasures and delights of the senses."[35]

Michelangelo would have agreed with him. A source that purports to record conversations with the artist (Francisco de Hollanda) quoted Michelangelo as saying that to render the image of our Lord, the painter should be of blameless life, even if possible a saint, so that the Holy Spirit could inspire him. Furthermore, he insisted on the value of artistic quality, because a badly wrought image could distract the attention and prevent devotion, "while those that are divinely fashioned excite even those who have little devotion or sensibility to contemplation and tears and by their austere beauty inspire them with great reverence and fear."[36] Here he introduced a point that those churchmen who were not particularly attuned to aesthetics did not grasp. What Michelangelo is saying is that only great artists can truly serve the devotional needs of the Church. The most conservative of the Counter-Reformation critics, the bishop of Bologna, Gabriele Paleotti (1582), makes the same impossible demand. As Paleotti conceived it, the artist's image was an instrument to unite man with God. He should "recall men from vice to the true cult of God," but his artistic excellence should always be in the service of his devotion. It was not enough to be a good artist and to show the excellence of art: the

artist is a Christian and is therefore obliged to seek to show in his images a Christian soul.[37] It is ironic indeed that Michelangelo, who was arguably the most devout artist of the cinquecento, should have become the source of so much abuse on the part of his followers and the target of the Counter-Reformation campaign to reform religious imagery.

There was even a serious threat to destroy the fresco during the papacy of the fanatical Paul IV Carafa (1555–9). This zealous reformer had been the first general of the Inquisition when it was established in Rome in 1542. When more space was needed in the chancel area of the Sistine Chapel to accommodate the enlarged College of Cardinals, he proposed tearing down the altar wall and moving it back, thereby incidentally demolishing the *Last Judgment*. In the event, the space was provided by moving the chancel screen forward to its present location, but the threat to the fresco had been real. It is an index of the intensity of the animosity it aroused in some and the seriousness of the demands for reform of sacred art. Protestant attacks on the Church for idolatry and abuse of images goaded the ecclesiastical hierarchy to redefine the position of the Church on the proper use of images and to take a fresh look at religious art.

Complaints against the artists proliferated after the first meetings of the Council of Trent in 1546. A Sienese Dominican, Ambrogio Catarino writing in 1552, noted that painters did not imitate nature; he had seen "some images so extravagant that you can hardly recognize the human figure in them. . . . And elsewhere you see compositions made with so much artifice that at times among so many improper gestures they ignore the decorum of the figures, and do not have any dignity and do not excite any devotion at all."[38] This was the crux of the issue: that the virtuoso display of artistry led the worshiper away from devotion to contemplating the art, rather than the sacred subject. Catarino, however, was writing for ecclesiastical circles – his text was in Latin – and it would be another decade and more until Gilio's *Dialogue* in the vernacular would aim such denunciations directly at the painters and their patrons.

These complaints of the corrupting influence the fresco had on other painters were only one part of the problem. In the eyes of the Church, the viewing audience was even less comprehending and more misled. The theologian Giovanni Andrea Gilio's attack on the *Last*

Judgment was based on concern that the fresco was not eliciting the proper response from the viewer. More than once he remarked that the worshipers would be moved to laughter when they should be awed and devout.[39] What lies behind this mismatch between audience and fresco is not that Michelangelo misjudged. His *Last Judgment* was the casualty of a media revolution, a first step in the modern democratization of art. Just at the time the fresco was unveiled, printmaking took a decisive turn toward reproductive engravings. Engravings and woodcuts had been around for more than two generations, but they had been used to create new works of art, for example Dürer's Passion cycles. Many of Raphael's works had been engraved, but these were made from *modelli* or works never executed. Landau and Parshall date the beginning of reproductive printmaking to the 1530s. They cite an engraving of Raphael's *Transfiguration* as the earliest dated print of an independent, complete work of art, inscribed 1538. The earliest reliable date found on a print after a fresco is Niccolò della Casa's engraving of Michelangelo's *Last Judgment*, dated 1543, just two years after its unveiling.[40] For the *Last Judgment* this was only the beginning: it was copied by Giorgio Ghisi again already in the 1540s and by Giulio Bonasone around 1546. By the end of the century, seventeen printmakers had made editions of their copies of the fresco.[41] Thus the image was made available to a far different audience from that for which it had been conceived. The congregation that would assemble in the Sistine Chapel was made up principally and regularly of the College of Cardinals and members of the papal court and household,[42] most of whom would have been familiar with the theology surrounding the Final Resurrection. The public that could purchase the reproductions had no training in theology and were not necessarily familiar with Michelangelo's style or with the conventions of Renaissance art. No wonder Gilio worried.

Gilio published his treatise attacking Michelangelo's *Last Judgment* in 1564, the same year that the Decrees of the Council of Trent were published and that Michelangelo died. Apparently out of respect for the venerable man, Gilio waited until his death, for he says that the treatise had been completed in 1562. The full title indicates its thrust: *Dialogue on the Errors and Abuses of the Painters . . . with many notations on the Last Judgment of Michelangelo . . . with clarification of how they should paint sacred images.* He criticized the fresco for many small departures from scripture and for the excessive nudity, although he acknowledged

that when the final trumpet sounds we will certainly be raised naked. In demanding clarity, purity, and piety in sacred images Gilio was restating what by then were widely held views that were codified in the Tridentine Decrees. Gilio's real concern was that the virtuosic display of the "excellence of art" distracted from the religious content and was therefore inappropriate in sacred images. He made Michelangelo's *Last Judgment* the scapegoat because it had engendered so many of the abuses by the painters that he wished to bring to an end, the same abuses criticized by Borghini and Armenini a quarter century later as already described. Armenini's book is proof that Gilio's point was successfully made and the artistic establishment became persuaded that a new kind of sacred image was required because – unlike Gilio's book, which is dedicated to the leading patron of the day in Rome (Cardinal Alessandro Farnese) – Armenini's is advice from one artist to others.

At one point in his treatise Gilio broaches a discussion of hidden allegorical meanings that might be concealed from the understanding of the simple and the uninitiated. The Church had often held that some truths are so precious, they should be cloaked in mystery to guard their sanctity. Martin Luther had attacked the premise that the laity are not worthy of sharing in these mysteries. He denounced the exclusiveness of such practices as the priest lowering his voice in the Mass so that the congregation should not hear the words of the consecration of the host. In its efforts to democratize itself the Church was moving away from arcane and hidden meanings. Already in 1557, in his treatise *Dialogo della Pittura intitolato L'Aretino*, Ludovico Dolce discussed the possibility that Michelangelo's fresco contained hidden allegories. As Melinda Schlitt describes in her essay, Dolce has his Aretino rail against inventions that can be understood only by an intellectual elite.[43] Aretino, the most intellectual of intellectuals, is championing the ignorant masses who have become, through the new means of reproductive engravings, the fresco's principal audience.

The compromise to save the fresco from destruction was that some of the nudes would be covered with loincloths and the most troubling juxtaposition of Saints Catherine and Blaise (Fig. 14) would be adjusted. Out of respect for the master, Michelangelo's closest follower, Daniele da Volterra, was assigned the task of making these changes. This section of Michelangelo's original fresco attracted more criticism than any other because the juxtaposition of the two figures invited bawdy jokes. Saint Blaise stood behind Saint Catherine and looked

down at her as she leaned over to lift the broken wheel, symbol of her martyrdom, and turned her head back to look toward Blaise. As Gilio remarked, it looks as if she is saying to him, "What are you doing [back there]?" Daniele da Volterra was called in to fix it in 1565, soon after the master's death in 1564. He made his repairs in true fresco, adding drapery to the upper body of Catherine and turning Blaise's head away so that he looks at Christ and ignores Catherine. Now that the fresco has been cleaned, Catherine's drapery, executed in a bold *cangiantismo* in which the green shifts in the lights to yellow, stands out. Daniele chose the green pigment malachite, which Michelangelo had not employed anywhere else in the fresco, possibly because he could not match the earth green used in Catherine's skirt.[44]

Daniele died the following year, but he began the process of adding loincloths to cover the genitals, for which he was nicknamed Il Braghettone, "the britches-maker." This was a process that continued in the seventeenth and eighteenth centuries and, astonishingly, was considered even in recent times. A scholar reported that in 1936 rumors were current that Pius XI intended to continue the work of adding breeches. It was decided in the recent restoration not to remove most of them on the grounds that they can be taken off at any time in the future because all the changes, except these of Daniele, were made in *secco* on top of Michelangelo's original paint and, furthermore, that these additions have become part of the history of the piece. Objections have been voiced on aesthetic grounds that because the fresco had darkened and the additions were matched to the dirty surface, their dark, murky tones now stand out against the pure colors of the cleaned fresco.

TECHNIQUE

In executing his Old Testament frescoes on the vault, Michelangelo had used three methods of transferring his design onto the plaster. In the lunettes of the *Ancestors of Christ* on the side walls, no signs of either pouncing or incision were found. It appears that he enlarged his small sketches freehand and painted without other preparation. In the bold strokes of thinly applied paint one can sense his relief at being released, if only temporarily, from the discomfort of having to reach over his head to paint, as he had to do on the vault. On other sections,

especially where the vault curved and foreshortenings were a problem, he used pouncing, the most sure method of transfer – and the most time-consuming. Taking his full-scale cartoon and holding it up to the *intonaco*, he pricked the outlines with a pin, then flung a bag of charcoal systematically along the holes. The tiny dots that served as his guide in painting can sometimes still be seen at close range, but they disappear, of course, from a distance. The cartoon could also be traced with a blunt point, and the indentation would be recorded in the damp plaster of the *intonaco*. This was a less tedious procedure than pouncing, and Michelangelo appears to have used it with increasing frequency as he gained experience and felt increasingly pressed for time.[45] All three techniques were used in the *Last Judgment*.[46] Again he used pouncing at the top, then as he proceeded downward, incisions become more frequent. There were groups of figures painted without cartoon, in fact added afterward in *secco*, sometimes at a distance of several days. The crowds of indistinct heads among the Elect, appearing in the rearmost plane, are such later fill (see Figs. 7, 15).[47]

The artist is older and more shrewd. He is less the perfectionist and more pragmatic, less in love with effects that could never be seen from the floor, more aware of what is worth taking the time to render carefully and what would be quixotic. There is more *secco* than in the vault, there are more corrections, and the preparation is more economical, the brushstrokes broad and rapid, the palette reduced and simplified. His choices are astute. In preparing the plaster to go under figures, he takes the trouble often to add marble dust, presumably to make the surface smoother and the base lighter in color. On the other hand, in the vault a figure had on occasion been elaborately prepared with different tones of *terra verde*, umber, and *verdaccio* (dirty green). Nothing of the sort appears in the *Last Judgment*. All the figures are prepared with a brown local color, usually umber, then the midtones and lights are added on top. This is a quick and efficient method, making it possible to execute the vast number of figures that people the wall. He is also less cautious about using *secco* to make corrections, additions, and refinements. Whereas on the vault he normally scraped away the *intonaco* in such cases, in the *Last Judgment* he scrapes away only the color.

Michelangelo was prohibited from following one of the fundamental rules of fresco painting. Because it is almost impossible to match a

color from one *giornata* to another, the frescoist arranged to encompass all of a single field of color in a *giornata*. For this reason we normally see the seams of a day's work following the contours of a figure or a drapery. The blue of the sky here, however, had of necessity to be executed in many patches, with the result that there were seams running across *giornate* that the painter had to go back and conceal with *secco*. Over the centuries they became visible again as the *secco* wore away. In old photographs, they are very apparent, but happily they were successfully concealed again in the recent restoration.

The use of ultramarine for the sky and the preparation under it is another instance of Michelangelo's perspicacious use of time and resources. The pope was paying for the materials, so Michelangelo used precious ultramarine, replacing the much cheaper smalt that had been used for the blues in the vault. To bring out its purplish tone he underpainted it with red ochre, giving it a rosy tonality. Never before had ultramarine, which is derived from the semiprecious stone lapis lazuli, been used on such a scale. Michelangelo recognized that no effort should be spared to enhance its richness and its brilliance.

In fact the color scheme hinges on the blue, which dominates and binds together the enormous painting. The other colors are scattered across the prominent nude flesh, and the pigments are fewer in number than on the vault. The typical pigments of fresco prevail: yellow and red ochre, *terra verde* for green, lime white (*bianco di sangiovanni*), vine black (obtained by burning grapevines), and for browns, umber and burnt sienna. In *secco* passages, however, he used pigments that were almost never used in fresco: red lake, orpiment, and lead-tin yellow (*giallolino*). These last two were needed to give sufficient brilliance to the sunlike aureole behind Christ.

The problem of how to represent the celestial sphere must have occupied Michelangelo's mind. The traditional gold background of mosaic was normally replaced in frescoes from Giotto onward with blue. Giotto's background was done with azurite applied *secco*, but as happens when the wall becomes wet, in places it has turned green. Signorelli used a very pale background, almost white. Michelangelo's solution in terms of the extravagance of ultramarine was a brilliant innovation. It carried some of the same connotations as gold, without appearing to be a throwback to an outmoded medievalism. No

sixteenth-century viewer would have failed to recognize its precious-
ness and its novelty.

In the lower right corner where Hell is depicted, the tonality shifts
abruptly. In Dante's *Inferno*, the light is so dim, it is hard to make
out the forms. Thus the painter, following Dante, when he came to
grapple with the demons and Damned at the entrance to Hell, needed
a deeper palette than fresco can provide, with its technique of applying
semitransparent tones over a white ground. The ultramarine sky does
not penetrate here; instead we see the murky waters of the river Styx,
and dingy figures barely distinguishable in the forbidding gloom. To
obtain the doleful effect he sought, Michelangelo covered the white
intonaco with a reddish-brown umber, then painted the midtones and
lights on top. In a few passages in this zone where he wanted to use
certain green and blue metallic pigments that are not compatible with
fresco, he used oil as his medium, as Sebastiano del Piombo had proven
could be done successfully in his murals in the chapel in San Pietro in
Montorio.[48]

Shortly after the fresco was completed the pope commissioned
Perino del Vaga to design a tapestry to hang below on the wall behind
the altar. Perino was the pope's other favorite painter. He had recently
executed a similar commission, the *basamento* in Raphael's Stanza della
Segnatura, frescoed with caryatids and fictive bronzes containing nar-
ratives from antique mythology, and he was at work on the stuccoes
in the Sala Regia. Although the tapestry was never executed, Perino's
cartoon has survived.[49] To our eyes its exuberant ornament in the
maniera (mannerist) style contrasts strikingly, even shockingly, with
Michelangelo's skeletal bodies rising from the grave and the Damned
crossing the river Styx into the mouth of Hell. Here, in a nutshell,
is to be seen the unresolved dichotomy of the age. In the cultivated
circle of the Farnese pope there was no conflict between the two
images. The Farnese elite simply could not see, apparently, what the
Catholic reformers saw: that Perino's splendid frame would frivolize
Michelangelo's apocalyptic image.

RESTORATIONS

The recent restoration has brought back to life the image and the
colors, which had been masked by the accumulated grime and smoke,

and distorted by earlier attempts to refresh or restore them.[50] The restoration was the culmination of a fourteen-year campaign begun in 1980 with the Ancestors of Christ in the lunettes, unveiled to universal acclaim in 1984. The vault required six years. The *Last Judgment* was begun in early 1990 and presented to the public in March 1994.[51]

The problem for the restorers presented by the *Last Judgment* was the unevenness of its discolorations – the condition of the vault had been more homogeneous. This was due only in part to Michelangelo's technique, and more to the variety of interventions in different parts that the fresco had undergone over the previous centuries. The lower zone in particular, in the vicinity of the altar candles, had become so dark that it was almost illegible, and the lunettes high above were still light and legible. That lower zone, being easily accessible, was subjected to numerous restorations in the past. Beginning soon after Michelangelo completed it, and continuing even into the past century, the fresco was regularly dusted, which damaged the fragile *secco* passages and abraded the surface. As in the vault, animal glue, to which was added a small amount of vegetable oil, had been applied to the surface to refresh the colors, much as varnish was used on oil paintings. Not only did this coating darken, like varnish, but it encouraged the growth of fungus, producing a spotty appearance, particularly in the upper part of the fresco. In some places oil alone was used to resaturate the colors, and where the *intonaco* was porous it absorbed the oil, penetrating the cracks and creating irregular dark spots, some of which cannot be removed. Nevertheless, because there was no water damage, there were fewer layers of glue than had been found when the vault was cleaned. There were numerous retouchings, including reinforcement in the shadows to revive the modeling. Where the additions were heavy, the surface was dark and vitreous; where thin, it was lighter.

The strategy the restorers devised allowed them to move slowly and to compare a newly cleaned segment with what had already been completed to assure that the same level was achieved. The delicate sky required special treatment because it could not be rubbed even with a soft brush, and matching the color throughout was critical: the dirt had to remove with a blotter, wet with a sponge, so that no friction was created. With its completion the chapel has attained a new coherence that not had been seen for centuries. The brilliant ultramarine sky,

though unique within the chapel, focuses the decorative scheme so that the altar wall becomes the dramatic climax.

CONCLUSION

Until this point in Michelangelo's career the premise of High Renaissance humanist art had remained intact and operative: the body conveys the dignity of human creation in the *imago dei*. To judge from the change in his style that took place following the *Last Judgment*, what Michelangelo discovered here was the limitation of the Ideal as a visual metaphor for humankind in God's image, for he abandoned it after the *Last Judgment* and never used it again. In his last paintings in the Pauline Chapel (Vatican, Figs. 27, 28), in his late drawings and sculptures, and even in his architecture, he turned to a late medieval model – we are reminded of his own early drawings after Giotto – and invented what has been dubbed his "drab manner."[52] In place of his elegant and dynamic serpentine poses we find heavy, stolid, blocklike figures who move ponderously as if weighed down.

In his search to express the spiritual body in visual terms, Michelangelo had drawn on his lifelong conception of the ideal body. Not only in the Sistine vault but generally in Michelangelo's artistic language, strength and energy had always been his means to express ideality. The *Moses* (Rome, San Pietro in Vincoli) is an old man with flowing beard, but his bared arm and muscular build convey the power of his sanctity and his closeness to the Lord. Michelangelo's amazonian Madonna in the Doni *Holy Family* (Florence, Uffizi) is a far cry from Leonardo's lovely evocations of feminine grace in his Madonnas, but she is no less potent a metaphor for the terrestrial embodiment of the divine.

In the lowest zone of the *Judgment*, the final setting of the scaffolding, the idealized and perfected body was not suitable to represent those being reclothed in flesh at the left or the demons in the cave at the center and in Hell at the right. His Damned, anticipating the Pauline Chapel frescoes, are as powerful physical specimens as are the Elect, but they move ponderously and without the grace of the Elect. Nowhere in this lowest and ultimate zone of the fresco was the idealized and perfected body appropriate.[53] Particularly to depict the Damned, Michelangelo had to search beyond his accustomed

repertory to present human forms that were still Saint Paul's "spiritual bodies" and yet were outside God's grace. Did this trigger his rethinking that resulted in his forsaking Renaissance ideality and his conversion to the drab style? His personal spiritual odyssey in these years had brought him to the tormenting fear that he would not be among the Elect and the recognition that most of humankind had not earned redemption. Doubt in the enterprise to which he had dedicated his life, to make the aesthetic the manifestation of religious devotion, was expressed in his late writings. His poem of the 1550s says it poignantly:

> So the affectionate fantasy
> That made art an idol and sovereign to me
> I now clearly see was laden with error,
> like all things men want in spite of their best interests.[54]

It has often been commented that the modeling of Michelangelo's figures is exaggerated. Late in the sixteenth century Annibale Carracci characterized the nudes in the *Last Judgment* in contrast to the figures of the Sistine Ceiling as "too anatomical."[55] The criticism has also been made that the similarity in the way old and young, male and female, are treated in the *Last Judgment* results in a certain schematism. The sense of lifelikeness is compromised. Precisely that individuation that Michelangelo sought falters and is replaced by a not fully plausible artistic pattern. It may be the tragic irony of this work that it is impossible to do what Michelangelo set out to do: represent all of humankind, respecting each person's uniqueness but conforming his or her form to an ideal, an ideal that includes physical maturity, consummate strength and energy. If everyone must have a perfected body, how is it possible to introduce sufficient variation to depict nearly 400 figures? To compensate for the uniformity of his bodies he had to rely on diversifying their poses in what, with so much repetition, came to appear contrived. The very diversity was an artistic asset, however, in Michelangelo's century (unlike today) when virtuosity was expected of an artist and admired. This commission demanded a tremendous virtuosity; possibly no artist but Michelangelo commanded a repertoire of anatomies equal to the task. But if what he undertook could not be achieved, what he did accomplish was monumental: to balance in tension the terror and the joy of the Final Day, and to

represent both God's initiative and man's responsibility as no artist before had done.

NOTES

1. This text is a revised version of Marcia B. Hall, "The Last Judgment," in *Michelangelo. The Frescoes of the Sistine Chapel* (New York: Abrams, 2002).

2. On the history of Pope Sistus IV's chapel and the damage to the vault in 1504, see John Shearman, "The Chapel of Sixtus IV," in *The Sistine Chapel. The Art, the History, and the Restoration* (New York: Crown-Harmony, 1986), 22–91, esp. 32.

3. John Shearman amassed evidence concerning the history of this project, which he presented as a lecture in several venues. His intention to contribute an essay on it to this volume was cut short by his untimely death.

4. Michelangelo's preparatory drawings have been studied many times, recently by Michael Hirst, *Michelangelo and His Drawings* (New Haven: Yale University Press, 1988), who cites the earlier bibliography. Bernardine Ann Barnes convincingly argued the case for the Metropolitan and Courtauld sheets as copies of the lost *modello*: "A Lost *Modello* for Michelangelo's *Last Judgment*," *Master Drawings* 26 (1988): 239–48.

5. If, as is generally supposed, Pope Clement first proposed the project in the fall of 1533, then Michelangelo submitted the *modello* in the summer of 1534 and continued to ponder the subject until May 1536, when he actually began to paint.

6. See the drawings of the resurrected Christ assembled by De Tolnay (*Michelangelo V: The Final Period* [Princeton: Princeton University Press, 1960]): Casa Buonarroti 66F (De Tolnay, V, no. 179), and 61F (De Tolnay, V, no. 163); London British Museum 1895-9-15-501 recto (De Tolnay, V, no. 166), as in n. 18: Marcia B. Hall, "Michelangelo's *Last Judgment*: Resurrection of the Body and Predestination," *Art Bulletin* 58 (1976): 89.

7. De Vecchi, "Michelangelo's *Last Judgement*," in *The Sistine Chapel. The Art, the History, and the Restoration* (New York: Crown-Harmony, 1986), 186.

8. For the connection between Michelangelo's image of Christ and Copernicus, see Valerie Shrimplin-Evangelidis, "Sun-Symbolism and Cosmology in Michelangelo's *Last Judgment*," *Sixteenth Century Journal* 21 (1990): 607–44.

9. Leo Steinberg ("Michelangelo's *Last Judgment* as Merciful Heresy," *Art in America* [November/December 1975]: 49–63) did away with the contention that one book contain the names of the Elect, and the other the Damned. He correctly asserted that there is no such thing as a Book of Death, which was instead conveniently "invented for the occasion by Michelangelo scholars" (56).

10. It was identified as limbo by De Tolnay (V, 28 and 104–05, n. 23), but it is too fiery and demon inhabited for that neutral place of waiting. The fire is more appropriate to Purgatory, the place of purgation. Loren Partridge (*Michelangelo, The Last Judgment: A Glorious Restoration* [New York: Abrams, 1997], 33–5) describes it as Hell's Mouth. According to Steinberg ("A Corner of the *Last Judgment*," *Daedalus* [Spring 1980]: 268, n. 54), this identification had been denied by De Campos,

who pointed out that "Steinmann and others were wrong to call it the mouth of Hell, since Hell is indicated in the lower right corner." Barnes (*Michelangelo's Last Judgment: The Renaissance Response* [Berkeley: University of California Press, 1998], 121) called it a mound and associated it with the passage in Isaiah (2:10–19) admonishing people to conceal themselves in caves in the rocks to hide from the wrath and splendor of the Lord of Hosts on the day of doom. Those hiding in these rocks are demons, however, not sinners.

11. Discussed at length later in the Introduction.

12. Barnes (1998) reproduced a photograph of the temporary altar in place: see fig. 63.

13. On Signorelli's frescoes, see Jonathan B. Riess, *Luca Signorelli: The San Brizio Chapel, Orvieto. The Great Fresco Cycles of the Renaissance* (New York: George Braziller, 1995), and idem, *The Renaissance Antichrist: Luca Signorellli's Orvieto Frescoes* (Princeton: Princeton University Press, 1995).

14. Millard Meiss's thesis has been much criticized and somewhat revised because of his exclusive focus on the Black Death, but the changes in iconography that he pointed out are undeniable, and they include, importantly, a renewed interest in the Last Judgment (*Painting in Florence and Siena after the Black Death* [Princeton: Princeton University Press, 1951]).

15. On the interpretation of the *Last Judgment* as a response to the Sack of Rome, see Andrè Chastel, *The Sack of Rome, 1527*, trans. Beth Archer (Princeton: Princeton University Press, 1983), esp. 200. This reading was repeated by De Vecchi (1986), 181, and Partridge (1997).

16. See D. P. Walker, *The Decline of Hell: Seventeenth-Century Discussions of Eternal Torment* (Chicago: University of Chicago Press, 1964). Although he devotes relatively little space to the sixteenth century, he discusses the Renaissance revival of early Church Fathers, and the appeal of Origen to the Florentine humanists. He points out that they steered clear of Origen's heretical beliefs.

17. The Colloquy between representatives of the Protestants and the Catholics reached agreement on most of the important issues, including the crucial question of justification. Luther's hostility gradually made it clear, however, that reunion of the Church was impossible. As Elizabeth Gleason put it, after the death of Contarini (1542) and others in the early 1540s, the age and spirit of toleration was over. The new leaders were militant, regarding the Protestants as the enemy. "The old church of the Renaissance was about to disappear, and with it the religious openness that had characterized many of its leading figures, including the *spirituali* cardinals. It was not a matter of fanatics replacing proponents of toleration, but of legalistic bureaucrats succeeding more latitudinarian prelates who had been educated in the spirit of Renaissance humanism" (*Gasparo Contarini: Venice, Rome, and Reform* [Berkeley: University of California Press, 1993], 300–1). A symptom of the shift is the refounding of the Roman Inquisition in 1542. See also Mayer's essay in this volume.

18. See Melinda Schlitt in this volume (n. 22) for references and a translation of Pitti's letter of 1545.

19. This is not to claim anything so extreme as Steinberg (1975), who found evidence in the fresco of the heresy of disbelieving in the eternity of Hell, but rather to

try to take into account the diversity of opinions among theologians and clerics within the Church. See the *Dictionnaire de theologie catholique*, "Jugement."

20. De Tolnay, V, 19, followed by other scholars, interpreted the letter dated 20 February 1534 from Nino Sernini, an agent of Gonzaga – in which he spoke of the *Resurrection* that the pope had managed to persuade Michelangelo to paint above the altar in the Sistine chapel – as evidence that it was only as a second thought that the subject was changed and the commission enlarged to include the whole wall. De Vecchi (1986, 180) followed my interpretation (1976, 85). The theme of the Resurrection of the Body is further developed in my essay in this volume.

21. Michelangelo had followed Augustine as his guide for the vault. See Esther Dotson, "An Augustinian Interpretation of Michelangelo's Sistine Ceiling," *Art Bulletin* 61 (1979): 223–56, 405–29. Reprinted in William E. Wallace, ed. (*Michelangelo. Selected Scholarship in English*, 5 vols., vol. 2, *The Sistine Chapel* [New York: Garland, 1995], 203–27), whose interpretation of the theology underlying the vault program is the most convincing to have been offered.

22. *City of God*, bk. XX, ch. 6.

23. *Summa Theologica*, supplement, q. 69: "Whether souls are conveyed to heaven and hell immediately after death." The *Dictionnaire de theologie catholique* is clear that the orthodox position is that there is no delay (vol. 5, "Enfer"), but it also makes clear that such a consensus had not been reached by the sixteenth century.

24. Barnes (1998, 44) discusses the issues of gender related to the fresco.

25. Heinrich Wölfflin, *Classic Art*, trans. Linda and Peter Murray (1899; reprint, London: Phaidon, 1952), 198. Steinmann (*Die Sixtinische Kapelle*, 2 vols. [Munich: Bruckmann, 1905], vol. 2, 535) also identified anger expressed by the martyrs. Barnes, who notes this reference (144, n. 48), interprets especially Peter's expression as outrage over the desecration of relics in the Sack of Rome. She points out that the relics of several of the saints represented were among those looted in the sack (56).

26. Jack M. Greenstein linked the imagery to the Transfiguration: " 'How Glorious the Second Coming of Christ:' Michelangelo's *Last Judgment* and the Transfiguration," *Artibus et Historiae* 20 (1989): 33–57. I reproduce his argument here.

27. Barnes makes this interesting point (57), which would reinforce the orthodoxy of Michelangelo's fresco.

28. De Tolnay (V, 37 and 117) identified the Virtues, seeing these figures in correspondence to the Vices on the opposite side, which had already been pointed out by Vasari and Condivi. Partridge (1997, 70) identified the most prominent of the helpers, the blond with green fillet around his head, as an angel, which is probably correct, but there are adjacent figures who could represent Charity.

29. See Steinberg (1980, 207–73) for the identification and interpretation of this anecdote and figure.

30. Barnes (1998) has discussed the critical reception of the fresco most recently and most thoroughly. Romeo De Maio has catalogued and discussed the early responses to the fresco after its unveiling: *Michelangelo e la controriforma* (Bari: Laterza, 1978).

31. Raffaello Borghini gave his advice to painters in his treatise, *Il riposo* (Florence: 1584). Facsimile edition with bibliography and index, Mario Rosci, ed., 2 vols. *Gli storici della letteratura italiana*, no. 13 (Milan: Edizioni Labor, 1967), 181.

32. Armenini, bk. 1, ch. 8 (English ed., 138).

33. Ibid.

34. For discussion of Bronzino's and Salviati's uses of Michelangelo's *Last Judgment*, see Marcia B. Hall, *After Raphael: Painting in Central Italy: 1520–1600* (New York: Cambridge University Press, 1999), for example, 158–60, 238, 243–4.

35. Armenini, bk. 3, ch. 5.

36. Francisco De Hollanda was an artist visiting Rome from his native Portugal. He made the acquaintance of Michelangelo and wrote his dialogues, allegedly quoting the artist, probably in 1539. The passage quoted is from the Third Dialogue, 65–6: *Four Dialogues on Painting*, trans. Aubrey F. G. Bell. (1548; reprint, Oxford: Oxford University Press, 1928).

37. Paleotti, the bishop of Bologna, took a very conservative position in his treatise regarding what was appropriate for sacred images. The comments cited are taken from bk. 1, ch. 21, 215; ch. 19, 211; ch. 3, 136, of his *Discorso intorno alle imagini sacre e profane* (Bologna, 1582). In Paola Barocchi, ed., *Trattati d'arte del cinquecento fra manierismo e controriforma*, vol. 2 (Bari: Laterza, 1960–2), 117–503.

38. Scavizzi quoted Catarino's "Disputatio de cultu et adoratione imaginum," in *Enarrationes* (Rome, 1552), 130–40: *The Controversy on Images from Calvin to Baronius*. Toronto Studies in Religion, no. 14 (New York: Peter Lang, 1992), 251.

39. Gilio, 39, 78, 79; Paleotti dedicated a chapter of his treatise to ridiculous paintings: bk. 2, ch. 31, 390–7.

40. David Landau and Peter Parshall, *The Renaissance Print, 1470–1550* (New Haven: Yale University Press, 1994), 166.

41. Steinmann (vol. 2, 789–92) listed the seventeen prints after the *Last Judgment* before 1600. Many were reproduced in *Michelangelo e la Sistina: la tecnica, il restauro, il mito*, exh. cat. (Rome: Fratelli Palombi, 1990).

42. John Shearman described who would have been admitted to the Sistine Chapel ("The Chapel of Sixtus IV," 1986, 22): "The Papal Chapel was a remarkably large and diverse body, and was not, as is often supposed, exclusive of laity. In addition to the pope and the College of Cardinals . . . senior churchmen attached to the Chapel would include generals of the monastic and mendicant orders, the patriarchs, and visiting archbishops and bishops. Qualifying members of the papal household or of the curial bureaucracy would include the master of the Sacred Palace (the resident theologian), the sacristan, the majordomo, chamberlains, secretaries, notaries and auditors. Accredited laity included the Senators and Conservators of the City of Rome, the diplomatic corps, visiting princes, and a few officials such as the captain of the Swiss Guard. Three further groups of some size were the servants of the cardinals, the papal choir (usually about twelve), and those engaged in the service itself (the celebrant, deacons, and acolytes, the Master of Ceremonies, and so on). Barnes (1998) adds information for the early cinquecento in her chapter 2, "Aura and Audience in the Sistine Chapel."

43. Dolce's discussion of hidden allegory: Mark W. Roskill, ed. *Dolce's "Aretino" and Venetian Art Theory of the Cinquecento*. Monographs on Archaeology and the Fine Arts, no. 15 (New York: College Art Association, 1968), 167.

44. Daniele's use of malachite was identified in Mancinelli, Colalucci, and Nazzareno (1994), 254. In the same source, the document for Daniele's scaffolding, with dates and dimensions, is quoted, 236–8. It was built high enough to reach John the Baptist and Simon of Cyrene, so it is presumed that Daniele made the *secco* additions to these figures. The scaffolding had to be removed in December 1565 because the death of the pope required that the chapel become the site of the conclave to elect the new pope. Anthony Blunt (*Artistic Theory in Italy 1450–1660* [1940; reprint, Oxford: Oxford University Press, 1962]) reported that it was rumored more "modifications" to the nudes in the *Last Judgment* were planned in 1936 (119, n. 1).

45. Michelangelo's technique on the vault was analyzed by the curator in charge of the restoration, the late Fabrizio Mancinelli, "Michelangelo at Work: The Painting of the Ceiling," and by the chief restorer, Giancarlo Colalucci, "Michelangelo's Colours Rediscovered," both in *The Sistine Chapel. The Art, the History, and the Restoration* (1986), 218–65.

46. These techniques are illustrated in Hall, *Michelangelo*, 2002, 232.

47. Analysis of the technique of the *Last Judgment* is given in Mancinelli et al. (1992), 236–55. The results of further analysis of the pigments was reported by the same authors, and they give more detail in this article comparing Michelangelo's technique in the *Last Judgment* with the Sistine vault, "Il Giudizio universale," *Art Dossier*, no. 88 (March 1994), 8–10.

48. For a discussion of Sebastiano del Piombo's technique of using oil on the wall, see Marcia B. Hall, *Color and Meaning: Practice and Theory in Renaissance Painting* (New York: Cambridge University Press, 1992), 137–42.

49. On Perino del Vaga, see Elena Parma Armani, *Perin del Vaga. L'anello mancante* (Genoa: Sagep, 1986), and Hall, *After Raphael*, esp. ch. 4. Partridge has reconstructed Perino's tapestry design to scale in the area below the fresco (1997, 149–54).

50. On the restoration of the *Last Judgment*, see Mancinelli et al. (1992, 1994).

51. The entire restoration was funded by Nippon, the Japanese television company, which scrupulously recorded every stage on film. In exchange Nippon received exclusive rights to the photographs, which expired three years after each phase of the restoration was completed.

52. The designation of Michelangelo's late style as the "drab style" we owe to Paul Joannides (" 'Primitivism' in the Late Drawings of Michelangelo: The Master's Construction of an Old-age Style," in *Michelangelo's Drawings*, ed. Craig Hugh Smyth in collaboration with Ann Gilkerson, 245–62. *Studies in the History of Art*, no. 33, National Gallery of Art, Washington, DC. Center for Advanced Study in the Visual Arts, Symposium Papers, XVII (Hanover, NH: University Press of New England, 1992). See also my discussion of the Pauline Chapel frescoes in *After Raphael*, 176–81.

53. The Damned retain their perfected bodies but show that they feel pain and torment (see my essay in this volume).

54. Michelangelo Buonarroti, *Rime*, ed. Enzo Noè Girardi (Bari: Laterza, 1960).

> Onde l'affettuosa fantasia
> Che l'arte mi fece idol e monarca
> Conosco or ben com'era d'error carca
> e quel c'a mal suo grado ogn'uom desia.

The translation is Nagel's, 198, whose thoughtful treatment of this theme is very useful.

55. Walter Friedlander cited Carracci's criticism of Michelangelo's modeling in his "The Anticlassical Style," in *Mannerism and Anti-Mannerism in Italian Painting* (New York: Columbia University Press, 1957), 17 (trans. of "Die Entstehung des antiklassischen Stiles in der italienischen Malerei um 1520," 1925).

WILLIAM E. WALLACE

"NOTHING ELSE HAPPENING": MICHELANGELO BETWEEN ROME AND FLORENCE

The noted biographer Richard Holmes opened a recent essay by asking, "How close can we really get to the ordinary men and women of the distant past? Can we know what they gossiped about each day and worried about each night? Can we catch the sound of their voices across the centuries?"[1] Holmes's subjects are the "ordinary" men and women of mid-sixteenth-century England, and it is implied that recovery of their voices is sufficient justification for the attention of the historian/biographer. But what if our subject is Michelangelo and the making of the *Last Judgment*? We know a lot about this famous artist; at times we *can* catch his voice and are afforded highly revealing glimpses of his daily life. But is it sufficient to listen to the gossip and voices of the distant past? How might such biographical fragments help us to understand the genesis or meaning of a great work of art? First, we must listen.

I

It is generally thought that the commission for the *Last Judgment* originated in mid-1533 and that Pope Clement VII spoke with Michelangelo about the new project when the two met briefly at San Miniato al Tedesco on 22 September 1533.[2] Michelangelo may have made some sketches, but the work could not have advanced very far before the death of Clement VII in 1534. There are many reasons for believing this, the primary one being that during the years prior to the *Last Judgment* Michelangelo's principal residence was Florence, and his

chief obligations were the completion of the Library and New Sacristy at San Lorenzo. In addition, the still unfinished Julius tomb remained a constant preoccupation. Although Michelangelo may have given some thought to Clement's scheme, his mind and efforts were directed elsewhere. This essay considers Michelangelo's multiple distractions before and during the painting of the *Last Judgment*. An examination of the tenor and rhythm of the artist's life offers a vivid image of an important but insufficiently examined moment of artistic and personal transition. It also sets a biographical stage – cluttered with mostly mundane, microhistorical furniture – on which Michelangelo performed one of his most sublime productions.

The years between the end of the last Republic of Florence in 1530 and the beginning of the *Last Judgment* in 1536 were not Michelangelo's most productive. The artist was at the height of his fame and creative powers, but he was in limbo between Florence and Rome. In biographies of Michelangelo, this hiatus is a convenient place for a chapter break, neatly separating his life into artificially self-contained units. Reality is messier, and in Michelangelo's life, there was as much continuity as caesura: whether living in Florence or Rome, whether it was 1530 or 1540, the artist's concerns were largely the same: the Julius tomb, family, and money – probably in that order.

There are less than forty letters to and from Michelangelo during the five years he worked on the *Last Judgment* (1536–41). This may be an accident of survival, but it may also may be evidence of the artist's preoccupation with the giant fresco, for there are more than four times as many letters from the five years immediately prior to the *Last Judgment*.[3] From this material, it is possible to reconstruct the rich texture of Michelangelo's life, and his juggling of simultaneous obligations – some artistic, but many personal and domestic. Let us first examine Michelangelo's life and, by extension, his frame of mind, during the years just prior to the *Last Judgment*.

The expulsion of the Medici from Florence in 1527 and the establishment of the Last Republic (1527–30) resulted in the suspension of Michelangelo's Medicean commissions at San Lorenzo. Despite Pope Clement's efforts to dissuade him, Michelangelo elected to remain in his native city. In her hour of need, Michelangelo directed Florence's defenses, devoting himself to resisting the man who had been his pope,

patron, and strongest supporter for ten years. With Michelangelo as director of fortifications, Florence withstood a grueling ten-month siege.[4] The city finally capitulated in August 1530 and then suffered a protracted witch hunt of retribution. It is something of a miracle that Michelangelo survived the brutal and chaotic aftermath of the Republic. Having little reason to expect mercy from his former patron, it is testament to Clement's character and his unique relationship with his artist that Michelangelo was forgiven his defection and asked to complete his work at San Lorenzo.

While the pope's forgiveness must have been a relief, other matters occupied Michelangelo's immediate thoughts. The siege had seriously disrupted the regular cycle of planting and harvesting. By 1530, the countryside around Florence had been ravaged by the contending forces; there was little food in the city, roads remained insecure, and a dangerous outbreak of plague compounded the misery. In August, Michelangelo's brother Gismondo wrote that in Florence "we are still in great need of bread for there is none; however, some cheese, dried meat and eggs are beginning to arrive."[5] Just three days later, Gismondo again wrote: "Here there still is nothing to eat or drink: it costs like blood."[6] The family, whose prosperity depended largely on farm holdings around Florence, was temporarily reduced to near indigence. Michelangelo's immediate concern was to provide money and food for his family and to assist his tenant farmers in the recultivation of their devastated lands.[7] It is against this bleak backdrop that he once again shouldered his artistic obligations.

Pope Clement renewed Michelangelo's salary in December 1530, but regular payments for the *fabbrica* of San Lorenzo did not resume until 1532.[8] The artist was supposedly working "con diligentia et sollicitudine," although his biographer Ascanio Condivi noted that he was "driven more by fear than by love."[9] It is evident that Michelangelo no longer felt his former commitment to the Medici commissions; moreover, he was suddenly pressed to satisfy a long list of old and new obligations. The heirs of Pope Julius II yet again renewed their demands that Michelangelo complete the tomb of their ancestor, and there were urgent requests from Duke Alfonso d'Este to deliver his *Leda*, from Alfonso d'Avalos for a painting (*Noli me Tangere*), from Baccio Valori for a sculpture (*David/Apollo*) and a design for a house, and from Bartolomeo Bettini for a painting of *Venus and Cupid*. Michelangelo

also promised works or received requests – some of which he could not refuse – from Federigo Gonzaga, Cardinal Innocenzo Cibo, Cardinal Antonio Pucci, Cardinal Giovanni Salviati, Matteo Malvezzi, the widow of the Prince of Orange, Alessandro de' Medici, and King Francis I – all in the few years prior to the *Last Judgment*.[10] In contrast to the focus and concentrated energy that characterized Michelangelo's work at San Lorenzo during the 1520s, his creative energies in the early 1530s were diffused.

A long letter from Giovan Battista Mini, uncle of Michelangelo's pupil Antonio Mini, provides an indication of Michelangelo's state of mind a little more than a year after the fall of the Republic.[11] Mini hadn't seen Michelangelo for some months for the artist had remained at home on account of the plague. However, in the previous three weeks Michelangelo had come by Mini's house in the evenings to pass some time with him and his nephew Antonio Mini and their mutual friend Giuliano Bugiardini. Finding Michelangelo emaciated and undernourished, Mini and his friends feared he would live only a short time if the situation were not remedied because "he works a lot but eats little and poorly, and he sleeps less." In addition, for the last month Michelangelo had been experiencing difficulty with bowel movements, as well as suffering from headaches and dizziness. In sum, according to Mini, Michelangelo had two major afflictions, one of the head and the other of the heart. As regards that of the head, he had been commanded by the pope not to work in the sacristy during the winter and yet he was anxious to complete that commission. The sickness of the heart was due to his troubles with the heirs of Pope Julius II, who were importuning him to complete the long-overdue tomb.

In the artist's correspondence prior to the *Last Judgment* there is no more persistent topic than the Julius tomb. Pope Clement was determined to have Michelangelo complete the library and family burial chapel at San Lorenzo and made a concerted effort to protect his artist from the multiple demands upon him, especially those of Julius's heirs. Clement's best efforts were not enough, however, to relieve Michelangelo of his persistent, and justified, anxiety regarding the longstanding obligation.[12] "Never a day passed without his being troubled by the agents of the duke of Urbino," wrote a sympathetic Giorgio Vasari.[13] At one point, the duke of Urbino's representative, Girolamo Stacculo, accused Michelangelo of dishonesty, claiming that the artist

wished to sell his house and use the embezzled money to fulfill his obligation in an abbreviated fashion.[14] Understandably, Michelangelo worried about such malicious slander.[15] Repeated assurances from his friends Sebastiano and Giovanfrancesco Fattucci were scarcely enough to assuage the artist. Even a trip to Rome in April 1532 to arrange a new tomb contract only partially, and temporarily, alleviated his anxiety.[16]

Far from Rome and under obligation to Pope Clement, Michelangelo felt his hands tied. What, for example, could he possibly do to protect the great pile of marble – badly weathered and now slowly being pilfered – that languished on the Ripa in Rome? His self-professed "state of restlessness and distress" is evident from a letter he wrote in September 1533 to his friend Bartolomeo Angelini in Rome:

> My dear Bartolomeo, although I may seem to jest with you, please realize that I am also serious in saying that I have aged twenty years and lost twenty pounds since I've been here, and I don't know when the Pope is leaving Rome, what he wants of me, nor where he wishes me to be.[17]

Michelangelo took his friends by surprise when he impulsively suggested selling his workshop in Florence and all its marbles.[18] Nothing came of the irrational proposal, but one senses the artist floundering for some sort a solution to an intractable situation.

While Michelangelo was in Florence, Angelini looked after the artist's affairs in Rome, regularly sending him poems and reports on his friends and his house with its small orchard and "tutti l'animali."[19] In the summer of 1533, for example, Angelini reported that the figs "are very good" and the muscat grapes were ripening nicely, which, according to Michelangelo's wishes, were shared with his friends Sebastiano del Piombo and Tommaso de' Cavalieri.[20] Subsequently, Angelini harvested the pomegranates – "especially beautiful this year" – and gave a box to Cavalieri and one to Sebastiano's son.[21] To Michelangelo's friends it seemed like "a thousand years" since Michelangelo had been in Rome: even the cats "much lament your absence," joked the generally upbeat Angelini.[22] The artist fully reciprocated the sentiments.

Michelangelo was anxious to discharge his obligations at San Lorenzo, even accepting the pope's expedient of delegating more

work to assistants.[23] Increasingly disaffected with Florence, where the last vestige of republican government was stamped out in 1532, Michelangelo longed to spend more time in the Eternal City. He was in Rome for approximately three weeks in April 1532 and again at the end of the summer. He remained between nine and eleven months despite his recent agreement to devote the majority of his time to the Medici commissions in Florence. After returning to Florence for less than five months, he was once again in Rome by November 1533. He returned to Florence just one more time, for less than four months in 1534, finally leaving the city for good in September, taking as his excuse Pope Clement's fatal illness. In this restless itinerary, one senses Michelangelo's desire for a new start, a new project.

Perhaps we underestimate the importance of domestic concerns in Michelangelo's life because they seem far removed from the activity of a marble sculptor, an architect, and a creative individual; however, in the years prior to the *Last Judgment*, Michelangelo devoted a surprising amount of his time to his family and the management of his farm properties. Evidence for these preoccupations is found in his letters and personal records (*ricordi*) but also, more unexpectedly, on sheets and drawings connected with his work at San Lorenzo. For example, a paper template for the entablature of the Laurentian Library entrance door is the type of ephemeral material that is normally discarded after use at the worksite (Figs. 21, 22), but Michelangelo utilized both sides of the irregularly cut paper to count bushels of grain, note prices, and draft a bit of poetry.[24] Such conjunctions of work, everyday life, and creative activity are common; poetry, odd memoranda, calculations, and records of farm produce are jotted on sheets that double as sketches, plans, and, in this case, a template. The sheet offers a small but vivid reminder of the overlap between daily life and creative endeavor. So does his family.

It is a little-known aspect of the artist's biography that for some years he was a surrogate father closely involved in child rearing. In 1528, Michelangelo was deeply affected by the death of his favorite brother Buonarotto. Buonarroto and his wife, Bartolommea della Casa, had had three children: Francesca (b. 1519), Lionardo (b. 1522) and Simone, (b. c. 1526). Michelangelo paid the funeral expenses for Buonarroto and then, as was customary, returned the handsome dowry to his

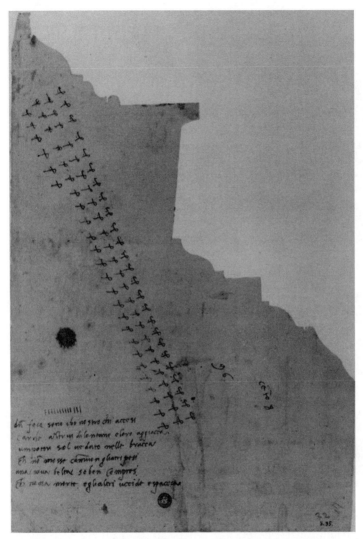

FIGURE 21. Paper template for entablature, Laurentian Library, Florence. Archivio Buonarroti, Florence, XIII, fol. 127r (Photo: author).

widow.[25] In Renaissance Italy, the children belonged to the lineage of their father; therefore, rather than return with their mother to the family home in the Mugello, they became Buonarroti wards.[26] Michelangelo entrusted the care of Francesca, who was not quite nine years old, to the sisters at the monastery of Boldrone, where she

FIGURE 22. Michelangelo, entrance door to the Laurentian Library Reading Room
(Photo: Alinari).

remained until marriageable age. Michelangelo paid eighteen ducats
a year for her upkeep, provided her clothing needs, and periodically
presented the sisters with gifts of food and money.[27]

Finding a suitable match for Francesca was also Michelangelo's
responsibility, just as it would be again when her younger brother
Lionardo came of age (Simone died while still a young child).
Michelangelo made inquiries on Francesca's behalf as early as 1534,
but it wasn't until May 1537 that an excellent match was arranged with
Michele Guicciardini, scion of one of Florence's premier families.[28]

FIGURE 23. Michelangelo, drawing, designs for fortifications, Casa Buonarroti, 17Ar (Photo: author).

Michelangelo provided Francesca with a princely dowry and her entire trousseau.[29] Protracted negotiations regarding payment of the dowry, which included a large farm at Pozzolatico just south of Florence, occupied the artist throughout the painting of the *Last Judgment*.[30] While he was at work on the great fresco, Francesca became pregnant and gave birth to a baby boy, Gabriello, on 7 March 1538.[31] Michelangelo took "great pleasure" in the couple's male children (three by 1541),[32] but, of course, the continuation of the Buonarroti line depended not on Francesca's children but on Lionardo, who did not marry until 1553. Michelangelo was deeply invested in the propagation of the family, recognizing in Lionardo the only hope "to remake and enlarge the family" ("rifare et acrescere la casa").[33]

Lionardo, who was just six at the time of his father's death, initially went to live in Settignano with his eighty-four-year-old grandfather, Lodovico Buonarroti. Evidently the child was too much for the elderly

Lodovico to handle, and so, in September 1528, the child went to live with Michelangelo in Florence. Lodovico advised his son that Lionardo "eats and drinks like a grownup," he is "very lively" ("molto vivo"), and "he has certain manners that don't please me." At the same time, Lodovico admitted that he "loved him without limits" and noted, "I think he is a good boy, because he is intelligent." In closing, Lodovico reminded Michelangelo to "buy clothes for him."[34]

On that very day, Michelangelo recorded purchasing a number of items needed for the child: a silver spoon, a knife with nail scissors in a sheath, a bristle brush, a pair of clogs, and some cloth, threads, and ties from which the tailor made Lionardo shirts and a smock. Subsequently, Michelangelo purchased a black hat, a pair of small-sized shoes, and a pair of grey stockings for the boy, as well as some black cloth ("San Matteo nero") to make a long cloak (zimarra).[35] In November, Michelangelo gave little "Nardo" a silver coin (grossone) to give the schoolmaster so the two could enjoy a fire during their lessons.[36] Lionardo remained with uncle Michelangelo almost seven months, undoubtedly watching as the artist drafted designs for the defense of Florence, one of which (Fig. 23) bears notes regarding expenditures for the upkeep of his nephew and niece.[37]

By April 1529, Michelangelo was completely occupied with the defense of Florence and was soon to leave for Pisa and Ferrara; therefore, he sent Lionardo to the boy's grandfather in Settignano.[38] Shortly after the fall of the Republic, however, Lodovico once again asked Michelangelo to take Lionardo "because he is of our flesh."[39] The artist was extremely busy at San Lorenzo, but someone had to cared for the child; Lodovico was an old man and would die just a few months later.[40] Child rearing once again devolved to Michelangelo.

The death of his father in 1531, scarcely three years after the loss of his favorite brother, elicited one of Michelangelo's longest and most affecting poems:

> Already burdened with a heavy heart,
> I still thought I'd relieve the weight of woe
> through tears and sobbing, or at least in part.
> But fate, abounding, filled to overflow
> grief's source and stream, now welling unconfined
> with another death – no worse pain here below!

> That death your own, dear father. Now in mind
> two deaths, their claims distinct, for thought, talk, text:
> fraternal, filial, separate though entwined.
> My brother first, and you my father next;
> to one my love, to one devotion's due.
> And which the keener pain? My heart's perplexed.[41]

And so the poem continues for another nineteen stanzas. Michelangelo's personal grief was compounded by the mundane matters of family life, which weighed heavily on the artist. Already the principal breadwinner, Michelangelo was now the family patriarch, responsible for the well-being of the extended Buonarroti household and their various properties in and around Florence. His two younger brothers, Giovansimone and Gismondo, were still financially dependent on him, as were his orphaned niece and nephew. In later years, Lionardo was Michelangelo's heir and principal correspondent, but in 1531, he was still only nine years old. He continued to live with Michelangelo until the latter departed for Rome in 1534; his day-to-day upbringing was in the hands of Mona Margherita, the trusted family servant of more than sixteen years.[42]

The extent to which domestic concerns affected Michelangelo is revealed in his relationship with Mona Margherita. More *familiare* than servant, she was the domestic center of the all-male Buonarroti household. After the death of Lodovico, Mona Margherita and the nine-year-old Lionardo lived with Michelangelo in the house he rented in Florence. When he left Florence in 1534, Michelangelo asked Giovansimone to settle on the family farm in Settignano, thereby also providing a place for Mona Margherita "because," Michelangelo reminded his brother, "when he was dying my father commended her to my care, and I'll never abandon her."[43] Michelangelo was as good as his word: he continued to send her money from Rome, worried about her when she fell ill, and advised his brother to "be considerate to Mona Margherita."[44] To Lionardo he wrote, "treat her kindly in word and deed."[45] She died in November 1540, while he was working on the *Last Judgment*. In a letter to his nephew, Michelangelo poignantly lamented:

> The news of Mona Margherita's death has been a great grief
> to me – more so than if she had been my sister – for she was

a good woman; and because she grew old in our service and because my father commended her to my care, God is my witness that I intended before long to make some provision for her. For this He has not pleased that she should tarry. Alas![46]

Although he certainly had friends in Rome, it is evident that Michelangelo felt somewhat alone there, far from Florence and the only family remaining to him. He also had trouble finding reliable domestic help. In Florence, Michelangelo had kept one or more female servants to cook and clean, but in Rome he never found anyone like Mona Margherita. Throughout the painting of the *Last Judgment*, Michelangelo lived with his long-time assistant and companion, Urbino, but they had little help with the daily household chores. When Lionardo suggested coming to Rome with his brother-in-law Michele Guicciardini, Michelangelo put them off: he was much too busy with his affairs, he wrote, and "to have to do the cooking for the two of you would be the last straw."[47]

During the painting of the *Last Judgment*, Michelangelo wrote home infrequently, usually on Saturdays, his preferred day for correspondence.[48] Despite the paucity of letters, it is clear that Michelangelo was deeply attached to his family and, in periodically sending them money, committed to their welfare. At the same time his brothers and nephew could also be a source of petty irritation and distraction. He worried about the wayward Gismondo, who did the family little credit by "making a peasant of himself."[49] Conscious of gossip in Rome, Michelangelo subsequently advised his brother to leave off farming and live in Florence "so that it should no longer be said here, to my great shame, that I have a brother at Settignano who trudges after oxen."[50]

Michelangelo's brothers, Giovansimone and Gismondo, were still unmarried; therefore, all hopes for the continuation of the family line rested with his nephew, Lionardo. Because Michelangelo moved to Rome when his nephew was just twelve, he missed Lionardo's passage to adulthood. Thus, their relationship was complicated by distance and Michelangelo's increasing preoccupation with the family's social position. He admonished Lionardo to "try to be a man of honour yourself – otherwise, I would have you understand that you'll inherit

nothing of mine."[51] In sending money to his brother Gismondo in 1537, Michelangelo wrote, "take ten [ducats] for yourself, and give five of them to Mona Margherita; give the other five to Lionardo, if he's behaving himself."[52] At the death of Mona Margherita in 1540, the eighteen-year-old youth and his uncles were left on their own. Michelangelo, still busy with the *Last Judgment*, wrote Lionardo:

> With regard to the management of the house, you'll have to take thought for it yourselves and not look to me, because I'm old and have great difficulty in managing for myself. You have enough to enable you to keep a capable servant and to live like men of honour, if you are united in peace together; and for my part I'll help you as long as I live; if you are not, I'll wash my hands of it.[53]

Michelangelo was deeply attached to Lionardo, indeed loved him "as if he was his own son."[54] Although these are his own words, such sentiments can usually be discovered only between the lines of the artist's frequent admonitions, constant advice, and occasional grumblings. When, for example, Lionardo sent his uncle three new shirts, Michelangelo complained that they "are so coarse that there's not a peasant in Rome who wouldn't be ashamed to wear them."[55] Even when riding to the Vatican and working all day on the scaffold, Michelangelo wished to be dressed in a manner appropriate to his position as the pope's patrician artist. Next, Lionardo tried sending ravioli, but Michelangelo was scarcely more appreciative: "I imagine it was excellent in Florence, but it was completely ruined when it arrived here. I think it got wet.... It suffices, in short, that I've received it; that's all there is to say about it."[56]

Michelangelo also railed against Lionardo's letter writing, which seemed to be going from "bad to worse."[57] Five years later, it had scarcely improved: "every time I get a letter from you," Michelangelo lamented, "I'm thrown into a fever, such a struggle do I have to read it. I do not know where you learnt to write. If you had to write to the biggest ass in the world, I believe you'd write with more care."[58] Such complaints are related to Michelangelo's desire for his family, and especially Lionardo, to comport themselves in a manner consistent with their elevated social status, a concern that manifested itself with particular insistence in the 1530s and 1540s.[59]

As Michelangelo was finishing the *Last Judgment* in 1541, Lionardo, who by then was nineteen and had not seen his uncle in seven years, expressed a desire to visit Rome. Michelangelo put him off "because I'm so busy that I haven't time to pay attention to you, and every little thing extra is a great bother to me, not excepting even having to write this."[60] Similarly, even though his niece Francesca was not well, Michelangelo complained of not having time to answer her letter.[61] Indeed there are fewer letters during the painting of the *Last Judgment* than for any other five-year period of Michelangelo's life.[62] Yet there was a distinct increase in his poetic production, especially after he made the acquaintance of Tommaso de' Cavalieri and Vittoria Colonna.

The artist, itinerant and mentally restless in the early 1530s, was by 1534 settled permanently in Rome. There he found a large community of Florentine expatriates, and in Tommaso de' Cavalieri, a new friendship and a vigorous font of poetic and artistic inspiration. Michelangelo met Cavalieri toward the end of 1532 largely through his circle of Roman friends. Their "courtship" was brief and intense, their friendship long and enduring. It resulted in a large body of poetry and some of Michelangelo's most beautifully crafted drawings. It seems that Cavalieri reawakened those highly focused creative energies that Michelangelo commonly experienced at the beginning of projects that had lain mostly dormant during the last few years.

On 1 September 1535, Pope Paul III appointed Michelangelo supreme architect, painter, and sculptor of the Apostolic Palace. The income depended partly on revenues from a ferry crossing on the Po River; it was a generous prebend, but it also demanded Michelangelo's attention, and some "fatica."[63] As with most of his contemporaries, money was a perpetual concern, especially because so many accounts remained unsettled, the Julius tomb being only the most odious. Nagging financial worries during the *Last Judgment* included Michelangelo's repeated efforts to recover a large, forced loan to the Florentine government of the Last Republic,[64] correspondence to settle accounts regarding the *Risen Christ*,[65] and a claim from the Piccolomini that Michelangelo still owed 100 scudi from a commission he had received more than thirty-five years earlier.[66] These are just some of the unwelcome intrusions on the daily life of an artist trying to paint his first fresco in more than twenty-five years.

When Pope Paul III issued a *motuproprio* in November 1536, releasing Michelangelo from the Julius tomb to work exclusively on the *Last Judgment*, the artist was finally relieved of his most chronic anxiety.[67] Even the importunate Guidubaldo della Rovere, heir of Julius II, was resigned to waiting until the artist completed the fresco.[68] After the clamor and distraction of the previous few years, Michelangelo could turn his full attention to the *Last Judgment*. His progress was not without disruption, however, as we learn from a letter of 1539 that describes Michelangelo leaving in a great rage ("con gran furia") because his "beautiful figures" would be damaged if the chapel were not immediately repaired.[69] Was the roof leaking, or the wall ill-prepared? Then, shortly before he completed the fresco, he fell from the scaffolding and injured his leg.[70] These are just scattered glimpses. The documentary record, rich in the details of Michelangelo's life up to the *Last Judgment*, now falls comparatively silent.

II

Are the considerations just described in any manner relevant to our understanding of the *Last Judgment*? How does the daily life of an artist intrude on creativity?[71] When the documentary record dries up, may we assume the artist's intense preoccupation with work? If so, does it mean that his other concerns – family, friends, and other artistic obligations – were less important? I think not, but the relationship between art and life, always tenuous at best, now becomes even more difficult to fathom. Thus, we return to the questions posed at the beginning of this essay: how close can we get to the distant past, and can the glimmerings of biography help us to understand the creation and interpretation of a great work of art?

The following is not a "new interpretation" of the *Last Judgment*; rather, it is a suggestion about how a work that spans many years in some manner must be tinged by the quotidian. Michelangelo's life is rich in both the sublime and the mundane; it is worth wondering how the two intersect, overlap, and color one another. It is also worth considering how life influences the viewing of art – in particular, how the experience of Rome could have affected the making and perception of Michelangelo's great fresco.

To a greater extent than might generally be recognized, a number of Michelangelo's commissions – including the *Last Judgment* – are related to the Christian veneration of relics. Some of the artist's earliest sculptures were made to adorn the tomb of Saint Dominic in Bologna. More significantly, the Rome *Pietà* and the *Risen Christ* have strong topographic associations, eliciting memory of important sites and relics in early Christian Rome.[72] Shortly before embarking on the *Last Judgment*, Michelangelo designed a reliquary tribune balcony in San Lorenzo for the safe storage and ceremonial display of the Medici collection of relics.[73] He judged it to be a "bella cosa,"[74] which, thanks to Clement's insistence, was completed before Michelangelo left Florence in 1534.

Some years before, Michelangelo had designed a marble reliquary tabernacle for the Roman church of San Silvestro in Capite that housed two especially important relics: the head of Saint John the Baptist and the *vera-imago*, a cloth with the miraculous image of Christ's face similar to the more famous veil of Veronica in Saint Peter.[75] During the final stages of painting the *Last Judgment*, Michelangelo made a special effort to see the *vera-imago*, which was kept in the reliquary shrine he had designed more than twenty years earlier. For the opportunity to see the relic, Michelangelo was indebted to his friend Vittoria Colonna. As the descendent of the great family that endowed the church, she had privileged access to the relic and could arrange a special viewing of it.[76] To Michelangelo it was not just a religious artifact but rather "la testa di Cristo." The coincidence is suggestive: this was the very moment that Michelangelo was imagining the face of Christ in the *Last Judgment*, a face unlike any other in the venerable tradition of that subject. The incident affirms the central importance of relics for Michelangelo, and for the Renaissance in general, both as objects of devotion and as creative inspiration.

The worship of relics, and pilgrimages undertaken to see them, are not phenomena of the Middle Ages only; they have been a continuous part of Christian practice from antiquity to the present. As the recent experience of a Holy Year (2000) has testified, Christian pilgrimage is very much alive. In the Renaissance, Rome was the chief destination of pilgrims, as the distant sites of the Holy Land were occupied by infidels. In Rome, pilgrims could visit an astonishing number of shrines, relics, and places associated with the saints and apostles, including the most important holy site in Western Christendom: the tomb

of the apostle Peter. Pilgrims flocked to Rome, especially during holy years.[77] Of the more than 1,000 churches in Rome – according to Pope Sylvester's chronicle – seven have been granted special privileges, and these constitute the obligatory stops on the Roman pilgrim's itinerary: San Pietro, San Paolo fuori le Mura, San Giovanni Laterano, San Lorenzo fuori le Mura, Santa Maria Maggiore, San Sebastiano, and Santa Croce in Gerusalemme.[78] In 1550, Michelangelo joined the hoards of pilgrims who were visiting the principal shrines and relics of Rome. In his life of the artist, Vasari describes the pilgrim's visit the two friends made together: "Now at that time Vasari used to visit Michelangelo every day; and one morning (it being Holy Year) the Pope graciously gave them a dispensation to visit the seven churches on horseback and gain the indulgence together."[79]

Lionardo also visited Rome during the Holy Year, 1550. In addition to seeing his uncle, Lionardo was intent on obtaining the special indulgences granted for visiting Rome during the Jubilee.[80]

The first five of the seven major churches are the "patriarchal" basilicas, which are among the oldest foundations in the city (all except Santa Maria Maggiore having been founded by Constantine), and they enshrine some of the most important relics of the faith. In the words of Gregory Martin, author of a sixteenth-century pilgrim's guide to Rome: "The good Christian people of Rome did visite and frequent these five especially, making daily pilgrimage unto them."[81] Is it coincidental that we find these five holy figures – Peter, Paul, John, Lawrence, and Mary – clustered around Christ in Michelangelo's *Last Judgment*?

Peter Brown has emphasized the importance of relics for ensuring *praesentia*, the physical presence of the holy. Similarly, the representation of saints and their relics stimulates memory of *praesentia*, the actual experience of seeing those tangible manifestations of the holy.[82] In her study of Christian pilgrimage, Georgia Frank demonstrates how texts helped shape pilgrimage.[83] The converse is also true: pilgrimage informs perception, helping to shape the reading of texts, whether verbal or visual. After visiting the shrines of Rome, replete with relics of the faith, to stand before Michelangelo's *Last Judgment* is to stand in the presence of Christ and the saints.[84] In the mind of the devout, especially one fresh from the experience of pilgrimage, the painting might have stimulated recollection of the pilgrim's actual experience of Rome. In a sense, artistic composition is a sort of geography, the wall

a visual toponymy.[85] Looking becomes an analogue to pilgrimage, a sort of retracing of the pilgrim's itinerary. This observation arises from personal experience. Not Catholic, nor even especially pious, I saw Michelangelo's *Last Judgment* afresh – suggestive of Rome's sacred topography – following a visit, in one day and by foot, to the seven pilgrimage churches during Holy Year 2000.

Michelangelo's *Last Judgment* was ceremoniously unveiled on All Saints Eve, 31 October 1541. The first surviving letter Michelangelo wrote after completion of the fresco was to his nephew Lionardo nearly three months later, in January 1542. Michelangelo informed him that he had been meaning to write, but "I hadn't time and also because writing is a bother to me." He continued,

> I'm sending you fifty gold scudi in gold and instructions as to what you are to do with the money if you want to come to Rome. . . . And if you decide to come let me know first, as I'll arrange with some honest muleteer here for you to come with him. And if you really want to come, don't let Michele [Guicciardini] know about it, because I can't put him up, as you'll see if you come.[86]

There is no mention of the *Last Judgment*. Just money and mules; family, farms, and fretting: the usual business of Michelangelo's life. Art and life do intersect, but it is not always evident from Michelangelo's correspondence. When he again wrote to Lionardo two weeks later, Michelangelo appears solely occupied with money matters and he concluded his letter, as he often did, "Altro non achade": nothing else happening.[87] But, in fact, much else *was* happening, and art must have been on his mind. Pope Paul had already determined that, rather than completing the tomb of Pope Julius, Michelangelo would paint frescoes in the newly erected Pauline Chapel.

Thus the correspondence – both its abundance and comparative absence, along with its many silences – can be a reliable indicator of Michelangelo's life and concerns. Yet we once again face the unfathomable relation between life and art, between biography and creation. Beyond highlighting Michelangelo's humanity, do the facts of daily life matter? Perhaps it is enough to recognize the gulf between mundane reality and sublime creation, and to appreciate that Michelangelo repeatedly and successfully bridged this divide. Amid petty worries

of money, mules, family, and farms, Michelangelo created, the *Last Judgment*. "Altro non achade."

NOTES

I would like to thank Paul Barolsky and Ralph Lieberman for reading drafts of this essay and Mayu Fujikawa for a number of discussions on the *Last Judgment*, which is the subject of her master's thesis (Washington University, 2001).

1. R. Holmes, "Lord Lisle and the Tudor Nixon Tapes," *Sidetracks: Explorations of a Romantic Biographer* (New York, Pantheon Books, 2000), 183.
2. *I ricordi di Michelangelo*, ed. L. B. Ciulich and P. Barocchi (Florence, Sansoni, 1970), 278. Evidence of Clement's desire to commission Michelangelo for a project in Rome is found in a letter from Sebastiano to Michelangelo (*Il carteggio di Michelangelo*, ed. P. Barocchi and R. Ristori, 5 vols. [Florence, Sansoni, 1965–83], vol. 4, 18). For discussion with references, see C. De Tolnay, *Michelangelo: The Final Period* (Princeton, Princeton University Press, 1960), 19 and 99, and the most recent studies: *Michelangelo and the Last Judgment: A Glorious Restoration* (New York, Harry N. Abrams, 1997); B. Barnes, *Michelangelo's "Last Judgment": The Renaissance Response* (Berkeley, University of California Press, 1998); *Michelangelo, la Cappella Sistina*, 2 vols. (Novara, Istituto Geografico De Agostini, 1999); V. Shrimplin, *Sun Symbolism and Cosmology in Michelangelo's "Last Judgment"* (Kirksville, MO, Truman State University Press, 2000).
3. Periods of intense artistic concentration are sometimes reflected inversely, by a comparative absence of Michelangelo's correspondence. Something of the same happened during the most intense work at San Lorenzo; Michelangelo's normally regular correspondence fell off so drastically that Clement and his advisers had to beg Michelangelo to write more often; see W. E. Wallace, *Michelangelo at San Lorenzo: The Genius as Entrepreneur* (Cambridge, Cambridge University Press, 1994), 136–7.
 The precise number of letters, is difficult to determine because of occasional problems in dating and counting (does one count drafts as letters, and how does one count multiple drafts of a single letter?). Given these caveats, there are 173 letters to and from Michelangelo between 1530 and 1536, as well as internal evidence of nearly forty more. Between 1536 and 1541, there are some thirty-nine letters and internal evidence for an additional nine now-missing letters. This material is supplemented by letters among members of Michelangelo's family, published as the *Carteggio indiretto*. Between 1530 and 1536, there are sixteen extant letters, but only two from the years 1536–41. See *Carteggio*, vols. 3 and 4, and *Il Carteggio indiretto di Michelangelo*, ed. P. Barocchi, K. L. Bramanti, and R. Ristori, 2 vols. (Florence, S.P.E.S., 1988, 1995).
4. For the historical background, see C. Roth, *The Last Florentine Republic* (New York, Russell and Russell, 1968), and J. N. Stephens, *The Fall of the Florentine Republic 1512–1530* (Oxford, Oxford University Press, 1983). For Michelangelo's role as supervisor of fortifications, see R. Manetti, *Michelangiolo: le fortificazioni per l'assedio di Firenze* (Florence, Libreria Editrica Fiorentina, 1980); P. C. Marani, *Disegni di fortificazioni da Leonardo a Michelangelo* (Florence, Cantini, 1984), and

W. E. Wallace, " 'Dal disegno allo spazio': Michelangelo's Drawings for the Fortifications of Florence," *Journal of the Society of Architectural Historians* 46 (1987): 119–34.

5. Gismondo in Florence to his father Lodovico in Pisa, 25 August 1530: "anchora siamo in gran peniura dell pane, che non ce n'è; pure c'è chominc[i]ato a venire dell chassc[i]o, charnesecha e uuova" (*Carteggio indiretto* 1: 330).

6. "Qui per anchora nonn è che mang[i]are né che bere: charo chome sangh[u]e" (*Carteggio indiretto* 1: 331).

7. W. E. Wallace, "An Unpublished Michelangelo Document," *Burlington Magazine* 129 (1987): 181–4; see also *I ricordi* 267–72.

8. W. E. Wallace, "Bank Records Relating to Michelangelo's Medici Commissions at San Lorenzo, 1520–1533," *Rivista d'arte* 44 (1993): 3–27; see also *Carteggio indiretto* 1: 337.

9. G. Gaye, *Carteggio inedito d'artisti dei secoli XIV–XVI,* 3 vols. (Florence, Presso G. Molini, 1839–40), 2: 222; A. Condivi, *Michelangelo: Life, Letters and Poetry,* ed. G. Bull (Oxford and New York, Oxford University Press, 1987), 45.

10. For these many commissions and requests, see C. de Tolnay, *Michelangelo: The Medici Chapel* (Princeton, Princeton University Press, 1948), 14–17 and passim.

11. *Carteggio* 3: 329–30, a long letter that I freely paraphrase.

12. In June 1531, Clement attempted to assure Michelangelo, via his secretary Pier Polo Marzi, that he was free of the tomb obligation, "per liberarvi da questo fastidio, molestia et fa[n]tasia" (*Carteggio* 3: 312–13).

13. G. Vasari, *The Lives of the Artists,* trans. G. Bull (Harmondsworth and Baltimore, Penguin Books, 1965), 374–5.

14. As reported by Sebastiano in a letter to Michelangelo, 22 July 1531 (*Carteggio* 3: 316–17).

15. For example, *Carteggio,* 3: 308.

16. *Carteggio* 3: 388–90.

17. *Carteggio* 4: 14–15; trans. E. H. Ramsden, *The Letters of Michelangelo,* 2 vols. (Stanford, Stanford University Press, 1963), vol. 1: 194–5.

18. *Carteggio,* 3: 405, 413, 426; *Carteggio,* 4: 4, 5, 7.

19. Which included at least a rooster and some hens, as mentioned in *Carteggio* 4: 13.

20. *Carteggio* 4: 13, 20, 25, 32–3, 40–1, 42–3, 53–4.

21. *Carteggio* 4: 56.

22. *Carteggio,* 4: 13, and Michelangelo's partially jocular reply (*Carteggio,* vol. 4: 14–15).

23. Wallace, *Michelangelo at San Lorenzo,* 128–34.

24. C. De Tolnay, *Corpus dei disegni di Michelangelo,* 4 vols. (Novara, Istituto Geografico De Agostini, 1975–80), no. 539.

25. *Ricordi,* 239, 369–70.

26. C. Klapisch-Zuber, "The 'Cruel Mother': Maternity, Widowhood, and Dowry in Florence in the Fourteenth and Fifteenth Centuries," in *Women, Family, and Ritual in Renaissance Italy,* trans. L. Cochrane (Chicago and London, The University of Chicago Press, 1985), 117–31, esp. 125. See also G. Calvi, "Widows, the State and the Guardianship of Children in Early Modern Tuscany," in *Widowhood in Medieval and Early Modern Europe,* ed. S. Cavallo and L. Warner (New York, Longman, 1999), 209–19, and R. Goffen, "Mary's Motherhood According to

Leonardo and Michelangelo," *Artibus et Historiae* 40 (1999): 55, with references. Bartolommea kept in touch with Lionardo, occasionally sending him food and clothing (e.g., *Carteggio indiretto* 2: 20, 22). The youngest child, Simone, was extremely sick in September 1530 (*Carteggio indiretto* 1: 333), and probably died that same year.

27. *I ricordi*, 242–3, 274, 276; *Carteggio* 3:277; *Carteggio* 4: 21, 80; *Carteggio indiretto* 1: 330, 352.

28. *Carteggio* 4: 64, and *Carteggio indiretto* 1: L.

29. See W. E. Wallace, "*Miscellanea Curiositae Michelangelae*: A Steep Tariff, a Half Dozen Horses, and Yards of Taffeta," *Renaissance Quarterly* 47 (1994): 345.

30. Michelangelo subsequently reacquired the farm from the newly wedded couple; see *Carteggio* 4: 77, 79, 85, 94, 108, 109, 111, 112, 114, 115, 124, 127; *Carteggio indiretto* 2: 1, and *I ricordi*, 278–9, 302.

31. Nicolò Guicciardini, father of Michele, wrote to Michelangelo "mio *spectabili viro* parente" giving news of the birth (*Carteggio* 4: 92).

32. *Carteggio* 4: 116.

33. *Carteggio* 4: 210, also published in *Carteggio indiretto* 2: 7.

34. *Carteggio* 3: 260, 261.

35. *I ricordi*, 243, 245, 272–3.

36. "uno grossone a Nardo che lo decte al maestro della scuola pel fuoco" (*I ricordi*, 245).

37. Casa Buonarroti 17A; see De Tolnay, *Corpus* no. 579, and *I ricordi*, 244. Michelangelo continued to purchase clothes and pay for the upkeep of his nephew and niece (e.g., *I ricordi*, 272–3, 276–7).

38. *Carteggio indiretto* 1: xxxvii.

39. *Carteggio* 3: 297.

40. The evidence for Lodovico's death in 1531, not 1534 as De Tolnay and other scholars have believed, is discussed in Ramsden, *Letters* 1: 295–7 (appendix 22).

41. *The Complete Poems of Michelangelo*, trans. J. F. Nims (Chicago and London, The University of Chicago Press, 1998), no. 86.

42. Lionardo was still living with Michelangelo at the end of October 1533 (*I ricordi*, 277; see also 249).

43. *Carteggio* 4: 63; trans. Ramsden, *Letters* 1: 176.

44. *Carteggio* 4: 109.

45. *Carteggio* 4: 108.

46. *Carteggio* 4: 114; trans. Ramsden, *Letters* 2: 7.

47. "Non mi mancherebe altro che avervi a far la cucina!" (*Carteggio* 4: 117, trans. Ramsden, *Letters* 2: 9–10).

48. Michelangelo's friend Benvenuto della Volpaia alludes to this characteristic of Michelangelo's correspondence (verified from the correspondence itself) when he writes that he understands that Michelangelo has "other occupations to attend to than writing letters every Saturday" (*Carteggio* 3: 403).

49. "ci fa poco onore a essersi facto un contadino" (*Carteggio* 4: 110).

50. *Carteggio* 4: 249; trans. Ramsden, *Letters* 2: 64. On the "vivacity of the city's oral and gossipy life" and the concern not to be mistaken for country peasants, see L. Martines, "The Italian Renaissance Tale as History," *Language and Images of*

Renaissance Italy, ed. A. Brown (Oxford, Oxford University Press, 1995), 313–30.

51. *Carteggio* 4: 108; trans. Ramsden, *Letters* 2: 5. The sentiment was reiterated, *Carteggio* 4: 116.

52. *Carteggio* 4: 113; trans. Ramsden, *Letters* 2: 3.

53. *Carteggio* 4: 114; trans. Ramsden, *Letters* 2: 7.

54. Luigi del Riccio, writing on behalf of Michelangelo, assured Lionardo that Michelangelo "vi ama assai et come se li fussi fig(liuo)lo." Michelangelo added a postscript stating that he had read what del Riccio had written "e così è l'animo mio" (*Carteggio* 4: 210–11).

55. *Carteggio* 4: 108; trans. Ramsden, *Letters* 2: 5.

56. *Carteggio* 4: 123; trans. Ramsden, *Letters* 2: 93.

57. *Carteggio* 4: 117.

58. *Carteggio* 4: 242; trans. Ramsden, *Letters* 2: 63, and *Carteggio* 4: 281 and 293, for further complaints about Lionardo's poor letter writing.

59. W. E. Wallace, "Michael Angelus Bonarotus Patritius Florentinus" in *Innovation and Tradition: Essays on Renaissance Art and Culture*, ed. D. T. Andersson and R. Eriksen (Rome, Edizioni Kappa, 2000), 60–74.

60. *Carteggio* 4: 117; trans. Ramsden, *Letters* 2: 9.

61. *Carteggio* 4: 116.

62. That is, since 1506, when there is a regular survival of Michelangelo's correspondence.

63. D. Redig de Campos, *Il giudizio universale di Michelangelo* (Milan and Florence, Aldo Martello–Giunti Editore, 1975), 81–5; *Carteggio* 4 : 73–4, 75–6, 96–7, 118, and *I ricordi*, 279–84. See also A. Ronchini, "Michelangelo e il porto del Po a Piacenza," *Atti e memorie delle RR. Deputazioni di storia patria per le provincie modenesi e parmensi* 2 (1864): 25–35, and R. Hatfield, *The Wealth of Michelangelo* (Rome, Edizioni di Storia e Letteratura, 2002), 161. At one point, Michelangelo contemplated giving up the income as his close friend, Luigi del Riccio, reported to Lionardo: "Ora mi pare sia d'animo di non tenerlo che dice è molto vechio et non può più la fatica né lavorare, et per questo non vuole premio" (*Carteggio indiretto* 2: 26, 23 and *Carteggio* 4: 203). In addition, Michelangelo was paid fifty scudi a month throughout his work on the *Last Judgment*, for which payments, see K. Frey, "Studien zu Michelangelo Buonarroti und zur Kunst seiner Zeit," *Jahrbuch der königlich preuszischen Kunstsammlungen* 30 (1909): 139–40, doc. 14.

64. *Carteggio* 3: 323, 337; *Carteggio* 4: 31, 38–9, 44–5, 77, 394–5, and *I ricordi*, 259. On war loans, see M. M. Bullard, *Filippo Strozzi and the Medici: Favor and Finance in Sixteenth-Century Florence and Rome* (Cambridge, Cambridge University Press, 1980), 18, 20.

65. *Carteggio* 3: 407, 415, 416, 423, and *I ricordi*, 275.

66. *Carteggio* 4: 89.

67. For the *motuproprio*, see Redig de Campos, *Il giudizio universale*, 86–90. Michelangelo's relief was only temporary because just a few months after the unveiling of the great fresco, the heirs of Julius II did not fail to remind him of his still-outstanding obligation; see letter of Guidubaldo della Rovere, duke of

Urbino, to Michelangelo, 6 March 1542 (*Carteggio* 4: 128–9, and *Carteggio indiretto* 1: 3).

68. *Carteggio* 4: 106.

69. Letter from Marco Bracci in Rome to Agnolo Niccolini in Florence: "Michelagnolo ancora che dipignere nella Gran Capella di Sixto, si levo da lavorare con gran furia e ha fatto intendere a sua S.ta se lei non vi ripara la capella se ne viene in tera certo saria gran dano per amore di quelle belle figure" (ASF: Mediceo del Principato 337, fol. 247; reference from "The Medici Archive Project" [www.medici.org], entry no. 305).

70. De Tolnay, *Final Period*, 22, 103.

71. For some recent attempts to ground culture studies in the materiality of daily life, what Patricia Fumerton calls a social historicism of the everyday, see *Renaissance Culture and the Everyday*, ed. P. Fumerton and S. Hunt (Philadelphia, University of Pennsylvania Press, 1999). But rather than the daily life of the common person and the marginalized, I am interested in the practice of everyday life in relation to the making of high art. Also relevant are H. White, *Metahistory: The Historical Imagination in Nineteenth-Century Europe* (Baltimore, The Johns Hopkins University Press, 1973); M. de Certeau, *The Practice of Everyday Life*, trans. S. Rendall (Berkeley and Los Angeles, University of California Press, 1988); H. Lefebvre, *Critique of Everyday Life*, trans. J. Moore (London and New York, Verso, 1991); L. C. Orlin, *Private Matters and Public Culture in Post-Reformation England* (Ithaca, Cornell University Press, 1994), and *Subject and Object in Renaissance Culture*, ed. M. de Grazia, M. Quilligan, and P. Stallybrass (Cambridge and New York, Cambridge University Press, 1996).

72. See W. E. Wallace, "Michelangelo's Rome *Pietà*: Altarpiece or Grave Memorial?" *Verrocchio and Late Quattrocento Italian Sculpture*, ed. S. Bule, A. Darr, and F. S. Gioffredi (Florence, Casa Editrice Le Lettere, 1992): 243–55, and idem, "Michelangelo's *Risen Christ*," *Sixteenth Century Journal* 28 (1997): 1251–80.

73. W. E. Wallace, "Michelangelo's Project for a Reliquary Tribune in San Lorenzo," *Architectura: Zeitschrift für Geschichte der Baukunst* 17 (1987): 45–57.

74. *Carteggio* 4: 22.

75. W. E. Wallace, "Friends and Relics at San Silvestro in Capite, Rome," *Sixteenth Century Journal* 30 (1999): 419–39.

76. *Carteggio* 4: 120, 122, and Wallace, "Friends and Relics," 436–9.

77. See H. Thurston, *The Holy Year of Jubilee. An Account of the History and Ceremonial of the Roman Jubilee* (Westminster, MD, Newman Press, 1949); *Roma 1300–1875: L'arte degli anni santi*, ed. M. Fagiolo and M. Madonna (Milan, A. Mondadori, 1984); *Roma 1300–1875. La città degli anni santi*, ed. M. Fagiolo and M. Madonna (Milan, A. Mondadori, 1985); *Roma Sancta. La città delle basiliche*, ed. M. Fagiolo and M. Madonna (Rome, Gangemi, 1985); H. L. Kessler and J. Zacharias, *Rome 1300: On the Path of the Pilgrim* (New Haven and London, Yale University Press, 2000), and D. Howard, *Venice and the East: The Impact of the Islamic World on Venetian Architecture 1100–1500* (New Haven and London, Yale University Press, 2000), esp. chap. 7: "The Pilgrim City." A good introductory overview is provided by Barbara Wisch, "The Roman Church Triumphant: Pilgrimage, Penance and Processions Celebrating the Holy Year of 1575," in *"All the world's a stage . . . ":*

Art and Pageantry in the Renaissance and Baroque, 2 vols., ed. B. Wisch and S. S. Munshower (University Park, PA, The Pennsylvania State University Press, 1990), vol. 1; 83–117.

78. L. Schudt, *Le guide di Roma: Materialen zu einer Geschichte der römischen Topographie* (Vienna and Augsburg, B. Filser, 1930), 21.

79. Vasari, trans. Bull, 393. In 1545, Michelangelo was considering a pilgrimage to Santiago da Campostella (*Carteggio* 4: 220), and when he fled Rome for Spoleto in 1556, his intention was to visit the shrine at Loreto. The Christian pilgrim seeking salvation is an important aspect of the medal made by Leone Leoni for Michelangelo. For this, see P. Barolsky, *Michelangelo's Nose: A Myth and Its Maker* (University Park, PA, and London, The Pennsylvania State University Press, 1990), 44–48.

80. *Carteggio indiretto* 2: 32. On the Jubilee indulgence, see Thurston, *Holy Year*, chap. 8. Lionardo returned to Florence via Loreto, where he visited the famous pilgrimage shrine, the Holy House of the Virgin Mary.

81. Gregory Martin, *Roma Sancta* (1581), ed. G. B. Parks (Rome, Edizioni di Storia e Letteratura, 1969), 18. See also Schudt, *Guide*; J. Schlosser, *La letteratura artistica*, trans. F. Rossi (Florence, La Nuova Italia Editrice, 1964), 600–3; W. Brewyn, *A XVth Century Guide-Book to the Principal Churches of Rome*, trans. C. Woodruff (London, The Marshall Press, 1933), and O. Panciroli and F. Posterla, *Roma sacra e moderna* (Rome, Mainardi, 1725).

82. P. Brown, *The Cult of the Saints: Its Rise and Function in Latin Christianity* (Chicago, The University of Chicago Press, 1981), chap. 5; see also A. Grabar, *Martyrium: recherches sur le culte des reliques et l'art chrétien antique* (1946; reprint, London, Variorum Reprints, 1972); B. Abou-El-Haj, *The Medieval Cult of the Saints: Formations and Transformations* (Cambridge and New York, Cambridge University Press, 1994); D. Freedberg, *The Power of Images* (Chicago and London, The University of Chicago Press, 1989), and H. Belting, *Likeness and Presence: A History of the Image before the Era of Art*, trans. E. Jephcott (Chicago and London, The University of Chicago Press, 1994).

83. G. Frank, *The Memory of the Eyes: Pilgrims to Living Saints in Christian Late Antiquity* (Berkeley and Los Angeles, The University of California Press, 2000); see also J. Sumption, *Pilgrimage: An Image of Mediaeval Religion* (Totowa, NJ, Rowman and Littlefield, 1975); V. Turner and E. Turner, *Image and Pilgrimage in Christian Culture: Anthropological Perspectives* (New York, Columbia University Press, 1978), esp. chap. 1; J. Z. Smith, *To Take Place: Toward Theory in Ritual* (Chicago, University of Chicago Press, 1987); *The Blessings of Pilgrimage*, ed. R. Ousterhout (Urbana, IL, University of Illinois Press, 1990); *Contesting the Sacred: The Anthropology of Christian Pilgrimage*, ed. J. Eade and M. J. Sallnow (London and New York, Routledge, 1991); *Sacred Journeys: The Anthropology of Pilgrimage*, ed. A. Morinis (New York, Greenwood Press, 1992) and R. Ousterhout, "Architecture as Relic and the Construction of Sanctity: The Stones of the Holy Sepulchre," *Journal of the Society of Architectural Historians* 62 (2003): 4–23.

84. See M. B. Hall, "Michelangelo's *Last Judgment*: Resurrection of the Body and Predestination," *Art Bulletin* 58 (1976): 85–92.

85. Charles Burroughs has suggested that "through both symbolic and, to a degree, iconic means it [the fresco] constitutes a schematic reference to and even representation of Roman sacred topography." He further noted "a series of allusions that relate the transcendent imagery of the fresco to the contingent world of human society." See C. Burroughs, "The *Last Judgment* of Michelangelo: Pictorial Space, Sacred Topography, and the Social World," *Artibus et Historiae* 32 (1996): 55–89. An exemplary essay relating Michelangelo's art to the sacred topography of Rome is P. Fehl, "Michelangelo's *Crucifixion of St. Peter*: Notes on the Identification of the Locale of the Action," *Art Bulletin* 53 (1971): 326–43. See also M. Rohlmann, "Michelangelos *Jüngstes Gericht* in der Sixtinischen Kapelle: Zu Themenwahl und Komposition," in *Michelangelo: Neue Beiträge* (Munich and Berlin, Deutscher Kunstverlag, 2000), 205–34; M. Schapiro, *Words and Pictures: On the Literal and Symbolic in the Illustration of a Text* (The Hague, Mouton, 1973); M. R. Miles, *Image as Insight: Visual Understanding in Western Christianity and Secular Culture* (Boston, Beacon Press, 1985); idem, *Practicing Christianity: Critical Perspectives for an Embodied Spirituality* (New York, Crossroad, 1988). Also relevant are M. J. Carruthers, *The Book of Memory: A Study of Memory in Medieval Culture* (Cambridge, Cambridge University Press, 1990), and idem, *The Craft of Thought: Meditation, Rhetoric, and the Making of Images, 400–1200* (Cambridge and New York, Cambridge University Press, 1998). In this latter book, Carruthers notes that "the physical activity [of pilgrimage and procession] exactly mirrors the mental activity in which the participants were engaged" (44). A reverse corollary is also true: the mental activity of observing the fresco mirrors the physical activity of pilgrimage.

For a recent discussion of maps and how they relate to imagined pilgrimage, see D. K. Connolly, "Imagined Pilgrimage in the Itinerary Maps of Matthew Paris" *Art Bulletin* 81 (1999): 598–622; see also J. F. Baldovin, *The Urban Character of Christian Worship: The Origins, Development, and Meaning of Stational Liturgy* (Rome, Pont. Institutum Studiorum Orietalium, 1987).

86. *Carteggio* 4: 124; trans. Ramsden, *Letters* 2: 10.

87. *Carteggio* 4: 127.

THE HISTORICAL AND RELIGIOUS CIRCUMSTANCES OF THE *LAST JUDGMENT*

After one of the shortest and least contentious conclaves on record, Alessandro Farnese was elected Pope Paul III on 12 October 1534, just after his predecessor Clement VII had commissioned Michelangelo to begin the *Last Judgment*. Among the oldest (he was born in 1468) and most experienced cardinals, Farnese had risen originally under the patronage of one of the worldliest of popes, Alexander VI, who had a long affair with Farnese's sister Giulia. Farnese followed Alexander's lead and fathered several children after entering the hierarchy. To us, this will immediately appear problematic and highlights how difficult it is to think our way back into early modern Italy. For Farnese and his contemporaries, there was no cause for alarm. Because he was not in orders, he was not required to be celibate. As did many others including some identified as "reformers," he postponed becoming a priest until 1519, ten years after becoming a bishop and twenty-five after he was made a cardinal.[1] Thereafter, Paul "got religion" in the days of Leo X and by the time of his election inspired great hopes among those who wished for major changes in the Catholic Church. For example, Jacopo Sadoleto, prominent curial humanist and former papal secretary, was overjoyed.[2] Paul faced daunting difficulties. One of them was schism. Martin Luther and his Protestant supporters looked likely to carry the entire Holy Roman Empire out of the Church after fifteen years of increasingly strident attacks on doctrines and practices that they labeled abuses. Earlier in 1534, England had formally broken away from papal obedience with the passage of the Act of Supremacy making Henry VIII supreme head

of the church in England.[3] The year before, the papacy had already lost important English revenues, exacerbating the weak state of the papal treasury. Schism and finance were just the beginning.

Paul inherited many of his problems most directly from his predecessor Clement VII. As indecisive as Clement undoubtedly was, he had found himself in an almost impossible situation relative both to England and the wider problem of religious dissent as a consequence of one of the most shattering events of the sixteenth century, the Sack of Rome. On 6 May 1527, an imperial army composed mainly of Spanish and German mercenaries, many of the second Lutheran sympathizers, captured Rome and besieged the pope in Castel Sant'Angelo. Other churchmen were seized, tortured, robbed, and murdered. Churches were desecrated and the city severely damaged.[4] More important than the physical destruction, the psyche of the upper reaches of the Roman church, as of much of the Italian intelligentsia, was severely wounded. The imperial papacy that had developed from at least the time of Innocent III (1198–1215) had proved powerless in the face of the empire's military strength. The *renovatio Romae* (the renewal of Rome) under way since the middle of the previous century and the object of an intense cult among Roman humanists consciously directed by many popes came ignominiously to an end.[5] Politically and economically, the church in Rome was nearly put out of business. Clement found himself under imperial domination by 1530, as did much of the rest of Italy. Because Henry of England's first wife, Katherine of Aragon, from whom he fervently wished a divorce, was the emperor Charles V's aunt, Clement was unable to make a deal with the king. His paralysis in this case typified the last seven years of his pontificate in most other domains. The backlog of unaddressed crises built up steadily.

Clement does not deserve sole blame. Since the French invasion of Italy in 1494, an even more disruptive event than the Sack, the papacy, like most other Italian powers, had been forced to confront a serious decline in power and prestige. This was a political problem and could have been attacked with political means. The papacy, however, was more than a political power. Unlike most of its competitors, it also had a theoretically more important spiritual side, that made it responsible for the salvation of all (Christian) Europeans.[6] This signal success of papal policy, again dating from Innocent III, brought with it another set of

problems.[7] Because the popes had persuaded European Christians that they had (or at least should have) complete control of the machinery of salvation, they had also to take charge of fixing anything that went wrong in it. They did not always succeed. Part of the difficulty arose from the fact that the popes increasingly defined salvation in legalistic terms as an impressive bureaucracy grew up to handle the business of salvation. It worked well, even during the exile of the papacy from Rome to Avignon in the fourteenth century, bewailed by Petrarch.[8] This very success slowly changed the nature of the papal church and led to an unspiritual emphasis on the institution as a business, a property to be exploited like any other. Large numbers of clergy came to think of their benefices in these terms, aided and abetted by Rome. This was especially true of the upper reaches of the hierarchy in Italy, many of whose members, in common with Pope Paul himself, saw golden opportunities to advance their families through the clerical offices they held.[9] Two of the central organs of the papal bureaucracy, the Datary and the Penitentiary, gained standing and value in proportion to how many fees they brought in. The Datary accounted for about half the papacy's total annual receipts.[10] People who had encountered problems getting to Heaven while yet on earth could approach one or both or any number of other papal organs for help in the form of dispensations, especially for improper marriages in the case of the laity, or for judicial remedy in the central papal courts. The papacy was only somewhat more precocious than its secular competitors in efforts to capitalize – literally – on this business by, for example, the sale of offices.[11] Its special distinction was profit making from indulgences, graces reducing the amount of time a soul (one's own or a relative's) had to spend in purgatory. Both institutions – purgatory and indulgences – had grown up together in the fourteenth century, originally as efforts to reduce anxiety about salvation.[12] Indulgences had been freely granted by popes as an act of charity.[13] By the end of the succeeding century, they had turned into a high-powered fundraising tool. One of the most notorious instances of such use served as a trigger of Luther's revolt.

Luther objected to the sale of indulgences in any case on theological grounds, but he was especially annoyed that the funds being raised were earmarked for the construction of new St. Peter's in Rome.[14] In Italy, by contrast, the church as an economic enterprise and the

related phenomenon of nepotism, like the lack of clerical celibacy, were taken as perfectly natural and together proved to be Paul III's particular blindspots when it came to reform.[15] It was from sources like indulgences and the sale of offices that the Renaissance in and of Rome was financed.[16] This was all very expensive, and, despite the vast Medici riches and the even vaster resources of the network of Florentine bankers who largely controlled papal finances by the early sixteenth century, the papacy by Clement's day was almost bankrupt.[17]

Thus even before the Sack the former grandeur of Rome under Clement's cousin and predecessor Leo X was severely reduced. Much of what remained, especially the intellectual framework, had come under severe strain.[18] Roman humanism, although it lost many of its most notable proponents, including Sadoleto who almost always refused thereafter to leave his diocese of Carpentras, yet survived and took a more religious direction.[19] Many other high-ranking churchmen fled Rome and refused to return. One of them was Gianmatteo Giberti, formerly Clement's datary, who withdrew to his diocese of Verona, where he set one of the most widely imitated models of episcopal administration and renewal.[20] The imperial incursion, just one moment in the interminable Habsburg-Valois wars in Italy not ended until 1559, had other large consequences. One of the most important was a revolt in Florence that produced what proved to be its Last Republic.[21] The millenarian expectations stirred up by Savonarola a generation earlier flourished again, a preoccupation to which Rome was not immune as waves of prophecy washed over it, especially of the angelic pope who would resolve all difficulties.[22] Florence experienced an upsurge of republican ardor, even if the republic under siege pretty quickly deteriorated into a virtual dictatorship. Nevertheless, this environment would long survive the restoration of the Medici in 1530, providing an important locus in the Medici court for heterodox ideas once Cosimo I became duke in 1537. Cosimo's majordomo, Pierfrancesco Riccio, is just one high-profile case.[23]

In the minds of some, especially Gianpietro Carafa, cofounder of the Theatine Order and later Pope Paul IV, heresy was an increasing problem, intensified in Carafa's case by a wrenching personal experience of the Sack, which had derailed his career in Rome and sent him to an almost ten-year exile in Venice.[24] In Italy persons like Carafa regarded *heretic* and *Lutheran* as synonyms. Now as then this

is an unhelpful simplification. It is crucial to understand that until the 1560s, many central dogmas of Christianity were undefined, among them one of the most essentially contested in all varieties of the Reformation, justification. What precisely were the mechanics by which one got to heaven? Some, like Luther, insisted that the hopelessly corrupted believer could contribute nothing, making justification dependent on faith alone. Others emphasized the importance of human effort in the form of good works.[25] Probably the vast majority of believers and theologians alike stood somewhere in between. Luther drew radical consequences from his position, leading to the identification of the pope as Antichrist and the condemnation of virtually the entire penitential and legal system of Rome, as well as the mass, which Luther insisted was not a sacrifice. Although deeply conservative and therefore reluctant to part from the rest of the church, the logic of Luther's position, or perhaps even more importantly the intensity of his polemics, slowly forced him and his followers into a new camp. Few Italians overtly followed him.[26] A substantial number nevertheless held similar views. One of the most important was Gasparo Contarini, who experienced at just about the same time as the young Luther a similar crisis of faith and reached a similar solution. He was one of many in Venice and its territories to do this, perhaps partly as a result of the severe trauma inflicted by its defeat in the battle of Agnadello in 1509. The old Venetian civic pieties came under great pressure as highly placed nobles like Contarini were tempted to withdraw from the world and become monks.[27] Many did, and in the strictest orders.[28] Contarini ultimately did not, but the resolution of his crisis lasted at least a decade.[29]

Contarini became a powerful proponent of change, and it was as such that Pope Paul brought him into the College of Cardinals in 1535. Although Paul is famous for skillfully rising above faction, in his early promotions of cardinals he named a substantial number of those known as reformers, many of them at Contarini's suggestion, even if his first promotion was purely nepotistic: his grandsons Alessandro Farnese and Guido Ascanio Sforza.[30] Perhaps the most notable promotion came in December 1536. It included two future popes (Carafa and Giovanni Maria Ciocchi del Monte [Julius III]), along with the Englishman Reginald Pole (assigned by Vasari to the "B" list of Michelangelo's friends) who would miss election to the papacy by

one vote, Sadoleto and Rodolfo Pio da Carpi.[31] In December 1539, it was Federico Fregoso's turn, along with Marcello Cervini, the future Marcellus II.[32] Immediately before the 1536 promotion, Paul had already put some of the new cardinals to work on a commission over which Contarini had a great deal of influence.[33] This was a blue ribbon panel, all the members of which, save one, either were then or would be cardinals.[34] Their job was to identify the papacy's failings. Paul manifested the seriousness of his intent by declaring in consistory while the commission was sitting that "reformation" was of the essence, beginning with himself and the cardinals.[35] Sadoleto's opening address to the commission linked its assignment directly to the Sack, denounced the state of the church, and almost predicted the apocalypse unless Paul took reform seriously.[36] In March 1537, the commission presented its work to the pope. The *Consilium de emendanda ecclesia* (Legal opinion about fixing the church) wasted little time on flattery.[37] It began by warning that the church was "about to collapse headlong into ruin" unless Paul acted under the Holy Spirit's inspiration. The root of the problem was flattery of the pope, who had been led to believe that he was "lord of all benefices." In other words, the target was the church as property and as a legal institution. The solution was simple. The pope had to be "not a master but a steward" and submit himself to the laws. The specific abuses addressed included clerical ordination, nonresidence (especially of bishops), financial manipulation of benefices to the harm of souls, alienation of church property, holding of incompatible benefices (two or more with cure of souls), the holding by cardinals of multiple bishoprics *in commendam*, peculation in the Datary and Penitentiary, laxity in religious orders, abuse of dispensations, a long list of financial abuses including indulgences, and higher education that ought to be under episcopal control. The framers also left an important straw in the wind by calling for improved censorship (officially established at the Fifth Lateran Council in 1515), singling out Erasmus's *Colloquies* for prohibition.[38] Nothing happened immediately, and Vittoria Colonna, famous poet and proponent of a more spiritual church, was very disappointed. When she asked Contarini and Pole why Paul had done nothing, they could only shrug their shoulders.[39] Part of the reason lay in the international context. Luther had somehow gotten a copy of the top-secret *Consilium* and published it with scurrilous comments. The Strassburg reformer Jean

Sturm treated the text similarly and engaged in a sharp (at least for these two irenic personalities) controversy with Sadoleto about it.[40] For Paul to act on it any time soon would thus make it appear that he had bowed to Protestant pressure. Conservatives in the curia also mounted determined opposition. Nevertheless, perhaps Colonna and the others were too impatient. By the time of the last session of the Council of Trent in 1563, the document had become "the golden *consilium*" and had been assigned a central place in the prehistory of this great council.[41] The pope also pushed ahead with some of the *Consilium*'s proposals, above all "reformation" of the Datary and Penitentiary, as well as clerical residence, and continued to do so, even if it is not always easy to see consistency in his approach.[42] By 1540, Cardinal Ercole Gonzaga, one of Paul's bitterest enemies, grudgingly allowed that reform might be moving forward under Contarini's stimulus.[43]

Trent had good reason to trace its origins to the *Consilium*. Although Paul had tried almost from the first to convene a general council, first for Mantua and then for Vicenza, both proved abortive, largely because of the international situation and the hostilities between France and the empire and within the empire between Charles and the Lutherans.[44] Undeterred, while the *Consilium* commission was meeting, Paul appointed another for the council. Its membership was a classic instance of Paul's balancing act, but it included Pole as well as four other reformers, among them Contarini, and thus provided direct continuity to the first summons to Trent in 1542, with Pole as one of the three legates, as he was again when the council finally opened in 1545.[45]

Trent grew directly out of demands for change, for reform. When Contarini and his contemporaries used this word, they almost always did so in the literal sense of returning things to their original state, almost never introducing something new, which was, after all, one of the classical definitions of heresy.[46] It had, however, begun (but little more) to drift in the direction of change in a forward direction and could also be highly elastic.[47] Reform was frequently still used in reference to discipline and morals, not doctrine – for example, by Paul in his very first consistory.[48] This kind of reform was nothing new, and the discussion current during Paul's reign went well back into the fifteenth century. The Cassinese Benedictines were in the forefront. This congregation had begun at Santa Giustina in Padua early in the

fifteenth century and had in 1505 won over the mother house of the entire Benedictine Order at Monte Cassino, hence the congregation's change of name. Originally a disciplinary movement, its spirituality and theology became tremendously influential. Its theologians drew on Paul and on Greek exegetes, especially John Chrysostom, eventually in a deliberate effort to reach out to the Protestants.[49] Then and earlier they had close ties to pivotal reforming figures, among them Pole, Contarini (the congregation's protector before Pole), and Gregorio Cortese, a Cassinese abbot.[50] Cassinese theology took a distinctive view of salvation. It depended on justification by faith, but, unlike Luther's understanding, the human nature of the believer who embraced it was not irretrievably corrupted and could be restored to its original state through reliance on Christ.[51] This was a literal "reformation."

As an inherently conservative concept, talk of reform was especially widespread among religious orders, not just the Cassinese. Paul began his reign by ordering overhauls of several of them, especially the Augustinian Hermits, Luther's order.[52] A few years later, the pope appointed as their general Girolamo Seripando, who personally inspected all the order's houses except those in the empire.[53] In this he followed in the footsteps of the earlier general and major advocate of reform, Giles of Viterbo.[54] Other reforms arose among the orders themselves, perhaps above all the latest strict version of the Franciscans, the Capuchins.[55] They were successful in part because of their preaching. The same was true of a new order, soon to become one of the largest, the Jesuits.[56] The original ten members received their bull of foundation in 1540 under Contarini's patronage, and they continued to make common cause with Contarini's wing of the church. Nicolás Bobadilla, for example, earlier an enemy of the followers of Juan de Valdés in Naples, preached Lent for Cardinal Pole in Viterbo in 1541. His topic was the epistles of Paul.[57]

Preaching had by then become a neuralgic point and was about to become even more so as concern increased about the consequences of evangelizing the masses.[58] Another reason preaching became worrisome was the success and subsequent apostasy of the Capuchin General Bernardino Ochino. Perhaps the most famous preacher of the time, Ochino was in such demand at Lent that the pope had to decide which city could enjoy his services. Ochino attracted a number of

devoted disciples, among them Colonna, close friend and patron of Michelangelo.[59] By the mid-1530s, her interests had become religious, increasingly so throughout the rest of her life, and her poetry did as well.[60] Ochino was one of her principal spiritual guides, followed later by Pole. One of the points linking her most closely to both was belief in justification by faith as well as an intensely Christocentric piety, which all shared with Michelangelo.[61] All of them competed for one of his drawings of the Pietà which graphically embodied this piety.[62] These two ramified much more widely. Perhaps the most famous group adhering to both was the so-called church of Viterbo, centered around Pole. A close relative of Henry VIII, Pole had gone into Italian exile in 1532 and four years later damned and blasted his king in *Pro ecclesiasticae unitatis defensione*, one of the first manifestoes of the Contarini wing.[63] His circle in Viterbo likewise included a number of Contarini's satellites, and many others made it a point to stop by Viterbo in the early 1540s to take advantage of the spiritual devotions led by Marcantonio Flaminio. This larger group, including Colonna, became known as *spirituali* in Pauline contradistinction to the "carnal" persons who stayed immired in this world.[64] A large number of them were Michelangelo's friends. Their principal monument, given its final form by Flaminio in Viterbo in 1542–3, was the *Beneficio di Christo*.[65] Superficially a simple work, written in reasonably plain Italian, the *Beneficio* has generated a great deal of controversy, especially over its sources.[66] These are no doubt complex, including Cassinese Benedictine spirituality injected by its original author Benedetto Fontanini, as well as large chunks of both Luther and John Calvin, not to mention the fathers of the church and Saint Bernard.[67] A good bit of its content came from Valdés, under whose sway Flaminio came in Naples in 1540–1.[68] Valdesian beliefs in the *Beneficio* included a stress on illumination, individual conscience, and experience, but not Valdés's accompanying de-emphasis of scripture. Valdés's ideas in turn were composed of a complex mix of Spanish alumbradism and Erasmianism, with large measures of Luther especially in the *Dialogue of Christian doctrine* (1529).[69] The *Beneficio*'s central concept, the benefit of Christ's death, may have derived from Luther's right-hand man, Philip Melanchthon, although it had become relatively widely diffused in Italy by the time the *Beneficio* was written.[70] The work proved immensely popular, supposedly appearing at Venice in

40,000 copies.[71] It may have been deliberately circulated in manuscript during the abortive opening session of the council of Trent (when many of Valdés's works were printed).[72]

The "little book" opens with the Augustinian premise that humans had been completely corrupted by the Fall, in which they had lost the "divine image and likeness" (106; cf. 110, 119). The remedy was to regain this image (107). Concupiscence posed the principal stumbling block; this was one of Luther's favorite concepts. The law, as Paul had said, revealed concupiscence and forced humans to turn to Christ as mediator to escape it (109). Thereafter the way ahead lay through imitation of Christ (110), a concept almost certainly descended from Thomas à Kempis's famous late-medieval devotional tract, which was popular in Italy.[73] The *Beneficio* insisted that this imitation did not contribute to salvation, which was entirely gratuitous (e.g., 112). Christ's sacrifice, the benefit of his death, came to believers through faith, incorporating them into His body (e.g., 115) and making them "participants in the divine nature" (e.g., 118). Michelangelo understood this concept so thoroughly that it motivated his no-strings-attached gift of one of his *Pietà* to Colonna.[74] Yet more was possible. Taking off from Paul's metaphor of the mystical marriage of the Church and Christ, the authors emphasized that the Church consisted of all souls, each one of which entered into an individual marriage with Christ that produced "union" between the two. Faith, which here meant believing the Gospel, produced the "certainty" of union (119). This point recurs frequently, usually along with mystical talk of light and fire (e.g., 133). An explicit metaphor, borrowed from Valdés, was offered to explain the point.[75] A king offered free pardon to all his rebels, but any who refused to believe it would be condemned to die in exile. So it was for anyone who rejected Christ's promise (120–1). Certainty was also possible because God has "elected him [the believer] to the glory of eternal life" (121). The elect, those predestined to salvation, got much attention. The mechanism began with faith, which "imparted" the Holy Spirit, who in turn engendered trust and finally works out of "force of love" (*violento amore*) (122). Faith was further equated with "purification" (127), which was also synonymous with sanctification (e.g., 130). This rather dubious point according to most mainstream theologians before and after emphasizes the mystical imprint on the *Beneficio*. The kind of faith required was living, not

historical, borrowing a leaf from Calvin (129). It led to making the believer a new creature, overcoming concupiscence, and in a point made numerous times, to "pacifying" consciences (e.g., 128, 130). In technical theological language, the believer's sins were no longer "imputed" to him or her, being replaced with Christ's righteousness.[76] Christians knew the truth of all this through "experience" (131 and 141). The authors were aware that such talk removed the traditional stimulus to good works and therefore insisted that their scheme also produced charitable action as believers responded to God's love for them with love of their neighbor and good works (e.g., 135). Imitation of Christ served the same end (138–9). Only at this point does the Church as something other than the union of souls with Christ reappear. Chapter six offered a remedy against "human prudence" (one of Valdés's principal bugbears) in the form of the Eucharist and "the memory of baptism" before immediately adding "and predestination." Participating in the Eucharist meant participating in the immortality of Christ's body, incorporation into it and, of course, a tranquil conscience (141–7). In brief, "salvation consists in the participation and union with Christ" (148) symbolized – but only symbolized – by the "remembrance" of the Eucharist. The rest of this longest chapter preached predestination and imitation of Christ before concluding that "on the one hand, the true Christian believes with certainty that he is predestined to eternal life and must be saved – not through his own merits certainly, but through the election of God, who has predestined us, not through our own works but to show his mercy. On the other hand, he pays attention to good works and to the imitation of Christ, as if his salvation depended on his own industry and diligence" (160).

The church as an institution virtually disappeared from the *Beneficio*. It did not, however, in the minds of most *spirituali* who refused to follow Ochino or Peter Martyr Vermigli into exile among the Protestants.[77] As Colonna put it in the wake of their apostasy, "[i]t grieves me deeply that the more Ochino tries to excuse the more he accuses himself, and the more he strives to save others from the shipwreck the deeper he sinks into the whirlpool, since he places himself outside the ark of salvation and security."[78] It is one of the great conundra of the Reformation that despite their profound reservations about the papacy all those involved in the *Beneficio*'s gestation ultimately

remained loyal to Rome, as did Michelangelo himself, even while per-
haps expressing such reservations in the *Last Judgment*.[79] Their loyalty
did not prevent them from coming under suspicion of heresy from a
group of conservatives, usually called *intransigenti*. The most outspo-
ken members of this group, men like Ambrogio Catarino, launched
a pointed campaign to root out these "Lutherans" and their ideas.[80]
When the Roman Inquisition was refounded in mid-1542 (Carafa
paying most of its expenses) the *spirituali*, especially in Viterbo, came
under observation.[81] Often this is made a moment of great conse-
quence, but in fact it gets ahead of the story, because for almost an-
other fifteen years the Inquisition did not succeed in causing much
trouble for them. Out-and-out heretics, like those in the Academy of
Modena or in Lucca, the Inquisition's original targets, received much
harsher treatment.[82] In many other places, however, the process of es-
tablishing the Roman Inquisition was drawn out and extends at least
into the 1560s.[83] The same is true of the parting of the theological
ways between the various parts of the reform tendency, both *spirituali*
and *intransigenti* and many in between.[84] The Dominican Catarino's
career provides useful cautions that the situation in the late 1530s and
early 1540s was much more complex than a neat division into two op-
posing groups and that we must be especially careful about when this
split may have happened.[85] In the late 1530s, he was close to Colonna
and Michelangelo, both of whom attended his lectures on the Pauline
epistles at San Silvestro al Quirinale, at least some of the time along with
Carafa.[86] Catarino attacked the *Beneficio* largely on stylistic rather than
theological grounds, for he remained close to its essentially Pauline
soteriology. Only at the very end of his criticism did Catarino fault
the work for ignoring the church's penitential system.[87] The point can
be made more broadly. Most of the circumstances thrown up or inten-
sified by the Sack continued until well into the 1550s and it helped to
fuel the climate of religious experimentation even longer. Rather than
seeing a particularly acute moment of crisis around 1540, as is often
done, it would be more accurate to think in terms of a long period
of fluidity that some would say lasted until the end of the century.[88]
Thus, a broad spectrum of belief that only gradually crystallized into
opposing groups marked both the 1530s, during which Michelangelo
painted the *Last Judgment*, and the first decade of its existence, the
1540s.[89]

NOTES

1. J. N. D. Kelly, *The Oxford Dictionary of Popes* (Oxford: Oxford University Press, 1986), 261. The meaning of *reform* is discussed later.

2. Ludwig von Pastor, *The History of the Popes from the Close of the Middle Ages*, vol. 11 trans. Ralph Francis Kerr (St. Louis, MO, and London: Herder and Kegan Paul, Trench, Trübner & Co., 1914), 27. The letter is Jacopo Sadoleto, *Opera quae exstant omnia*, 4 vols. (Verona: Tumermani, 1737), vol. 1, 197ff.

3. G. R. Elton, ed., *The Tudor Constitution: Documents and Commentary* (Cambridge: Cambridge University Press, 1960), 355.

4. André Chastel, *The Sack of Rome, 1527*, trans. Beth Archer, vol. 26 of the *A. W. Mellon Lectures in the Fine Arts*; Bollingen Series 35 (Princeton: Princeton University Press, 1983).

5. Charles L. Stinger, *The Renaissance in Rome* (Bloomington: Indiana University Press, 1985).

6. Paolo Prodi, *Il sovrano pontefice. Un corpo e due anime: la monarchia papale nella prima età moderna* (Bologna: Il Mulino, 1982), poorly translated by Susan Haskins as *The Papal Prince: One Body and Two Souls: The Papal Monarchy in Early Modern Europe* (Cambridge: Cambridge University Press, 1988).

7. Jeffrey Burton Russell, *A History of Medieval Christianity: Prophecy and Order* (New York: Thomas Y. Crowell, 1968).

8. See Petrarch's "Letter to Posterity" in K. R. Bartlett, ed., *The Civilization of the Italian Renaissance* (Lexington, MA, and Toronto: D. C. Heath, 1992), pp. 21–2. For the success of the Avignon papacy, see Guillaume Mollat, *The Popes at Avignon: The "Babylonian Captivity" of the Medieval Church*, trans. Janet Love (New York and Evanston, IL: Harper & Row, 1963).

9. Barbara M. Hallman, *Italian Cardinals, Reform and the Church as Property, 1492–1563* (Berkeley: University of California Press, 1985), Wolfgang Reinhard, "Nepotismus: der Funktionswandel einer papstgeschichtlichen Konstanten," *Zeitschrift für Kirchengeschichte*, 86 (1975): 145–85, and Pastor, *Popes*, 36.

10. Pastor, *Popes*, 174.

11. Peter Partner, *The Pope's Men: The Papal Civil Service in the Renaissance* (Oxford: Clarendon Press, 1990); cf. John F. D'Amico, *Renaissance Humanism in Papal Rome* (Baltimore: Johns Hopkins University Press, 1983); Jean Delumeau, *Vita economica e sociale di Roma nel cinquecento*, trans. Sarah Cantoni and Davide Bigalli (Florence: Sansoni, 1979), 205–9, and Elisabeth G. Gleason, *Gasparo Contarini: Venice, Rome and Reform* (Berkeley and Los Angeles: University of California Press, 1993), 144–6. See in general Peter Partner, "Papal Financial Policy in the Renaissance and Counter-Reformation," *Past and Present* (1980): 17–62.

12. Jacques LeGoff, *The Birth of Purgatory*, trans. Arthur Goldhammer (Chicago: University of Chicago Press, 1984).

13. R. W. Southern, *Western Society and the Church in the Middle Ages* (Harmondsworth, England: Penguin, 1970), 136–43.

14. Kurt Aland, ed., *Martin Luther's 95 Theses* (St. Louis and London: Concordia, 1967), 54 (thesis no. 50).

15. Elisabeth G. Gleason, "Who Was the First Counter-Reformation Pope?" *Catholic Historical Review* 81 (1995): 173–84, anticipated by Pastor, *Popes*, 36 and 38.

16. See Peter Partner, *Renaissance Rome 1500–1559: A Portrait of a Society* (Berkeley, Los Angeles, and London: University of California Press, 1976), and Stinger, *The Renaissance in Rome*.

17. Melissa Meriam Bullard, "*Mercatores Florentini Romanam Curiam Sequentes* in the Early Sixteenth Century," *Journal of Medieval and Renaissance Studies* 6 (1976): 51–71.

18. For the impact, see Kenneth Veld Gouwens, *Redefinition and Reorientation: The Curial Humanist Response to the 1527 Sack of Rome* (Leiden: E. J. Brill, 1991).

19. See, for example, Ronald K. Delph, "From Venetian Visitor to Curial Humanist: The Development of Agostino Steuco's 'Counter'-Reformation Thought," *Renaissance Quarterly* 47 (1994): 102–39, and Anne Reynolds, *Renaissance Humanism at the Court of Clement VII: Francesco Berni's Dialogue against Poets in Context*, ed. Raymond B. Waddington, Garland Studies in the Renaissance, vol. 7 (New York and London: Garland, 1997).

20. Adriano Prosperi, *Tra evangelismo e controriforma: G. M. Giberti (1495–1543)* (Rome: Edizioni di Storia e Letteratura, 1969).

21. Cecil Roth, *The Last Florentine Republic* (London: Methuen 1925) and J. N. Stephens, *The Fall of the Florentine Republic, 1512–1530* (Oxford: Clarendon Press, 1983).

22. See William V. Hudon, "Epilogue: Marcellus II, Girolamo Seripando, and the Image of the Angelic Pope," in *Prophetic Rome in the High Renaissance Period*, ed. Marjorie Reeves (Oxford: Clarendon Press, 1992). For Savonarola and his impact, see Donald Weinstein, *Savonarola and Florence: Prophecy and Patriotism in the Renaissance* (Princeton: Princeton University Press, 1970), Lorenzo Polizzotto, *The Elect Nation. The Savonarolan Moment in Florence 1494–1545*, ed. Denys Hay and J. B. Trapp, Oxford-Warburg Studies (Oxford: Clarendon Press, 1994), and most recently Stella Fletcher and Christine Shaw, eds., *The World of Savonarola: Italian Elites and Perceptions of Crisis* (Aldershot, England: Ashgate, 2000).

23. Massimo Firpo, *Gli affreschi di Pontormo a San Lorenzo: eresia, politica e cultura nella Firenze di Cosimo I* (Turin: Einaudi, 1997), 155–66, and Gigliola Fragnito, *Un pratese alla corte di Cosimo I. Riflessioni e materiali per un profilo di Pierfrancesco Riccio* (Prato: Società Pratese di Storia Patria, 1986).

24. Carafa lacks a biography. There is a stopgap in Alberto Aubert, *Paolo IV Carafa nel giudizio della età della Controriforma* (Città di Castello: Stamperia Tiferno Grafica, 1990), and Alberto Aubert, "Alle origini della Controriforma: studi e problemi su Paolo IV," *Rivista di Storia e Letteratura Religiosa* 22 (1986): 303–55. For the Theatines, see William V. Hudon, ed., *Theatine Spirituality: Selected Writings*, The Classics of Western Sprituality (Mahwah, NJ: Paulist Press, 1996).

25. Alistair E. McGrath, *Iustitia Dei. A History of the Christian Doctrine of Justification from 1500 to the Present Day*, 2 vols. (Cambridge: Cambridge University Press, 1986).

26. One of these was Vettor Soranzo. Filippo Tamburini, "La riforma della Penitenzieria nella prima metà del secolo XVI e i cardinali Pucci in recenti saggi," *Rivista di Storia della Chiesa in Italia* 44 (1990): 110–40, 124–6.

27. For the ritualistic nature of Venetian civic religion, see Edward Muir, *Civic Ritual in Renaissance Venice* (Princeton: Princeton University Press, 1981). For civic religion in general, see Luigi Donvito, "La 'religione cittadina' e le nuove prospettive sul

cinquecento religioso italiano," *Rivista di Storia e Letteratura Religiosa* 19 (1983): 431–74.

28. For Contarini's friends Paolo Giustinian and Vincenzo Querini, see Hubert Jedin, "Contarini und Camaldoli," *Archivio Italiano per la Storia della Pietà* 2 (1959): 59–118; Eugenio Massa, *L'eremo, la Bibbia e il medioevo in umanisti veneti del primo cinquecento* (Naples: Liguori, 1992); and Stephen Bowd, *Reform before the Reformation: Vincenzo Querini and the Religious Renaissance in Italy*, Studies in Medieval and Reformation Thought (Leiden: E. J. Brill, 2002).

29. Gleason, *Contarini*, 14–18, and Jedin, "Contarini und Camaldoli," passim.

30. Gigliola Fragnito, "Evangelismo e intransigenti nei difficili equilibri del pontificato farnesiano," *RSLR* 25 (1989): 20–47. Conrad Eubel and J. Van Gulik, *Hierarchia catholica medii et recentioris aevii*, vol. 3 (Münster: Bibliothek Regensberger, 1913), 23.

31. Eubel and Van Gulik, *Eubel*, 24–5. For the conclave of Julius III, in which Pole was almost elected, see Thomas F. Mayer, "The War of the Two Saints: The Conclave of Julius III and Cardinal Pole," in *Cardinal Pole in European Context: A Via Media in the Reformation*, Variorum Collected Studies (Aldershot, England: Ashgate, 2000), IV, 1–21.

32. Eubel and Van Gulik, *Eubel*, 26–7.

33. Pastor, *Popes*, 153 and Gleason, *Contarini*, 141–2.

34. The members were Contarini, Carafa, Sadoleto, Pole, Fregoso, Girolamo Aleandro, Giberti (who later refused the cardinalate), Gregorio Cortese, and Tommaso Badia.

35. Pastor, *Popes*, 158.

36. Pastor, *Popes*, 156; Gleason, *Contarini*, 142–3. The speech is in Societas Gorresiana, ed., *Concilium Tridentinum: diariorum, actorum, epistularum, tractatuum nova collectio*, 13 vols. (Freiburg/Breisgau: Herder, 1901–38), vol. 4, 108–19 (hereafter *CT*).

37. Gorresiana, ed., *CT*, vol. 12, 134–45; translation in Elisabeth G. Gleason, ed., *Reform Thought in Sixteenth-Century Italy*, American Academy of Religion Texts and Translations (Chico, CA: Scholars Press, 1981), 85–100. See the summaries in Gleason, *Contarini*, 143–9, and Pastor, *Popes*, 165–9. For the importance of this genre of legal literature and the force of such *consilia*, see Mario Ascheri, Ingrid Baumgärtner, and Julius Kirshner, eds., *Legal Consulting in the Civil Law Tradition*, Studies in Comparative Legal History (Berkeley: The Robbins Collection, 1999), especially Ascheri's essay, "Le fonti e la flessibilità del diritto comune: il paradosso del *consilium sapientis*, 11–53.

38. Thomas F. Mayer, *A Reluctant Author: Cardinal Pole and His Manuscripts*, vol. 99, 4, Proceedings of the American Philosophical Society (Philadelphia: American Philosophical Society, 1999), 22. For Erasmus's fate, see Silvana Seidel Menchi, *Erasmo in Italia 1520–1580* (Turin: Bollati Boringheri, 1987).

39. Gleason, *Contarini*, 169.

40. Pastor, *Popes*, 178. Luther's edition is in *Luther's Works, American Edition* (Philadelphia: Muhlenberg Press, 1960), 231–67. For Sturm, see Charles Schmidt, *La vie et les travaux de Jean Sturm*, (1855; reprint, Nieuwkoop: B. de Graaf, 1970), 41–7 and 314–15. The letters are Biblioteca Apostolica Vaticana, Vat. lat. 3436, folios 177r–8v and 179r–89v.

41. Pastor, *Popes*, 172.

42. Pastor, *Popes*, 186 and 195n for a report of the pope's further efforts in 1540 against "insolencies" and "extortions," and 209 for a decree on clerical residence of 13 December 1540. For reservations about Paul's intentions for the Datary, see Gleason, *Contarini*, 171, and see 157–76 for his reforming commissions of 1536–40. Cf. Tamburini, "Pucci."

43. Walter Friedensburg, "Der Briefwechsel Gasparo Contarini's mit Ercole Gonzaga nebst einem Briefe Giovanni Pietro Carafa's," *Quellen und Forschungen aus italienischen Archiven und Bibliotheken* 2 (1899): 161–222, 208, overstated in Pastor, *Popes*, 197.

44. See the masterful treatment of Trent's "prehistory" in Hubert Jedin, *Storia del concilio di Trento*, trans. G. Cecchi and O. Niccoli, 3d ed., vol. 1 (Brescia: Morcelliana, 1987), and cf. Pastor, *Popes*, chap. 2.

45. Gorresiana, ed., *CT*, vol. 4, 142, and Thomas F. Mayer, *Reginald Pole, Prince and Prophet* (Cambridge: Cambridge University Press, 2000), 133–36 and chap. 4.

46. Jürgen Miethke, "Reform, Reformation (reformare, reformacio)," in *Lexikon des Mittelalters* (Munich: Lexma, 1995), 543–50, and Eike Wolgast, "Reform, Reformation," in *Geschichtliche Grundbegriffe: historisches Lexikon zur politisch-sozialen Sprache in Deutschland*, ed. Otto Brunner, Werner Conze, and Reinhart Koselleck (Stuttgart: Klett, 1972–97), 313–60. Although classical and medieval usage of *reformatio* is well documented, there has been less work on the period of the Reformations. See John O'Malley, "Historical Thought and the Reform Crisis of the Early Sixteenth Century," *Theological Studies* 28 (1967): 531–48; John O'Malley, "Developments, Reforms, and Two Great Reformations: Towards a Historical Assessment of Vatican II," *Theological Studies* 44 (1983): 373–406; and his recent *Trent and All That: Renaming Catholicism in the Early Modern Era* (Cambridge: Harvard University Press, 2000) with its good bibliography. See also the useful survey in Michael A. Mullett, *The Catholic Reformation* (London and New York: Routledge, 1999), chap. 1.

47. For flexbility in the idea, see T. F. Mayer, "Cardinal Pole's Concept of *Reformatio*, the *Reformatio Angliae*, and Bartolomé Carranza," in *A Spanish Apostle of Reform: Bartolomé Carranza and the England of Mary Tudor*, ed. John Edwards and Ronald Truman (Aldershot, England: Ashgate, forthcoming). For reform as innovation, see Wolgast, "Reform, Reformation," 324–5.

48. John O'Malley, *Trent and All That: Renaming Catholicism in the Early Modern Era* (Cambridge: Harvard University Press, 2000), 17 for the ancient sense and Pastor, *Popes*, 135.

49. Barry Collett, *Italian Benedictine Scholars and the Reformation* (Oxford: Clarendon Press, 1985).

50. Mayer, *Pole*, 106 and 188–9, and Gigliola Fragnito, "Il cardinale Gregorio Cortese (1483?–1548) nella crisi religiosa del cinquecento," *Benedictina*, 30 and 31 (1983 and 1984), 129–69, 417–59, and 9–134.

51. Collett, *Italian Benedictines*, 25–7.

52. Pastor, *Popes*, 503.

53. Pastor, *Popes*, 511–13.

54. John O'Malley, *Giles of Viterbo on Church and Reform: A Study in Renaissance Thought* (Leiden: E. J. Brill, 1968).

55. Pastor, *Popes*, 533–41.

56. John O'Malley, *The First Jesuits* (Cambridge and London: Harvard University Press, 1993).

57. Mayer, *Pole*, 118–19.

58. Gleason, *Contarini*, 266–74.

59. Sylvia Ferino-Pagden, ed., *Vittoria Colonna Dichterin und Muse Michelangelos* (Vienna: Kunsthistorisches Museum and Skira, 1997), and Sergio M. Pagano and Concetta Ranieri, *Nuovi documenti su Vittoria Colonna e Reginald Pole*, vol. 24, Collectanea Archivi Vaticani (Vatican City: Archivio Vaticano, 1989).

60. Barry Collett, *A Long and Troubled Pilgrimage: The Correspondence of Marguerite d'Angoulême and Vittoria Colonna 1540–1545*, vol. 6, Studies in Reformed Theology and History, new series (Princeton: Princeton Theological Seminary, 2000), and Abigail Brundin, "Vittoria Colonna and the Poetry of Reform," *Italian Studies* 57 (2002): 61–74 and "Vittoria Colonna and the Virgin Mary," *Modern Language Review* 96 (2001): 61–81.

61. Emidio Campi, *Michelangelo e Vittoria Colonna: Un dialogo artistico – teologico ispirato da Bernardino Ochino* (Turin: Claudiana, 1994).

62. Alexander Nagel, "Gifts for Michelangelo and Vittoria Colonna," *Art Bulletin* 79 (1997): 647–68.

63. See especially Mayer, *Pole* and Thomas F. Mayer, *Cardinal Pole in European Context: A Via Media in the Reformation*, vol. 686, Variorum Collected Studies (Aldershot, England: Ashgate, 2000), passim.

64. For the term in contempoary usage, see Gigliola Fragnito, "Gli 'spirituali' e la fuga di Bernardino Ochino," *Rivista Storica Italiana*, 84 (1972): 777–811, esp. 780–81.

65. See the magisterial edition by Salvatore Caponetto, ed., *Il "beneficio di Cristo" con le versione del secolo XVI, documenti e testimonianze* (Florence, DeKalb, IL, and Chicago: Sansoni, Northern Illinois University Press, and The Newberry Library, 1972), and English translation in Gleason, ed., *Reform Thought*, 103–61, from which I quote. Page numbers in parentheses in the text.

66. One of the most important contributions is Carlo Ginzburg and Adriano Prosperi, *Giochi di pazienza. Un seminario sul "Beneficio di Cristo"* (Turin: Einaudi, 1975). This controversy is in part misguided because the use to which a set of ideas is put is much more interesting than where it came from, more or less the methodological position of Quentin Skinner. See T. F. Mayer, *Thomas Starkey and the Commonwealth: Humanist Politics and Religion in the Reign of Henry VIII* (Cambridge: Cambridge University Press, 1989), 9–10, for a summary of his views.

67. For the last, see Mayer, *Pole*, 121, and the summary of the debate, 120–25.

68. Alessandro Pastore, *Marcantonio Flaminio. Fortune e sfortune di un chierico nell'Italia del cinquecento* (Milan: Franco Angeli, 1981), 108–13.

69. Carlos Gilly, "Juan de Valdés: Übersetzer und Bearbeiter von Luthers Schriften in seinem Diálogo de doctrina," *Archiv für Reformationsgeschichte* (1983): 257–305. One of the best syntheses of Valdés's ideas is the intrduction to Massimo Firpo, ed., *Juan de Valdés, Alfabeto cristiano: Domande e risposte. Della predestinazione. Catechismo* (Turin: Einaudi, 1994). For Firpo's view of Valdés's impact in Italy, see especially his *Tra alumbrados e "spirituali." Studi su Juan de Valdés e il valdesianesimo nella crisi religiosa del '500 italiano* (Florence: Olschki, 1990) and the summary in "The Italian Reformation and Juan de Valdés," *Sixteenth Century Journal* 27 (1996): 353–64.

70. Caponetto, ed., *Beneficio*, 474; Mayer, *Pole*, 32–3 and cf. Mayer, *Starkey*, 191–4, for Jan van Kampen's development of the idea in Pole's and Contarini's circles.

71. Gleason, ed., *Reform Thought*, 207, n. 1.

72. Massimo Firpo, "Il 'Beneficio di Christo' e il concilio di Trento (1542–1546)," in Massimo Firpo, *Dal Sacco di Roma all'Inquisizione: Studi su Juan de Valdés e la Riforma italiana* (Alessandria: Edizioni dell'Orso, 1998), 119–46.

73. Collett, *Italian Benedictines*, 6–7, 72, 162, and 178.

74. Nagel, "Gifts," passim.

75. Caponetto, ed., *Beneficio*, 32.

76. See Campi, *Michelangelo e Colonna*, 28.

77. Campi is at work on a biography of Ochino. For Vermigli, see Philip McNair, *Peter Martyr in Italy: An Anatomy of Apostasy* (Oxford: Clarendon Press, 1967).

78. Pastor, *Popes*, 494; Ermanno Ferrero and Giuseppe Müller, eds., *Vittoria Colonna, Marchesa di Pescara, Carteggio* (Turin: Hermanno Loescher, 1892–9), 256, 257.

79. See Hall's the introduction to this volume.

80. P. Giacinto Bosco, "Intorno a un carteggio inedito di Ambrogio Catarino," *Memorie domenicane* 67 (1950): 103–20, 137–66, and 233–66.

81. For the Roman Inquisition, see the numerous studies of Firpo and Dario Marcatto, especially their monumental *Il processo inquisitoriale del Cardinal Giovanni Morone*, 6 vols. (Istituto Storico Italiano per l'Età Moderna e Contemporanea, 1981–95), together with John Tedeschi, *The Prosecution of Heresy: Collected Studies on the Inquisition in Early Modern Italy* (Binghamton, NY: Medieval and Renaissance Texts and Studies, 1991). See also Adriano Prosperi, *Tribunali della coscienza: Inquisitori, confessori, missionari*, vol. 214, Biblioteca di cultura storica (Turin: Einaudi, 1996).

82. For Modena, see Susanna Peyronel Rambaldi, *Speranze e crisi nel cinquecento modenese* (Milan: Franco Angeli, 1979): Massimo Firpo, *Inquisizione romana e controriforma. Studi sul Cardinal Giovanni Morone e il suo processo d'eresia* (Bologna: Il Mulino, 1992), chap. 1 and Susanna Peyronel Rambaldi, *Dai Paesi Bassi all'Italia: "Il Sommario della Sacra Scrittura." Un libro proibito nella società italiana del cinquecento* (Florence: Olschki, 1997), 217–52; for Lucca, Simonetta Adorni Braccesi, *"Una città infetta": La Repubblica di Lucca nella crisi religiosa del cinquecento* (Florence: Olschki, 1994); for the history of Italian heresy and Protestantism in general, see Salvatore Caponetto, *La riforma protestante nell'Italia del cinquecento* (Turin: Claudiana, 1992), translated by Anne C. Tedeschi and John Tedeschi as *The Protestant Reformation in Sixteenth-Century Italy*, ed. Raymond A. Mentzer, vol. 43, Sixteenth Century Essays & Studies (Kirksville, MO: Thomas Jefferson University Press, 1999); Massimo Firpo, *Riforma protestante ed eresie nell'Italia del cinquecento* (Bari: Laterza, 1993); and the briefer, older survey of Manfred Welti, *Breve storia della Riforma italiana*, trans. Armido Rizzi (Casale Monferrato: Marietti, 1985). The classic work remains Delio Cantimori, *Eretici italiani del cinquecento: Ricerche storiche* (1939; reprint, Florence: Sansoni, 1977). For Italian Anabaptism, see Aldo Stella, *Dall'anabattismo al socinianesimo nel cinquecento veneto: Ricerche storiche* (Padua: Liviana, 1967), and Aldo Stella, *Anabattismo e antitrinitarismo in Italia nel XVI secolo: Nuove ricerche storiche* (Padua: Liviana, 1969).

83. For the protracted negotiations in Mantua, see Sergio Pagano, ed., *Il processo di Endimio Calandra e l'Inquisizione a Mantova nel 1567–1568*, vol. 339, Studi e Testi (Vatican City: Biblioteca Apostolica Vaticana, 1991). For Venice, see Andrea

Del Col, *Domenico Scandella Known as Menocchio: His Trials before the Inquisition (1583–1599)*, trans. John Tedeschi and Anne C. Tedeschi, vol. 139, Medieval and Renaissance texts and studies (Tempe, AZ: Medieval and Renaissance Texts and Studies, 1997), xxvii–xlix.

84. This is my coinage designed to embrace all those from Carafa through Sadoleto and Contarini to Pole and Giovanni Morone who certainly in the 1530s and throughout most of the 1540s still shared more than divided them. See Mayer, *Pole*, esp. 8–9. There is a large earlier literature about how to label the phenomenon known as Italian Evangelism and its adherents. See Elisabeth G. Gleason, "On the Nature of Sixteenth Century Italian Evangelism: Scholarship, 1953–78," *Sixteenth Century Journal* 9 (1978): 3–25; A. J. Schutte, "The *Lettere volgari* and the Crisis of Evangelism in Italy," *Renaissance Quarterly* 28 (1975): 639–88; Alberto Aubert, "Valdesianesimo ed evangelismo italiano: alcuni studi recenti," *Rivista di Storia Della Chiesa in Italia* 41 (1987): 152–75; Susanna Peyronel Rambaldi, "Ancora sull'evangelismo italiano: categoria o invenzione storiografica?" *Società e storia* 5 (1982): 935–67; and the work of Paolo Simoncelli, esp. Paolo Simoncelli, *Evangelismo italiano del cinquecento: questione religiosa e nicodemismo politico* (Rome: Istituto Storico Italiano per l'Età Moderna e Contemporanea, 1979).

85. Much remains to be done on the Dominicans in the sixteenth century, important both because of their prominence as inquisitors and also because they always filled the post of master of the Sacred Palace or chief papal theologian. For a start see Salvatore I. Camporeale, "Giovanmaria dei Tolosani O. P.: 1530–1546. Umanesimo, Riforma e teologia controversista," *Memorie Domenicane*, n. s. 17 (1986): 145–252; Michael M. Tavuzzi, *Prierias: The Life and Works of Silvestro Mazzolini da Prierio* (Durham, NC: Duke University Press, 1997); and Guido dall'Olio, *Eretici e Inquisitori nella Bologna del cinquecento* (Bologna: Istituto per la Storia di Bologna, 1999), esp. for Leandro Alberti and Antonio Balducci.

86. Gigliola Fragnito, "Vittoria Colonna e l'inquisizione," *Benedictina* 37 (1990): 157–72, esp. 163–4, which corroborates Francisco de Hollanda's use of Catarino's lectures to frame his dialogues. Charles Holroyd, *Michael Angelo Buonarroti . . . with translations of the life of the master by his scholar, Ascanio Condivi* (London: Duckworth, 1903), 270–3, 275, 289, 306. For discussion of the work's authenticity, see Alexander Nagel, *Michelangelo and the Reform of Art* (Cambridge: Cambridge University Press, 2000), 278 n. 13.

87. Catarino's *Compendio d'errori e inganni luterani* (1544) is edited in Caponetto, ed., *Beneficio*, 343–422, and see Mayer, *Pole*, 122, for commentary.

88. Giuseppe Alberigo, "Dinamiche religiose del cinquecento italiano tra riforma, riforma cattolica, controriforma," *Cristianesimo nella Storia* 6 (1985): 543–60, esp. 559. For confirmation, see Gigliola Fragnito, *La Bibbia al rogo: la censura ecclesiastica e i volgarizzamenti della Scrittura (1471–1605)* (Bologna: Il Mulino, 1997).

89. For a similar argument, see William V. Hudon, "Religion and Society in Early Modern Italy – Old Questions, New Insights," *American Historical Review* 101 (1996): 783–804, and William V. Hudon, *Marcello Cervini and Ecclesiastical Government in Tridentine Italy* (DeKalb: Northern Illinois University Press, 1992), esp. the conclusion.

MICHELANGELO'S *LAST JUDGMENT* AS RESURRECTION OF THE BODY: THE HIDDEN CLUE

Many scholars today have accepted the interpretation of the *Last Judgment* as representing the resurrection of the body, and the identification of the principal text on which it is based as 1 Corinthians 15.[1,2] Several clues from the sixteenth-century sources reinforce this identification of the subject. The earliest reference to the commission is a letter dated 2 March 1534 in which the Mantuan agent, Nino Sernini, reports that Pope Clement has commissioned Michelangelo to paint a "Resurretione" on the Sistine altar wall. Some earlier scholars took this to mean a Resurrection of Christ and inferred that the subject was subsequently changed, but it is surely shorthand for the Universal Resurrection.[3]

The use made of the Pauline text by Michelangelo's contemporaries indicates that it was regarded then as the principal description of the events of the final day. As discussed in the Introduction, to this volume in 1564, Giovanni Gilio published his dialogue on the *Errors and Abuses of the Painters*, in which he centered his criticisms of painting on Michelangelo and his *Last Judgment*. Although it was his purpose to point out how Michelangelo had erred, Gilio evidently did not consider the choice of text an error. To explain the theology of the subject and what a representation of the Last Judgment should contain, he depended on Paul's First Letter to the Corinthians. His dialogue makes it sound as if the sixteenth-century reader needed enlightenment – as much as does the modern viewer of Michelangelo's fresco – when it came to the doctrine of the Final Resurrection. When one of the interlocutors remarks that he has heard theologians say that souls

do not occupy space, another, who is the theologian in the dialogue, replies: "But we are not talking just about souls but about souls and bodies, and although the bodies will be glorified, they will nonetheless certainly occupy space."[4] What the commentator and Michelangelo wished to convey is that the glorified body is still a body, but it is a more congruent container for the soul than the mortal body could be.

In fact the nature of our final state had been the subject of heated debate in theological and papal circles in the years prior to Clement's commission.[5] The question of whether there was such a thing as a personal life after death had been moot until shortly before Michelangelo's commission. The two Medici popes, Leo and Clement, had put their effort and their authority behind the endorsement made by the Fifth Lateran Council in 1513 of the doctrine of personal immortality.[6]

The controversy surrounding this question had come to a boil in the late fifteenth century. In the twelfth century the philosopher Averroes had proclaimed (on the authority of Aristotle) the mortality of individual souls. That is to say, there is no individual or bodily life after death. Averroes posited instead a kind of collective immortality, persons being immortal insofar as they participate in the transcendental intellect, an entity that is spiritual and immaterial, as well as immortal. It was from Florentine humanism that the refuter of Averroes arose, in the person of Marsilio Ficino. His book, published in Florence in 1482, grounded personal immortality in the humanist tenets of the dignity of humankind, our central position in the cosmos, and our desire to be like God.[7]

The leading theologian to address this issue in the sixteenth century, who would play a major role in this controversy for the next thirty years, was Tommaso de Vio, known as Cajetan, from Gaeta, where he was born in 1469. He presented to Pope Julius II a disputation on the subject in 1503. Even after the Lateran Council supported the doctrine of individual life after death, controversy continued to rage, and treatise after treatise was produced, either in support of Aristotle or opposing him. Cajetan entered the battle again and pronounced that, although the doctrine could not be proven by reason, it must be accepted as an article of faith based on scripture.

This may have taken care of the issue raised by Averroes of collective versus personal immortality, but there remained the problem

that "immortality of the soul" is a formulation of Greek philosophy, and in those terms it has no biblical base. The scriptural description is of the "resurrection of the body," which is referred to in several passages, but explained only by Paul in his Letter to the Corinthians.[8] Paul recognized that the first-century citizens of Corinth preferred their Greek conception of the immortal soul to the untidy Christian concept of bodily resurrection, so he addressed the questions of *how* the resurrection would take place and *what* would be resurrected. Paul said, "But some one will ask: 'How are the dead raised? With what kind of body do they come?' " (1 Cor. 15:35). He therefore undertook to explain how it would be possible for the dead to be raised at the time of the Second Coming of Christ. The essence of Paul's message lies in his distinction between the physical body, which must die, and the new spiritual body that will be issued to each of us when the trumpets sound. "Now if Christ is preached to you as raised from the dead, how can you say there is no resurrection of the dead? But if there is no resurrection of the dead then Christ has not been raised . . . and your faith is in vain" (1 Cor. 15:42ff.).

Cajetan was a major theologian of his day, and I believe he made a critical contribution to the iconography of Michelangelo's fresco. Pope Leo X made him cardinal in 1517. He died in the same year as Pope Clement, in 1534. Many of his contemporaries, it is said, believed that if he had lived he would have succeeded Clement as the next pope. Leo Steinberg has referred to him as "house theologian" to both Medici popes.[9] Among Cajetan's last writings are his commentaries on the Epistles of Paul, published in Venice in 1531 with a dedication to Pope Clement.[10] There is thus no doubt whatever that Cardinal Cajetan's writings were known and read in the papal inner circle. Within a couple of years of this publication, Clement would open discussion with Michelangelo on the subject of the *Last Judgment* commission.

In his commentary on Paul's Letter to the Corinthians, Cajetan lays particular stress on the spiritual, or glorified, or celestial, body. Commenting on the passage where Paul says, "What is sown is perishable, what is raised is imperishable. It is sown in dishonor, it is raised in glory. It is sown a physical body, it is raised a spiritual body" (1 Cor. 15:44), Cajetan wrote, "He [Paul] did not say it will be raised spiritual, but it will be raised a spiritual body" (*non dicit resurgit spirituali sed resurgit corpus spiritualis*). Reading between the lines, we can hear

in this insistence, as in the later dialogue of Gilio, a polemical concern to correct misapprehension or confusion.

Collaborating evidence that the spiritual body was in the mind of Clement and his contemporaries can be seen in this drawing by Baccio Bandinelli for Clement's tomb[11] – never executed but designed simultaneously with the commission for the *Last Judgment* (Fig. 24). Bandinelli's sculpted wall tomb shows Clement stretched on his bier at the bottom. The focus, however, is not placed here but on the middle zone, where, ascending from the dead, Clement is show as a splendid naked youth who, according to Chastel, resembles Michelangelo's *David*.[12] This is so because both Michelangelo's statue and Bandinelli's drawn nude embody the Renaissance ideal of the male figure. What Bandinelli has represented is Pope Clement's spiritual body being raised to the company of Christ, the Virgin, and the Apostles in the lunette at the top. How better to represent the celestial body than as an idealized youthful nude?

Paul in his Letter said, "Just as we have borne the image of the man of dust [that is, Adam] we shall also bear the image of the man of heaven" (v. 49). Cajetan comments, "Our body in the resurrection is compared without hyperbole to a celestial body."

It was indeed fortunate for Michelangelo that what he was required to paint was bodies, and not transparent, incorporeal souls. And it was fortunate for the pope that he had available the greatest painter of the human body of the time, possibly of all time. One can imagine Michelangelo pondering the problem of how to represent Hell. In an age of naturalism, and in an image where the wages of sin were intended to be taken seriously, this was no small problem. Blue-bottomed devils were more apt to call forth a titter than to inspire dread in the sophisticated viewer of Renaissance Rome. The grotesque physical tortures of the medieval Hell could too easily become humorous caricature. Were the sinners resurrected, too? If so, how were they different in appearance from the Elect? How was the painter to distinguish the Damned from the Elect? What would characterize the appearance of those who have earned their place in heaven (Fig. 7)?

Although Paul did not address himself to these questions, Cajetan did. Like the Elect, he said, the Reprobate will change from perishable to imperishable, but unlike them, the Reprobate will not become glorified or insensitive to pain. "The bodies of the Damned will be

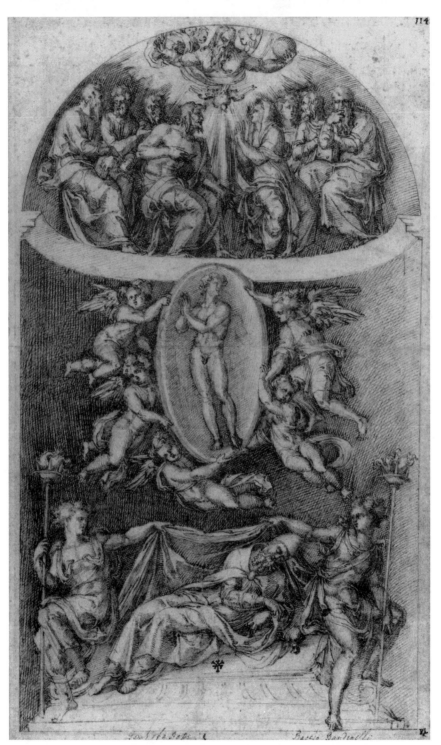

FIGURE 24. Baccio Bandinelli, design for the tomb of Clement VII, ink. Museum of Art, Rhode Island School of Design, Museum Works of Art Fund (Photo: Erik Gould).

imperishable with no use [need] of sex or food or body fluids, but they will not be glorified and insensitive to pain." This remark must have been of great help to Michelangelo. On the basis of it he could represent the Damned in as thoroughly corporeal a form as the Elect. But whereas the Elect are idealized, the Damned are ugly (Fig. 19); whereas the Elect have recovered from their physical suffering and have passed beyond it (Fig. 13), the Damned are tormented and anguished (Fig. 18).

Michelangelo set out, then, to create a race of human beings who were perfected. He must present them nude, as Signorelli had already done (Fig. 12). He surely was aware from the start that a wall measuring forty-six by forty-three feet covered with naked figures would seem, at least to some of the more conservative viewers, to be reveling in sensuality. Signorelli's dry, anatomical style had precluded this difficulty. Michelangelo needed to replace his existing figural paradigm with a new figure type, more muscled, less graceful, less sensuous, but no less ideal. Its purpose was not to demonstrate elegance, grace, sensuality, as in the prevailing aesthetic of *maniera*, but rather to embody force and energy, which had always been Michelangelo's model of ideality anyway. While painters like Parmigianino and Perino del Vaga and Salviati modeled their styles on Raphael's, Michelangelo turned to antiquity, and not to the graceful Praxitelean style or to the *Apollo Belvedere*, but to the hellenistic, Lysippean model. The *Laocoön* and the *Torso Belvedere* were his inspiration.[13]

Michelangelo insisted on corporeality in ways that make his *Judgment* altogether different from its predecessors. In earlier *Last Judgments* the Elect often appear to rise and float weightlessly on their way to eternal bliss. Michelangelo's figures are hauled up by angels and given a helping hand by other Elect (Fig. 2, at the left). Their weighty bodies are sometimes contested by competing demons and angels, and we are not allowed to think of the contest as a metaphorical struggle for the soul. Particularly in the zone of the resurrecting dead in the lower left, the pull of gravity makes itself felt on these shrouded figures who struggle to shed their mortal bodies and rise out of their graves (see Fig. 8).[14]

Michelangelo's love affair with the human body made him the painter who could discover the visual means to represent the mass of humankind assembled on the Final Day, each in idealized form, and

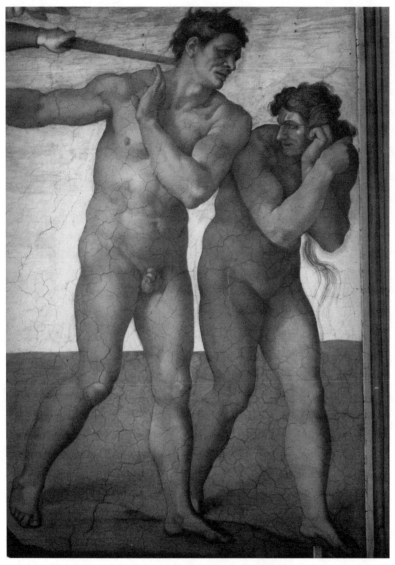

FIGURE 25. The Expulsion of Adam and Eve, Sistine vault (Photo: Vatican Museums).

imbue every one with individuality. That, in fact, was one of the things that most impressed his contemporaries.[15] Nevertheless, Michelangelo must have been sorely taxed to find enough varied poses for so many figures. Few drawings of individual figures have survived. We are told by Giovanni Battista Armenini, whose how-to book of advice to artists

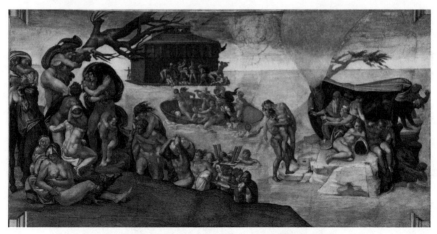

FIGURE 26. The Deluge, Sistine vault (Photo: Vatican Museums).

was published in 1586, that Michelangelo had used a different, more efficient method than drawing from the model. He made some wax figurines, which he would immerse in hot water and then twist the limbs of the soft wax to find the pose he wanted.[16] In this way he could bypass the time-consuming procedure of drawing from a live model in the studio. His profound knowledge of human anatomy permitted him to paint the musculature without referring to a model.

He solved the problem of representing the Reprobate in a theologically correct manner that would have satisfied Cajetan. He turned to his own models on the vault, in those three instances where he had been called on to depict the Fallen or the condemned. In the *Expulsion of Adam and Eve* (Fig. 25), we see figures startlingly different in appearance from the couple under the tree in Eden on the other side of the fresco. Michelangelo represented their fallen state by depriving them of the grace they previously had, making a quite literal equation of physical grace and divine grace. In the Eve of the *Expulsion* we see a woman who has become gawky, lumpish, and clumsy, without the lovely *contrapposto* and serpentine pose in which she was seen in Eden. Adam too has become blocklike and stocky. In the *Deluge* (Fig. 26), those who are condemned to drown in the rising waters contend brutally with one another for the high ground or the boat: one man beats another with an oar to prevent him from boarding. In the group at the left, the vulgar urgency of the struggle to survive has

FIGURE 27. The Brazen Serpent, corner pendentive, Sistine vault (Photo: Vatican Museums).

deprived men and women of both elegance and grace. In the *Brazen Serpent* (Fig. 27) the painter had designed a composition like a *Last Judgment*, with the saved on our left and the condemned on our right. Among those figures of the Damned are faces that are strikingly similar to his Damned in the *Last Judgment*, as if he returned to them as models thirty years later.

The Damned on the Final Day have bodies as palpable as those of the Elect, the difference is in their expressions of agony, both physical and mental. As Cajetan's commentary suggested, Michelangelo rendered the spiritual body of the Damned not deformed but registering the effects of pain. Prodded by Charon, dragged down by demons, his Damned have strapping bodies that become ironically powerless, weighty encumbrances to their reluctant obedience (Fig. 17). What distinguishes, say, Saint Peter (Fig. 15) from the *Anguished Reprobate* directly below him (Fig. 18), is not his body per se. The difference

is told in body language: Peter strides energetically forward, thrusting his keys, the *Reprobate* huddles into himself, pitched forward, knees pulled together, arms across his chest and covering his face, passively submitting to the demons who haul him down, the embodiment of self-rejecting shame. His mental torment is written on his face in his contracted brow, shadowed eye, open mouth. Gravity has entered every sinew of his body, pulling him inexorably down. What makes him so painful to contemplate is that he is not different in kind from the Elect. The demons are deformed, even grotesque, to be sure, but the damned are not. Unlike the damned of earlier *Judgments*, Michelangelo's have not lost their humanity.

In the context of the sixteenth-century debate over the issue of personal immortality and the nature of the apocalypse, Gilio felt the need to clarify the doctrine of our final resurrection for his reader, as we have seen. Michelangelo may have felt the same need, for I believe he inserted a clue to the text to guide the worshiper to the correct understanding of the event as he depicted it. Prominently placed just below Christ are the paired martyrs, Lawrence with the gridiron on which he was burned and Bartholomew displaying the knife with which he was flayed and in the other hand, his skin (Figs. 7 and 28). The traditional explanation in the literature for their prominence was that their feast days figured in the dedication of the chapel. The first mass to be celebrated in the chapel was on the vigil of Saint Lawrence's day, 8 August 1483, which was also the anniversary of the election of Pope Sixtus IV, who built the chapel. On Saint Bartholomew's feast, August 24, Sixtus celebrated his own first mass in the chapel. These two dates, it is further pointed out, frame the August 15 feast of the Virgin's Assumption to which the Sistine chapel was dedicated.[17] Yet as pointed out by Bernardine Barnes, the feast of Saint Bartholomew was not celebrated by special papal ceremonies in subsequent years, as one would have expected.[18]

Barnes, evidently finding this explanation unsatisfactory, sought to account for the conspicuous presence of these two saints by patron preference. She pointed out that Lawrence was dear to the Medici and therefore might have been the choice of Clement. She was able to adduce no comparable papal link for Bartholomew, however, even by extending the search to include Pope Paul.[19] With Barnes's discovery of copies of Michelangelo's *modello* for the fresco, it is now finally possible

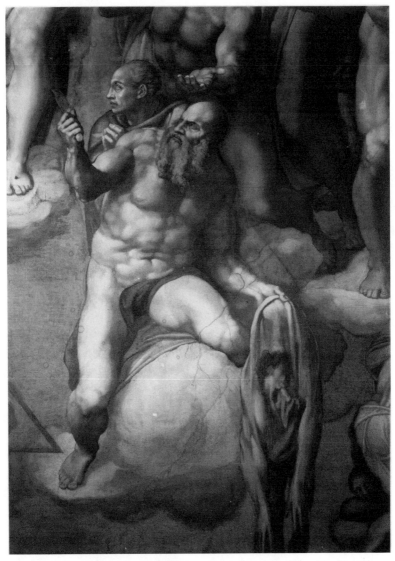

FIGURE 28. Detail from the *Last Judgment*, Bartholomew holding his skin (Photo: Vatican Museums).

to discard this altogether recherché explanation and to recognize that the placement of these two saints must have been the artist's choice.

Neither Lawrence nor Bartholomew appears in the earliest compositional sketches (Figs. 4, 5). We find Lawrence in what will become

Bartholomew's place in the New York and London (Fig. 6) copies of the *modello*. The skin with the face was painted without the aid of cartoons.[20] His late inclusion strongly suggests that Michelangelo conceived him as a pendant to Lawrence, almost as an afterthought, for more pressing reasons than to commemorate feast days. The bond between Lawrence and Bartholomew is that in the martyrdoms they suffered, each lost his flesh; their mortal bodies were destroyed. The restoration of their bodies, so conspicuously displayed, broadcasts the message of the fresco: the resurrection of the body.[21] In fact, each of the rather strange company of saints selected to be identified by their attributes suffered mutilation (see Figs. 7, 14). Saint Simon the Zealot was sawn in half longitudinally. Saint Andrew was crucified. The skin of Saint Blaise was abraded with curry combs. Saint Catherine was torn apart on a spiked wheel. Saint Sebastian was shot full of arrows. No one has adduced a persuasive argument for why these particular saints were chosen. Although they are not the only martyrs whose bodies were maimed, they certainly have that in common, as do Saint Lawrence and Saint Bartholomew.

Bartholomew (Fig. 28) had the added attraction to the Renaissance artist and viewer that he suffered the same fate as a character in antique myth. Marsyas, who had challenged the great god of music, Apollo, to a musical contest, was flayed for his hubris. When Michelangelo chose to represent Bartholomew in the pose of the *Torso Belvedere* and set him in proximity to his Christ who resembled the *Apollo Belvedere*, the learned Renaissance viewer would be unlikely to miss the allusion. The Marsyas story was particularly familiar. Besides numerous other versions, Raphael's rendition could be admired on the ceiling of the nearby Stanza della Segnatura in the papal apartments.[22] Opposing meanings adhere to the complementary references: whereas Bartholomew's flaying could earn him eternal reward, Marsyas's flaying was punishment for his arrogance. There was no conflict but, on the contrary, added richness provided by the pagan reference because it was understood that the pagans anticipated in imperfect form the truths of Christianity.

A yet more subtle symbolism is concealed here as well. Bartholomew is represented as a robust, gray-bearded man with a bald pate, but the head on the skin is clean shaven and covered with tousled dark hair. It was not until 1925 that the mask on the skin was identified as bearing the features of the artist.[23]

One finds portraits of patrons in religious images throughout the Renaissance. Artists' self-portraits are less common, and the examples that come to mind are in fresco cycles within chapels or oratories, rather than in altarpieces.[24] When painters did include their own likeness in altarpieces, it was usually half concealed at the edge. An example from mid-cinquecento Rome is Vasari's altarpiece for Pope Julius III in his chapel in San Pietro in Montorio, where the painter's head can be seen at the left edge among the witnesses to the *Conversion of St. Paul.* Michelangelo's self-portrait poses the issue of the painter's license. We have little solid evidence on which to make judgments about how much freedom the Renaissance artist was allowed and how it may have changed over time, from patron to patron, from artist to artist, or over an artist's lifetime.[25] We know, for example, that for his *Last Judgment* in 1498 Fra Bartolomeo was given a list of the saints he was expected to include.[26] We do not know whether Michelangelo was given such a list. The late inclusion of Bartholomew indicates that he was not prevented from making additions. Michelangelo wrote a letter in 1523 claiming an unheard of degree of license granted him by Julius II in designing the vault of the Sistine Chapel. According to Michelangelo's retelling, when the artist remarked to the pope that the plan to paint the twelve apostles and the usual ornaments would be a poor thing, the pope "gave me a new commission to do what I liked" and so the plan as executed came into being.[27] One wonders whether the artist was intentionally dissembling – the pope, long dead, could not contradict him, after all. It is certainly relevant, as Edgar Wind pointed out, that Michelangelo was threatened with a lawsuit by the heirs of Julius over the unfinished tomb. It was in his interest to show that he had executed much more than he had been contracted or paid for on the ceiling.[28]

One suspects that Vasari exaggerated artists' license as part of his agenda to demonstrate the rising status of the artist from craftsman to intellectual. The anecdote he told about Michelangelo taking revenge on the papal master of ceremonies, Biagio da Cesena, by representing him as Minos lends credence to other portraits some critics would like to see in the fresco. It is the perfect anecdote, at once impossible to prove or disprove, and memorable.

Bartholomew has been identified as Pietro Aretino on the basis of a supposed resemblance between him and Titian's portraits of Aretino.[29] Aretino had publicly denounced the *Last Judgment* as lascivious in

a sanctimonious letter he made public, condemning the indecency of nudes "in the most sacred chapel upon the earth." Scholars have generally overlooked how unlikely it would be for Michelangelo to elevate his powerful critic to sainthood and place him among the Elect, especially for remarks he would make four years after the fresco was unveiled.[30]

It is this self-portrait, almost universally accepted, that has most interested the modern viewer. It invites psychoanalytic delving into the artist's mind.[31] Some see it as a complaint, in a vein similar to Michelangelo's famous poem lamenting the physical suffering he had endured since he had spent the better part of four years standing on the scaffolding and reaching over his head to paint the Sistine vault: "I've already grown a goiter...Which sticks my stomach by force beneath my chin. With my beard toward heaven, I feel my memory-box atop my hump...My loins have entered my belly...In front of me my hide is stretching out and, to wrinkle up behind, it forms a knot."[32]

Others have interpreted it as an expression of Michelangelo's guilt over his homosexual feelings toward Tommaso Cavalieri and his sublimated filial rage toward his abandoning parents.[33]

Posèq has identified Bartholomew as a portrait of Pope Paul III. Inclusion of patron portraits in paintings, and even altarpieces, is less unusual than inclusion of artist's self-portraits. The patron as donor making an offering of the image for the sake of his salvation is a tradition as old as Christian images themselves. The resemblance to Pope Paul, whose features we know through portraits, especially those by Titian, can be acknowledged, if we allow for a degree of rejuvenation to bring the pope to a state of vigor that would pass for a glorified body. The less plausible aspect of the identification lies in the relationship it suggests between the patron and his artist. What kind of message would the artist be sending his patron, and is this fresco an appropriate place for it?

For an interpretation of the self-portrait to be convincing there are several requirements. It must enhance the theme of the fresco, or at least not contradict it. In terms of sixteenth-century decorum it would be unforgivably egotistical of the artist to insert himself so prominently unless the message was not only consonant with the religious content, but also enhancing to it. Furthermore, it must be in character with the Michelangelo we know in these years, a pious

and deeply devout, thinking Christian. We must grant Michelangelo enough self-awareness to have perceived the irony of repeating Marsyas's transgression of arrogance.

The most convincing interpretation of the self-portrait would be one in which the identification of it as a self-portrait is not essential to the meaning of fresco, but its inclusion nevertheless serves the theme of the fresco. The interpretation I propose meets these conditions. If Michelangelo wanted to provide a clue to the fresco as a resurrection of the body, what better way than to contrast a discarded mortal body with a glorified spiritual body? What is important for the viewer to recognize is the mismatch between Bartholomew's head and the face on the skin. This is precisely what was noticed by Don Miniato Pitti in his letter to Vasari written half a year after the fresco had been unveiled (although he also missed the point): "There are a thousand heresies here, and above all in the beardless skin of Bartholomew, while the [figure that is not flayed] has a long beard, which shows that the skin is not his, etc."[34] Don Miniato did not understand Michelangelo's clue and missed the point, but he noted the mismatch, and not the self-portrait, so there was no harm done. Whether or not it is Michelangelo's face is immaterial to anyone but the artist himself, for whom it would have served as a petition, a prayer. As Wilde remarked many years ago, "Perhaps it is not far wrong to see in this portrait an act of religious self-humiliation."[35]

The portrait of the artist is offered as a supplication from one whose mortal body gave him much pain. That sufferer, now in his sixties, expresses in the figure of Bartholomew his hope that he will be issued a glorified body for the resurrection and that he will be permitted to discard the one he now has. The skin is held precariously directly on the diagonal that descends to Minos, the Lord of Hell. The hope for salvation and the dread of damnation are expressed in this one gesture. As Saint Augustine had so succinctly remarked about the message of the thieves who were crucified with Christ: "Take heart, one of the thieves was saved. Beware, one of the thieves was damned."

NOTES

1. The essence of this essay was first presented in a paper at the CAA in March 1997 and in expanded form in lectures at Dickinson College and Lafayette College in 1999. The outline was included in my discussion of the Last Judgment in *After Raphael*.

2. I identified the principal text and the subject of the fresco in Hall, 1976. O'Malley (in *The Sistine Chapel*, 1986), Joannides (1996), and Partridge (1997), among others, have endorsed the interpretation. Earlier scholars did not single out the Pauline text: of the nine De Tolnay cited, the letter to the Corinthians was not included; V, 33. Thode (*Michelangelo: Kritische Untersuchen*, Berlin, 1908–12) cites all the possible relevant biblical passages, fifty from the Old Testament and seventy-four from the New Testament; Justi (*Michelangelo, Neue Beiträge zur Erklärung seiner Werke*, Berlin, 1909) cites only the Book of Revelation.

3. See Hall 1976, 85. Joannides (1996) confirms this reading of the letter, and Barnes (1998, 29) points out that the Casa Buonarroti sketch (Fig. 4) gives evidence for this interpretation. Hartt (1971) connects a group of drawings from the early 1530s with the supposed commission for a Resurrection of Christ.

4. The discussion of the theology of the Last Judgment begins on p. 60 of Gilio's treatise; see also 66.

5. On the Renaissance debate on the immortality of the soul see, Giovanni Di Napoli (1963).

6. The text of the bull *Apostolici regiminis*, promulgated on 19 December 1513 affirming the immortality of the soul, can be found in Di Napoli (1963), 220–1.

7. Ficino dedicated chap. 15 of his *Theologica platonica de immortalitate animorum* to his refutation of Averroes. *Platonic Theology*, eds. James Hawkins with William Bowen, 3 vols. Cambridge, MA, Harvard University Press, 2001–3. See Victoria Goldberg (1975/1976), 21.

8. Art historians frequently refer to a representation of the "immortality of the soul," which is unrepresentable, when they should say "resurrection of the body."

9. Steinberg (1980), 252.

10. The documentation cited here comes from Tommaso de Vio's (Tommaso Caejano) commentary on the Epistles of Saint Paul: *Epistolae Pauli et aliorum apostolorum ad graecam veritatem castigatae . . .* , Venice, 1531 (BAV R.I.II.712), esp. 69v, 70r.

11. On Baccio Bandinelli's design for Pope Clement's tomb, see Chastel (1983), 227ff and bibliography, 287, n. 31.

12. Chastel (1983), 228.

13. Joannides (1996, 168) characterizes Michelangelo's new figure type: "He produced a type – thick-waisted, rubber-muscled, a pulsating mass of gristle – of overwhelming power and energy but lacking in any of those delicacies of internal articulation that make for sensual interest."

14. Partridge (1997) points out the force of gravity in the resurrecting dead, 58.

15. Joannides (1996) reproduces a sampling of the kind of figure studies that were made after Michelangelo's *Last Judgment*. Probably in part because it was more accessible, there was much more copying of figures from the *Last Judgment* than from the vault.

16. Armenini discusses Michelangelo's practice of making wax models in bk 2, chap. 5 of his treatise.

17. De Tolnay (1960), 114, citing Pastor, Steinmann, and Wind (1944), 223, n. 32.

18. Barnes (1998), 106, n. 13.

19. Ibid., 56.

20. Ibid., 106.

21. Partridge (1997, 143) puts it eloquently: "Their deaths reinforced the belief that, despite one's physical mutilation or dismemberment, the resurrected soul would be newly enfleshed with the imprint of the individual's physical body intact."

22. Edith Wyss (*The Myth of Apollo and Marsyas in the Art of the Italian Renaissance: An Inquiry into the Meaning of Images* [Newark: University of Delaware Press, 1996], 155), lists at least 104 images made between 1460 and 1575.

23. La Cava (1925). The literature discussing the mismatch between Bartholomew's head and the features on his skin is presented in a footnote by Bernardine Ann Barnes, (1995), 68, n. 21. She notes that in the engraving by Nicholas Beatrizet of 1562, Michelangelo's name is inscribed just below the figure as if it were an identifying label. Leo Steinberg ("The Line of Fate in Michelangelo's Painting," 1980, 411–54), discussed the self-portrait and its neglect in the literature since the fresco was first seen. His observation that the head on Bartholomew's skin is intersected by the diagonal that connects the upper and lower corners of the fresco (433) can be adduced as further evidence that Michelangelo inserted it as a crucial key to the theology of the fresco's iconography, though Steinberg attributes different significance to its placement.

24. There appear to be self-portraits in several of the frescoes in the Oratory of San Giovanni Decollato, Rome. Four artists' heads, including the painter, are crowded into Bronzino's *Martyrdom of Saint Lawrence* (San Lorenzo, Florence) at the left edge. Woods-Marsden (*Renaissance Self-Portraiture* [New Haven: Yale University Press, 1998], 57–61) discusses two quattrocento instances of interest. First, Fra Filippo Lippi's likeness in the *Dormition of the Virgin* fresco on the altar wall in the Duomo at Spoleto, a portrait that was probably posthumously executed by Fra Diamante immediately following Lippi's death in 1469, suggests a petition for merciful intercession addressed to the Virgin. Second, Domenico Ghirlandaio's self-fashioning is bolder and less devout in his fresco of the *Expulsion of Joachim from the Temple* at Santa Maria Novella; however, it is not on the altar but is part of the cycle behind the originally double-faced altarpiece in the choir chapel and is therefore less conspicuous.

25. The view that the patron determines the work that needs to be done and controls its subject matter, while the artist controls its actual elaboration, has been enunciated by Salvatore Settis, "Artisti e commitenti fra quattrocento e cinquecento," *Storia d'Italia, Annali 4. Intellectuali e potere* (Turin, Einard, 1981), 701–61.

26. De Tolnay, V, 109. He cites *Rivista d'Arte* (vi [1909]: 62ff) and von der Gabelentz (*Fra Batholommeo*, vol. I, 137ff). The Frate was required to include the twelve apostles, hierarchies of angels, the Virgin, the prophets Elias and Enoch, and the Archangel Michael.

27. Ramsden, letter no. 157, to Giovan Francesco Fantucci in Rome.

28. Wind, 1958, 223, n. 33.

29. De Tolnay (V, 114), citing earlier literature.

30. Posèq makes a similar observation, 8. See Melinda Schlitt in this volume for discussion of Aretino and his letters.

31. Posèq (1994) has reviewed the interpretations and added his own.

32. Michelangelo's sonnet, "I' ho già fatto un gozzo in questo stento," is no. 5 in Saslow's translation, *The Poetry of Michelangelo* (New Haven: Yale University Press, 1991), 70.

33. Robert S. Liebert, *Michelangelo: A Psychological Study of his Life and Images*, New Haven: Yale University Press, 1983, 343–59. Liebert cited earlier psychoanalytic investigation of Michelangelo's personality by Richard and Edith Sterba.

34. For this letter dated 1 May 1545, see Vasari III (ed. Paola Barocchi), 1260.

35. Johannes Wilde, *Michelangelo, Six Lectures*. (Oxford: Oxford University Press, 1978), 165.

PAINTING, CRITICISM, AND MICHELANGELO'S *LAST JUDGMENT* IN THE AGE OF THE COUNTER-REFORMATION

Upon seeing Michelangelo's completed *Last Judgment* for the first time, Pope Paul III is said to have fallen to his knees before the fresco, crying out "Lord, charge me not with my sins when Thou shalt come on the Day of Judgment."[1] However spurious this well-known comment may be, it has become part of the complex, revealing, and often impassioned history of critical responses to the *Last Judgment* that have continued to the present day.[2] Although resonating with the character of a dramatic anecdote, Paul III's spontaneous response nonetheless underscored a recognition of the conceptual power and pictorial effect of the painting and Michelangelo's art, qualities that undoubtedly, and perhaps inevitably, saved the work from being torn from the wall despite strong curial pressure throughout the sixteenth century to have it replaced. Ironically, it was those very same qualities of artistic invention and pictorial effect that were exploited by critics for political gain and ideological control during one of the most tumultuous and significant periods of reform in Western religion and culture.

The larger and more problematic issue in attempting to sort out and contextualize the abundance of sixteenth-century critical sources about the *Last Judgment* is style – both as it pertained to artistic identity and cultural definition. (I am not referring here to the art-historical problematics of formalism, but rather to the idea of style as it was understood in relation to invention and genre.) No painting in the history of the Renaissance was critiqued so assiduously or broadly about its decorum, religious significance, visual expression, or genre. How we

situate the achievement and effects of the *Last Judgment*, historically and critically, has much bearing on how we define stylistic categories in sixteenth-century painting. In its expression, invention, and effect, the *Last Judgment* lies at the heart of the question of mannerism, Vasari's defintion of *disegno* and the *bella maniera*, and Counter-Reformation shifts in culture and ideology.[3]

In the decade during which the *Last Judgment* was completed and unveiled, theoretical principles were articulated and a pictorial language was formulated that would come to define the characteristic qualities of the so-called "second maniera" in Tuscan-Roman painting. In 1547, Benedetto Varchi, the brilliant and politically astute Florentine intellectual, delivered his famous *Due lezzione* in the Florentine literary academy (Accademia Fiorentina) on the relative nobility of the arts. He presented, in addition to a discussion of Michelangelo's art and now-famous poem "non ha l'ottimo artista," the philosophical principles of *disegno* that provided Giorgio Vasari with the theoretical foundation for his more expansive and influential definition of *disegno* in *Le vite de' più eccelenti pittori scultori ed architettori*, a project also begun during these years.[4] Michelangelo's *Medici Chapel* in Florence was also officially opened in 1546, and Bronzino, Salviati, Pontormo, and later, Vasari himself conceived pictorial styles under the aegis of Duke Cosimo I de' Medici that helped establish the visual presence of a ruling court in Florence for the first time in the city's history.

In Rome, epic history painting in the courts represented a style that has been identified specifically, and convincingly, with papal patronage of the period of Paul III and his nephews, the most significant examples of which are Perino del Vaga's and Pellegrino Tibaldi's frescoes in the *Sala del Consiglio* in the Castel Sant'Angelo (1545–9), Vasari's *Sala dei Cento Giorni* in the Cancelleria (1546), the beginnings of the decoration in the *Sala Regia* in the Vatican (1542), Francesco Salviati's later frescoes in the *Sala dei Fasti Farnesiani* in the Palazzo Farnese (begun 1550s), and Michelangelo's *Last Judgment* itself.[5] By the early 1540s, Pope Paul III – a pivotal figure both as patron and pontiff – had already initiated the first institutional gestures of Catholic reform, establishing a meeting at Mantua, which was soon to be followed by the more successful councils at Trent, and the important but failed Colloquy at Ratisbon, and seeing the reestablishment of the Roman

Inquisition in 1542 under the conservative Cardinal Carafa (later to become the authoritarian Pope Paul IV).

In thinking about the *Last Judgment* as part of a consideration of style and criticism during the 1540s and years of the Counter-Reformation in the following two decades, we might ask how this painting and Michelangelo stand at the fulcrum of a cultural shift in which stylistic paradigms were used to support ideological and political agendas that were often contrary to artistic ideals and motivation.

In his *Life* of Michelangelo from the second edition of the *Lives* (1568), Vasari described Michelangelo's *Last Judgment* as the exemplar of painting in the "grand manner," the perfection of *disegno*, and the complete expression of all the emotions that humanity could experience, seeing that the artist had "observed every decorum in the expressions, attitudes, and in every other natural detail he represented." With this work, Vasari claimed that Michelangelo had surpassed even his own stupendous achievement on the vault of the Sistine Chapel, having rendered figures in the *Last Judgment* that "equally stir the hearts of those who know nothing about painting as those who understand."[6] Four years earlier in 1564 (the year in which Michelangelo died and the decrees from the Council of Trent ordered that several of the nude figures in the *Last Judgment* be appropriately "corrected"), the theologian and *letterato* Giovanni Andrea Gilio published *A Dialogue on the Abuse of History by Painters. . .* , a text well known for its lengthy and detailed Counter-Reformatory criticism of the *Last Judgment* as an example of Michelangelo's willful violation of decorum, the flaunting of artistic skill and invention at the expense of sacred truth, and the representation of poetic embellishments inappropriate to the genre in which the Last Judgment, as a subject, should have been cast. The painting was accessible, in Gilio's argument, only to the learned rather than to the uneducated masses for whom sacred imagery should be conceived and directed. While his dialogue was primarily devoted to a critique of the *Last Judgment* and is often cited in isolation as such, it is also important to acknowledge the immediate context in which Gilio was writing in considering the significance of his argument. The text was dedicated to the prominent Cardinal Alessandro Farnese (an active and influential participant in the meetings at Trent) and contains a broad discussion of sixteenth-century frescoes that were owned or commissioned by the Farnese family. The *Last Judgment* was clearly

the most important of all Farnese commissions, but Gilio's larger pur-
pose was to address and rectify shifts in the definition and expression
of decorum and genre in painting, especially sacred imagery, which
he claimed had noticeably declined in recent years: "and now find-
ing that painting has been put into the hands of many [i.e., through
reproductions] who, for the most part, are ignorant... I am prepared
to give them a guide in order to demonstrate the diligence that is nec-
essary (in understanding) sacred painting, secular histories, and poetic
fictions." The *Last Judgment* was the best possible example, historically
and stylistically, for Gilio's argument and purposes as it was equally so
for Vasari's. It is not surprising, then, that Gilio observes and censures
many of the very same qualities that Vasari praised as demonstrating
the highest achievement in painting.[7]

Notwithstanding their diverse ideological agendas, a careful reading
of Vasari's and Gilio's language reveals that they understood the qualities
and effects of Michelangelo's style, invention, and the communicative
power of the painting within a similar framework of aesthetic and
critical references. Their critiques represent two of the more insightful
and intelligent examples of differing positions in what is a diverse
body of textual criticism about the *Last Judgment*, and they can stand
as exemplars for the two principal sides of the argument in sixteenth-
century criticism about the *Last Judgment*. Published more than twenty
years after the fresco was completed, Gilio's and Vasari's ideological
positions polarize the debate about the purposes and effects of painting
during the years of the Counter-Reformation and its future course
during the succeeding generation. It is the question of style generated
by the tension between the motivations of artists and writers trained
in the values of Renaissance humanistic culture on one hand and the
conservative values of a Counter-Reformation ideology on the other,
for which the *Last Judgment* stands as the exemplar that is the principal
subject of this essay.

The nature of sixteenth-century criticism about the *Last Judgment*
is varied and copious. In language, the sources range from the most
academic and arcane Latin to the most pedestrian vernacular; in genre,
from the most formal and public, to the most informal and private –
from letters, poetry, dialogues, and treatises, to papal briefs and witty
anecdotes. Sixteenth-century literary strategies and ways of reading
were quite distinct from our own, and thus part of the challenge in

discussing the sources lies in the very nature of the sources themselves. Genre and language were tied to content in a variety of meaningful relationships and, as with any rich cultural circumstance, the playing field is messy and often ambiguous. Asking what effect and resonance the critical sources commanded within a presumed audience is as imporant as exploring what they accomplished or ignored within a community of critical responses. And, although it is prudent to exercise caution in attributing authorial intention where none is explicitly stated, the rhetorical structures of sixteenth-century literary genres allowed, and indeed encouraged, an author to reveal opinions and ideological positions that are often quite discernable. The sources are most revealing, then, in suggesting the kind of expectations and assumptions that informed the ways in which the audiences that those sources addressed saw and understood painting in general, and the *Last Judgment* in particular.[8]

Pope Paul III was unequivocal in his desire to have Michelangelo work exclusively on the *Last Judgment* beginning in 1535, as is well known from the published documents.[9] Scholarly disagreement about whether Michelangelo conceived the imagery to represent a specific Counter-Reformation ideology, particularly prior to 1541, remains consistent and provocative. That the painting and its presence in the Sistine Chapel (and broader dissemination through prints during the sixteenth century) was of central importance for Paul III and the later politics of the Counter-Reformation, however, is beyond doubt. Immediately upon the unveiling of the painting, and even before it was completed, Michelangelo's contemporaries voiced widely diverse responses to the invention and particularly to the nude figures, which became the focal point for the most exemplary praise and the most scandalized criticism. Praise and blame originated both from within the innermost circles of the papal court and from points outside, as demonstrated, for example, by the letters written by Pietro Aretino from Venice and Niccolo Martelli from Florence, neither of whom had seen the painting in situ. Responses from individuals within or connected to the Church naturally varied with their particular religious and ideological positions, but this variety of, and at times confusion in, early responses to the *Last Judgment* can also be said to have reflected the profound spiritual dilemmas that defined this period, dilemmas for which the Church had yet to formulate a unified institutional response.

Although there were supportive responses from within the Church, the most substantial and severe criticisms against the painting from conservative clerics and theologians had the greatest practical impact and historical legacy, as the 1564 decrees from Trent and continued "corrections" to the nudes through the eighteenth century, for example, demonstrate.[10] In substance, the censure of the *Last Judgment*, as curial canon Agostino Maria Taja remarked to Pope Clement XI at the beginning of the eighteenth century, was primarily Catholic.[11] The broad arguments against the indecency and extreme postures of the nude figures and the call to appeal to the uneducated masses with a direct and uncomplicated message invoked old and familiar institutional gestures calculated to reassert control and ensure future survival by retaining and increasing the numbers of faithful. These arguments, however, were also often convenient rhetorical foils for what were other, more indirect objectives.

Responses in praise and support of the *Last Judgment* were similarly voiced before the painting was completed and increasingly after its unveiling. Unified in their recognition of the heights to which art could ascend through Michelangelo's singular genius, the specific language of praise and varied emphases of these responses constitute a veritable affirmation of the ideals and purposes of painting since Alberti. Of course, this was largely a Florentine (and later, Tuscan) position for which Vasari provides the most sustained and specific argument in the 1568 edition of the *Lives*. Yet it is also significant that virtually all of Michelangelo's most eloquent supporters during the 1540s and 1550s were either Florentine or were connected to the Florentine intellectual community through the literary academy or budding Accademia del Disegno – Niccolo Martelli, Bendetto Varchi, Antonfranceso Doni, Ludovico Domenichi, and Vasari himself are obvious in this regard. It was not without political purpose, then, that Vasari significantly revised his *Life* of Michelangelo and his discussion of the *Last Judgment* between the 1550 and 1568 editions – not only in response to Condivi's 1553 biography of Michelangelo, but also in response to some of the negative criticisms – for it was necessary to establish Michelangelo as the titular head (albeit in absentia) of the Florentine Accademia del Disegno, a position Vasari also secured for him in the Introduction to the Third Part of the *Lives*. In his discussion of the *Last Judgment*, Vasari provides capacious insight through theoretical and critical language chosen carefully for its contemporary resonance.

Consequently, phrases that may now seem transparent and rehearsed such as, "in the *Last Judgment*, one could see . . . all that which the art of disegno was able to do" (*tutto quello che l'arte del disegno poteva fare*), rather than repeating a time-worn cliché, defined the *Last Judgment* as a foundational topos for the institutional and theoretical ideals of practicing, and future, Tuscan artists.

Among the earliest criticisms of the *Last Judgment* is the often-cited comment attributed to the "scrupulous" (*scrupoloso*) master of ceremonies in the Sistine Chapel, Biagio da Cesena, who, as Vasari amply recounted in the 1568 edition of the *Lives*, remarked on seeing the fresco three-quarters finished in the company of Pope Paul III that the excessive number and shameful representation of the nudes made it better suited to a bath house or tavern than to the honored place it occupied. Michelangelo's retributive and bold response in memorializing Cesena as Minos among a "mountain of devils," with a serpent biting his genitals, functions as a clever paradigm in Vasari's account for all those who criticized the painting without understanding the "profondità dell'arte" and Michelangelo's stupendous achievement. Vasari's significant revision of this passage from the brief one sentence that appeared in the 1550 edition, also demonstrates his calculated response to specific criticisms made in the intervening years between the two editions of the *Lives*. He attributed particular critical charges, for example, "so many nudes that so immodestly show their shame" (*tanti ignudi che sì disonestamente mostrano le lor vergogne*) to Cesena when they were in fact expressed in print by other critics such as Aretino, Ludovico Dolce, and Gilio. As if to verify Vasari's account, Cesena's infamous legacy was further secured by Lodovico Domenichi in his *Facezie, motti e burle di diversi signori e persone private* (1564) in which he attributes a witty remark to Paul III about Biagio's immortalized fate as Minos: "M. Biagio, you know that I have power from God in heaven and on earth, but my authority does not extend into hell, so you will have to be patient since I am not able to free you from there." And in 1544, a satyrical sonnet by the loquatious "Pasquino" in Rome identified Cesena standing among the dead in the *Last Judgment* as punishment for his "mal governo."[12]

However anecdotal and simplistic Vasari's account of Biagio da Cesena may seem, it successfully established the main critical polemic as it was argued throughout the century – namely, the charge that Michelangelo had willfully ignored decorum and genre in flaunting

his own art and the ignorance of the critics making this charge in not understanding the nature and significance of what Michelangelo's art in the *Last Judgment* represented, a polemic that by the publication of the second edition of the *Lives* had already been well established.

Nineteen days after the *Last Judgment* was unveiled, a Mantuan envoy to the papal court, Nino Sernini, wrote to Cardinal Ercole Gonzaga with news of some of the first responses from within the curia and about his efforts to have a copy made. Sernini's letter, is frequently mentioned in discussions of the *Last Judgment* for its candid and revealing report of disagreement about the decorum and effect of the painting, along with Sernini's own modest critical assessment. It was also Sernini who initially secured Marcello Venusti to produce a copy of the fresco for Cardinal Gonzaga, the second version of which (for Cardinal Alessandro Farnese) has survived as the most important pictorial reproduction prior to the censures begun in 1564 by Daniele da Volterra. Less often acknowledged, however, is the context of Sernini's letter, which, in addition to being a private correspondence rather than a more stylized "familiar letter" intended for publication (such as were those by Pietro Aretino, Niccolo Martelli, or Anton Francesco Doni, for example), is one among many similar letters from Sernini over several years relating events and politics in the papal court, particularly concerning Counter-Reformation initiatives and the convening of a council at Trent. Sernini's letters reveal that he was clearly an informed "insider" who had in fact been commenting on the project of the *Last Judgment* as part of his correspondence since 1534 when he refered to it as "la resurrectione." The broader significance of Sernini's 1541 letter beyond the specific information it provides, then, is that it also underscores the role of the *Last Judgment* within the general politics of the early Counter-Reformation.[13] In its unrehearsed and unceremonious style, the letter creates a sense of immediacy that lends support to Sernini's position as a Vatican correspondent, and it is, for many reasons, one of the most revealing and interesting early critical responses to the *Last Judgment*.

> I have found no one with enough courage to draw in such haste that which Michelangelo has newly painted as it is a large and difficult work, and contains more than five-hundred

figures of a kind that to depict only one would, I believe, make painters think twice. Even though the work is of such beauty as Your Illustrious Excellency can imagine, there is nonetheless no lack of those who condemn it. The reverend Theatines are the first who say that the nudes displaying themselves (lit. "displaying their goods") in such a place is not right, although even in this [Michelangelo] has shown very great consideration since in scarcely ten [figures] of so great a number can one see immodesty. Others say that he has made Christ beardless and too young, and that Christ does not possess the majesty that [should] become him, and so, in a word, there is no lack of talk. But the reverend [Cardinal] Cornaro, who was [there] a long time to look at the fresco put it well, saying that if Michelangelo would give him a painting of only one of those figures he would pay him whatever he asked, and he is right, because to my mind one cannot see these things anywhere else. The said Cardinal has one of his painters there continuously copying it, and although he doesn't waste one minute he will not finish the entire work in less than four months. But, with all this, I will do my best to have at least a sketch so that Your Illustrious Execellency will be able to see the composition that Michelangelo has made, which I do not believe will be enough to satisfy you – Messer Giulio [Romano] would have done it more honor – and the work will be, when you see it, quite different than what one may think, since it is known that Michelangelo has put all of his effort into making imaginative figures in diverse attitudes.[14]

The contrast that Sernini draws between the responses of the Theatines (an ultra-conservative and relatively new reform order founded by cardinals Carafa and Cajetan) along with anonymous "others" who criticized the immodesty and inappropriateness of the nudes, as well as the decorum of Christ who appeared too youthful, without a beard, and lacking the requisite "majesty," and the response of Cardinal Cornaro who said that he would pay whatever Michelangelo wanted for a painting of just a single figure, locates the two sides of the debate within the Church itself as had Vasari's account of Biagio da Cesena. It is also significant that artists began copying the long-awaited fresco immediately after its unveiling since it was through prints – seventeen versions during the sixteenth century – that a wider and more diverse audience for the *Last Judgment* was established.

On the same date as one of Sernini's subsequent letters to Cardinal Gonzaga (December 4, 1541) in which he sent news about the still unfinished copy of the *Last Judgment* and the considerable challenge to Venusti in representing such a variety of difficult figures, Niccolò Martelli sent a brief letter to Michelangelo from Florence in which he characterized the *Last Judgment* in terms that cast it as a paradigm for the Florentine style by a native artist who was singular in his "divine" inspiration and ability to imitate, indeed surpass, Nature. While Martelli had not yet seen the painting, he knew Michelangelo well and was an important participant in the literary and artistic community in Florence that was, at that moment, in the process of shaping a new cultural identity under the watchful eye of a new autocratic ruler, Duke Cosimo I de' Medici. After having witnessed the dissolution of the Florentine Republic Michelangelo never again returned to his native city. This gesture was in part a sign of his political disapproval of the grand duchy, but his accomplishments and reputation in absentia remained central to both the political and artistic goals of grand-ducal Florence from the early 1540s through Michelangelo's public funeral orchestrated by the Accademia del Disegno in 1564.[15]

In contrast to Sernini's letter, Martelli's prose is a model of vernacular elegance and rhetorical sophistication. Intended for publication as part of a collection of "familiar letters" (1546), Martelli was astutely aware of both the intimately private and overtly public nature of the genre – as was Pietro Aretino in his *lettere familiare* – which he effectively exploited in an elevated, literary style.[16] Locating Michelangelo's virtue and civility in their shared Florentine patrimony and "heaven's gift," Martelli extolls Michelangelo as "the most beautiful imitator of nature that ever existed, whether as a painter, sculptor, or poet" before turning to the *Last Judgment*.

> Did not God miraculously create in your imagination the pure idea of the tremendous *Last Judgment* that you recently unveiled, which astonishes whoever sees it, and which so infatuates whoever even hears of it that a great desire to see it comes upon him and will not leave him until he does see it. And, who upon seeing it finds that its fame is great and immortal, but the work itself is greater still, indeed divine? Wherefore one may rightly speak of a Michelangel, God's messenger in heaven, and one [Michelangel] on earth, only

son and sole imitator of nature. But, so as not to venture upon such perilously high seas, I will come to an end, begging you to accept the rhymes that my affection for your goodness has inspired me to create, not as things worthy of you, but as things from your homeland.[17]

Martelli's careful choice of language in his affectionate and lofty description of the impact of the *Last Judgment* and his virtual deification of Michelangelo, alludes to both painting and painter as exemplary of part of a Florentine ideal that Benedetto Varchi and especially Vasari would further develop in the theoretical definition of *disegno* during the next few years. Central to the philosophical foundation of *disegno* is the Artistotelian revision of Plato's "theory of forms," which Varchi and Vasari borrowed from the *Nichomachean Ethics* and *Metaphysics* in the *Lezzione* and *Lives*, respectively.[18] The perfection of *disegno* as a theoretical and practical ideal rested in the artist's ability to realize an idea through invention and the imitation of nature (where the idealized human form was the highest manifestation) and which could only be achieved when the hand and mind worked harmoniously, and equally, together. Celebrating individual artistic achievement and expression as having been directly inspired by God, and as tantamount to divine perfection itself ("il divino"), was a familiar and meaningful Renaissance conceit that had been invoked years earlier with respect to poets. It was now, however, a concept increasingly at odds with emerging Counter-Reformation ideology in which individual will and the glorification of individual expression were submerged and actively restricted within a redefined system of universal symbols and abstract virtues. This was a cultural shift to which not only Michelangelo but also Vasari, Bronzino, Veronese, Tasso, and Galileo, among others, were directly, and in some cases painfully, subject.[19]

Martelli's characterization of Michelangelo's achievement in the *Last Judgment* as an act of divine creation was similarly expressed by Anton Francesco Doni in his letter of 1543. Doni, also a central participant in the Florentine literary and artistic community, alluded indirectly to some of the negative criticism outlined by Sernini (such as the decorum of Christ) and exercised little restraint in describing the astounding appearance and spiritual effect of the *Last Judgment*, even though he, too, had not yet seen it in person.[20] Shared Florentine patrimony is again crucial to the argument, as is the unique dispensation

of heavenly inspiration. Doni's musings on the *Last Judgment* border on a mystical experience where the "truth" of Michelangelo's invention inspires Doni to envision his own death before the painting.

> To my ears has come the fame of the *Last Judgment* which, for its beauty, I believe, on that day when Christ will come in Glory, will require that He command everyone to take on those poses [you have represented] and show that beauty, and [also] that hell [will] contain those shadows that you have painted in a way that cannot be bettered. And it seems to me that I feel so much pleasure and such consolation in seeing the work of your hands . . . I wonder if when I might stand before that *Last Judgment* I would be paralyzed, and in that sweetness, send forth my last breath flying towards heaven (by God's grace) and crying out: "Michele Agnolo, my divine!"[21]

Doni here further solidifies the topos of divine inspiration and perfection in Michelangelo's representation of this future history, such that it could not appear in any other way except by Christ himself commanding the movement and appearance of the figures that surround him precisely as Michelangelo has depicted them. Earlier in the letter, Doni had evocatively described Michelangelo imbuing the spirit of life (*anima*) into his sculpted figures in the Medici Chapel much as God had done with Adam, as they seemed so natural and lifelike to be capable of movement and thought. Such rhetorically vivid descriptions, far from being repetitive clichés, provided the contemporary reader with a dynamic and powerful response to the imagery, a response that also granted the reader the authority of Doni's own intellectual and literary reputation. By this point in time (and certainly during the years of the following three editions of his letters), Doni was well aware of the mounting negative criticism about the *Last Judgment* for which his carefully crafted praise in this letter undoubtedly served as a riposte.

The varied nature of the negative criticism by the mid-1540s began to resemble a collection of specific but randomly organized complaints that were usually rooted in contemporary doctrinal debates; Christ too young and without a beard, too many indecent nudes, and specific saints (such as Catherine and Blaise) who were inappropriately and confusingly portrayed. The list would grow and become more focused during the next two decades. A frequent correspondent and close friend of Vasari, the somewhat conservative Don Miniato Pitti,

reveals both the random quality and specific content of the criticism circulating at this time in a private letter from 1545:

> Most loved messer Giorgio, salute...I have a mountain of things to tell you, such as that I am well and would like to hear the same from you, and that I have received one of your letters which said that I was considered brutish in Naples because while in Rome, I had preferred the vault [of the Sistine Chapel] to the wall [*Last Judgment*]. Because in it, there are a thousand heresies, especially in the beardless skin of St. Bartholomew while the flayed one has a beard, which demonstrates that the skin is not his own, etc. [sic][22]

In addition to the casual and exaggerated reference to a "thousand heresies" (heresy, as the most serious of doctrinal charges, was never formally leveled against Michelangelo), Pitti's recognition that the skin Saint Bartholomew holds differs in its features from those of the saint himself, while cited as a specific transgression, is also noteworthy in that it is one of the very few sixteenth-century references to this obvious anomoly, which today is generally accepted as a self-portrait of Michelangelo (Fig. 28). Although Nicolas Beatrizet included Michelangelo's name next to the skin in his 1562 engraving of the *Last Judgment*, thus suggesting at least some recognition among Michelangelo's contemporaries, it is curious that there are no other contemporary sources, written or visual, that acknowledge the self-portrait.[23] Self-portraits in Renaissance painting were of course numerous and often referrentially meaningful – but Michelangelo's self-portrait in the *Last Judgment* is unique. At one of the most conflicted historical moments in the Catholic Church in one of the most sacred places, Michelangelo conceived himself in an image of profound spiritual uncertainty and complex personal identity. As the chosen exalt their perfect, heroic bodies and the damned are cast into the darkest oblivion, Michelangelo's own future hangs in the balance – a pathetic skin – the very antithesis of the powerful, idealized figures surrounding him, awaiting a judgment that has not yet been rendered. It was precisely this kind of bold declaration of individual will and spiritual uncertainty that the conservative tenets within the Counter-Reformation sought to submerge and that the most severe critics of the *Last Judgment* could have easily capitalized on in support of their

ideological agenda. Michelangelo was repeatedly criticized for flaunting his own art and identity at the expense of sacred truth in this painting. It is a curious historical lacuna that those critics intent on exploiting the *Last Judgment* and Michelangelo as justification for conservative reform overlooked this powerful assertion of personal identity at the expense of doctrinal literalism that could have effectively supported their purposes.[24]

One contemporary writer who did not shrink from a direct and specific attack on the *Last Judgment* while also having doled out portions of eloquent praise, was the prolific, opportunistic, and very well-connected Pietro Aretino. Of all sixteenth-century *letterati*, perhaps no one was more politically motivated, professionally self-conscious, or versatile when it came to using the written word – whether crafted in the highest, most refined style or the lowest, popularizing mode – as a means of persuasion and self-promotion. Fluid in virtually all genres and styles, Aretino was particularly a master of the epistolary genre. His *lettere familiare* are prodigious, addressed over several years to artists, *letterati*, princes, courtesans, and a host of others who together constitute the cultural and intellectual communities in which he operated and the ideally constructed audiences for whom he wrote. Aretino understood well the simultaneously public and private nature of the "familiar letter," which he manipulated with skill and rhetorical flair for what must have been a fairly large audience of readers, judging from the number of sixteenth-century editions. Much has been written about Aretino, and virtually all art-historical discussions of the *Last Judgment* have addressed his letters to Michelangelo as a special case, not only because his comments begin before the painting was completed and continue during the decade after its unveiling, but also because of his dramatic shift in tone and content.[25]

Of the forty-two letters Aretino published that mention Michelangelo or are addressed to him, the five concerning the *Last Judgment* (dating from 1537 to 1545, although the last was revised and not published until 1550) are ultimately less significant in what they specifically say about the painting (Aretino's opportunism and rhetorical craft, at times quite divisive, are obvious throughout) than what they suggest about prior expectations, subsequent reception, and Aretino's own goals within an audience that was in part being fashioned by the texts of the critics themselves.[26]

Some scholars have suggested that Aretino and other critics were in large part responding to a new, more conservatively oriented audience for the *Last Judgment* in their negative critiques as a way to explain these writers' motivations and, in the particular case of Aretino, his dramatic shift in tone.[27] While Aretino's awareness of the likely audience for his publications without question informed his critical and stylistic approach, the relationship between the audience we now presume and the letters themselves is also perhaps more subtle and reflexive than explaining his change in tone as primarily the result of catering to a particular audience. It may be more constructive to think about Aretino and other critics not principally as respondants to a new audience, but more so as active participants in creating one that would be receptive to their critical perspectives.

In his last letter to Michelangelo about the *Last Judgment* – the one most often discussed – Aretino adopts a rather weak critical position he does not sincerely believe nor convincingly represent, resonant though this letter may have been with subsequent critics.[28] In particular, Aretino's unpublished version of this last letter (1545) is remarkable for its vindictive and inflammatory tone, which stands in stark contrast to the laudatory nature and content of the three previous letters, but which also makes the most sense when read in the context of all five letters together. Interestingly, it is this version, rather than the revised and published version of 1550, that is most often quoted in discussions of the *Last Judgment*. Aretino's criticisms, while acrimonious and substantially unoriginal in content, are selectively aimed toward the most obvious and broadly stated objections to the painting and could therefore have served to incite further scandal and secure his primacy as its most legitimate commentator while also demonstrating his understanding of the basic controversy to a variety of audiences. Indeed, it is clear from the five letters that Aretino considered them as part of a unified discourse and not as independent texts. The scholarly literature on the *Last Judgment*, however, usually discusses selected letters without reference to all five, which depend on one another to revealing more clearly Aretino's motivations.[29] The letters of January 1538 and April 1544, for example, are rarely mentioned even though they provide important links between the first letter of 1537 and the harshly critical letters of 1545 and 1550.

The only consistent and unabashedly honest issue Aretino repeats throughout the 1538, 1544, and 1545 letters is his desire for a drawing by Michelangelo for his collection, a desire that he reiterates with frustrated and threatening disdain twice in the 1545 letter, only to retract it entirely from the published 1550 version. Indeed, the 1545 letter only confirms Aretino's resentment and vindictiveness about the drawing since the published version was not only substantially revised, but also somewhat awkward in its tone; the primary motivation for the 1545 letter is far more obvious and sincere. The publication of the revised version in 1550 was also, no doubt, in part a gesture of final retribution for still not having received anything from Michelangelo despite Aretino's assurance in the 1545 version that he would not publish the letter and risk damaging Michelangelo's reputation – a rhetorically transparent warning underscoring Aretino's perception of his own ability to sway public opinion and its potentially deleterious consequences. Aretino had already acquired a substantial collection of art by this time, and he had tried more than once to acquire something by Michelangelo's hand, both through the help of mutual friends and by direct requests. Attributing a more complex motive (his aspiration for the cardinalate or exemption of his objectionable publications from possible censorship have been proposed), other than Aretino's own personal gain and frustration, to this group of letters and his especially harsh tone in the last one, despite other relevant critical issues he raises, is a doubtful proposition in light of the repeated request for a drawing that the 1538, 1544, and 1545 letters share. Although I do not want to take the time here to rehearse the many analyses of Aretino's letters, a few issues merit discussion.[30]

Michelangelo wrote only one letter to Aretino between 1537 and 1545, a brief response to the first letter of 1537, which Aretino published among his *lettere* as part of his episolary discourse on the *Last Judgment* beginning with the 1542 edition.[31] This inclusion was also significant within the context of Aretino's suceeding letters and the simmering consternation expressed in them because Michelangelo added in closing, "In the meantime, if I have anything that would please you, I offer it with all my heart."[32] (It is important to note that Michelangelo does not specifically offer Aretino a drawing, which is most often how this sentence has been read: "se io ho cosa alcuna che vi sia a grado, ve la offerisco con tutto il core." The offer

is, rather, a generic one that Aretino turned into his now-famous request.)

Aretino's desire to possess a tangible part of Michelangelo's genius and fame practically reduced him to begging in the 1538 and 1544 letters: "But should not my devotion draw in return from the Prince of sculpture and painting a piece of those cartoons that you usually throw in the fire, so that I may enjoy it in life and carry it with me to my grave in death?" and "But why, O Lord, do you not reward my endless devotion such that I bow before your celestial nature, with a relic of those drawings that are less precious to you? Most certainly I would value two marks of charcoal on a page more than all those cups and gold chains that this or that Prince ever presented to me."[33] It is in the unpublished letter of 1545, however, that Aretino crafted a personally vindictive and ideologically conservative attack on Michelangelo and the *Last Judgment*, completely abandoning his previous rhetoric of praise and admiration. In a mixture of pious outrage and vituperative frustration at not having received Michelangelo's recognition, Aretino mentions in a rhetorical postscript that the invective was simply an "outlet" for his anger at the "cruelty" with which Michelangelo repaid his devotion and instructs him to tear up the letter as he himself says he has done, a gesture that is clearly belied by the surviving manuscript version and the publication of the revised version in the 1550 "fourth book" of Aretino's letters, addressed not to Michelangelo but to Alessandro Corvino.[34]

Although the fact that a manuscript version of this letter exists at all is significant and its contents are illuminating, it is ultimately less significant than the revised 1550 version, for it was that version that Aretino sent to press hoping to sway perception among Counter-Reformation leaders and the reading public by staking his claim as one of the foremost commentators in the growing controversy surrounding the painting. In his criticism of the painting Aretino adopts the broad, ideological position of the conservative reformers in arguing that sacred imagery (for which the *Last Judgment* had become the paradigm) should be accessible and inspiring to the faithful masses rather than to the learned few. He further argues that Michelangelo imprudently and deliberately violated the boundries of decorum and compromised his own religious piety in privileging his art over sacred truth in the most sacred of places, the Sistine Chapel. It is important to

note, as Barnes has insightfully observed, that the nature and content of Aretino's criticisms make the most sense in light of prints of the *Last Judgment* that were available by 1550, thus creating a wider and more diverse audience for the painting beyond the closed circles of the papal court and other privileged viewers.[35] It is also significant that prints were the primary medium through which the majority of critics formulated their objections rather than through a first-hand knowledge of the painting. Even the very best reproduction could only illustrate the invention. Color, scale, function within the architectural space, and the *Last Judgment*'s relationship to the earlier frescoes in the Sistine Chapel, all important to the painting's purpose and effects, are effectively eliminated in an engraving. Indeed, even Vasari, a great champion of prints as a medium for disseminating painting, lamented that many copies of the *Last Judgment* were of poor quality because they were made more for "profit than for honor."

While all of the vindictive personal attacks were excised from the 1550 version, they are nonetheless instructive in illuminating Aretino's primary motivations in writing the 1545 version, a motivation that was fleshed out with pointed criticism of the painting itself and reference to the drawing. One example will suffice here:

> And thus may God forgive you, for I do not speak this way out of resentment for the things I desired. Indeed, if you had sent me what you promised expeditiously, you would have procured every kindness, since in such an act you would have silenced (all) envy which says that only certain Gherards and Tommasos can dispose of them.[36]

As extraordinarily contrived and reactionary as the 1550 critique of the *Last Judgment* may seem, it is nonetheless remarkable for the effect it attributes to Michelangelo's style and imagery in confusing and, ultimately, damaging the viewer. Most significant in this respect is Aretino's outline for censorship with respect to the nude figures:

> May it be that the new pontiff, with the eternal rest of Paul III, imitate Gregory [the Great] who wanted immediately to despoil Rome of the proud statues of idols that took, in their quality and beauty, reverence from the humble images of the saints, for our souls have more need of the love of piety than the pleasure that the liveliness of *disegno* brings with it. An image

of glory is (for him) to straighten out this century in the temple
of posterity, if the preeminent man corrects the inappropriate
figures as I have described above.... But if it happens that
the immortal intellect [Michelangelo] resents hearing what
I write, I will tolerate it by saying that in the deed of such
a thing it is better to displease him by speaking about these
things, than injure Christ in keeping silent.[37]

As the first, published condemnation of the *Last Judgment*, this letter
had the greatest resonance of the five in more lengthy and sophisti-
cated critiques that appeared during the next two decades, most espe-
cially, Lodovico Dolce's dialogue *L'Aretino* (1557) and Gilio's *Dialogue
on the abuse of history by painters*... (1564). The legacy of Aretino's
criticism, which is more often reflected as a shared sentiment than a
specific reference, also resonates in the later and more conservative
treatises of Gabriele Paleotti (1582) and Federico Borromeo (1624),
both of whom formulated important arguments about the purposes
and effects of religious art in post-Tridentine Italy that depended in
large part on the continuing controversy over the *Last Judgment*. While
Aretino's last letter might have been sensationalist in tone, its content
was on the mark in highlighting the conservative religious position,
a position that was tied to an agenda of cultural reform within the
Church. With respect to Michelangelo, the conservative critical posi-
tion was consistent: in privileging the ideals of his art over the goals of
sacred truth, Michelangelo had compromised not only his own piety,
but also religion itself; in violating decency and proper decorum in
the heroic, complicated nude figures, the *Last Judgment* would con-
fuse and mislead the faithful away from piety; and the sophistication
of the invention and extreme manipulation of the figures, although
clearly evidence of Michelangelo's genius, were only accessible to the
learned while being equally inappropriate to the sanctity of the Sistine
Chapel.

 By midcentury, the controversy had become more polarized and
formalized. As conservative critics rehearsed particular charges and
objections, supporters of Michelangelo and the *Last Judgment* repeated
and elaborated on a set of different themes: as the highest and most
perfect of God's creations, the human body represented in its ideal
and most expressive state was itself a metaphor of divinity; in so com-
pletely mastering the human figure in motion (the greatest difficulty

in art) and expressing every conceivable emotion, Michelangelo not only exemplified the principles of *disegno*, but also surpassed the ancients, his contemporaries, and nature itself in demonstrating the heights to which an artist and art could ascend when guided by a divine intellect and superior ability; and finally, the complexity of the invention and difficult movements of the figures that embodied the profundity of the subject would lead the viewer toward pious devotion in recognizing the beauty, power, and truth of Michelangelo's visualization.

Formal statements of support continued to appear prior to Vasari's 1550 edition of the *Lives* in which he codified the *Last Judgment* as an exemplar of *disegno* and the perfection of painting, two themes that he expanded on in the 1568 edition in response to negative criticism. Tramezino, for example writing in 1544, emphasized the failure of Nature to match the beauty and variety of movements and gestures in Michelangelo's figures, such that

> one can see expressed all the manners, all the complexions, all the movements, all the possible states of a human body and all the movements of the soul – with foreshortened figures, projecting figures, figures exerting themselves, and a thousand other details which, among the ancients, were already miracles but in you, are ordinary things, so natural, so alive, so correct, that one would almost say that Nature herself would hardly know to improve upon them. Every day in the realm of Nature we see the blind, the maimed, the lame, and bodies entirely monstrous and paralyzed.[38]

The Aristotelian foundation for creating an ideal form that is purged of the "accidents" of Nature is also part of what informs Vasari's theoretical and practical definition of *disegno* and the highest perfection in style that results – the *bella maniera* – which he describes in the introduction to the "Third Part" of the *Lives* as one of the qualitative achievements of his generation.[39] Lodovico Domenichi similarly criticized those who failed to understand the significance of Michelangelo's nudes and his desire to return to the noble ideals of the ancients in, interestingly, *La nobiltà delle donne*, first published in 1548. After debating the relative beauty of the nude and clothed female body and arguing for the superior beauty of the nude female body as demonstrated by the ancients, one of the interlocutors remarks,

> Michelangelo Buonarroti in his wondrous painting in the
> Chapel of Rome had wanted ardently to return to the an-
> cient ideals, which he did, holding much more praise from
> those who have understanding than a few ignorant agitators
> who, out of shame, look at those most beautiful parts that are
> of one and the other sex.[40]

Domenichi's brief point in drawing a distinction based on particular
forms of cultural knowledge between those who understand and those
who do not in the presence of a supreme art inspired by Nature and
the ideals of antiquity, is also precisely the point around which Vasari
and Gilio develop their more formal and expansive critical positions.
Vasari's discussion of the *Last Judgment* in the 1550 edition of the *Lives*
defined the paradigm that informed virtually all subsequent critiques
of Michelangelo's achievement, whether by supporters or detractors.
(This is especially well-demonstrated by the interlocutors in Dolce's
and Gilio's dialogues who argue the artistic, stylistic, and thematic
merits of the *Last Judgment* with intelligence.)

It was through the unprecedented achievement and perfection
of *disegno* that Michelangelo demonstrated in the *Last Judgment* that
viewers would be led to understand the divine subject, and artists
shown the perfection of art. Vasari sets the context of his commentary
within the realm of letters in drawing an analogy between the power
of Michelangelo's imagery and the poetry of Dante, an analogy that
would have been understood by contemporary readers as a reference
to both Michelangelo's renowned knowledge of *The Divine Comedy*
and to contemporary debates about literary style in the *questione della
lingua*.[41] Vasari remarked that Michelangelo gave "such force to the
images of this work, he verified the words of Dante: 'Dead are the
dead, and the living seem alive;' and there, we understand the misery
of the damned and the joy of the blessed."[42] Also implied here is that
the effects of Michelangelo's style in painting are analogous to effects
of Dante's style in poetry where an epic subject is depicted with the
force of nature and truth, and where the psychological and emotional
states of salvation and damnation are shown through the experience
and movements of the body. The very poetic qualities that Vasari,
Varchi, and others especially praise in Michelangelo's representation of
the *Last Judgment* are those that Gilio and other critics especially con-
demn as unwarranted and willful violations of decorum that obsure,

rather than reveal, the truth. Following a lengthy ekphrastic descrip-
tion of the painting, Vasari gives a rhetorically astute critical evaluation
of Michelangelo's achievement and the painting's larger significance:

> And in truth, the multitude of figures, the *terribilità*, and
> grandeur of the painting are such that it cannot be de-
> scribed, since it contains every possible human emotion,
> each having been marvellously expressed... [and] because
> [Michelangelo] observed every decorum in representing his
> figures, whether in appearance, gesture, or any other natu-
> ral circumstance.... One who is discerning in judgment and
> understands painting will see the awesome power of art and,
> in those figures, perceives the thoughts and movements of
> the soul, which have never been painted in this way by any-
> one but him. Furthermore, one who is discerning will see
> there how he has achieved variety in so many diverse figures
> through the unusual and different gestures of the young and
> old, male and female.... For the *Last Judgment* equally stirs
> the hearts of those who know nothing about painting as those
> who understand.[43]

There could be no more stark a contrast in tone and content to
Aretino's letter of 1550 than this oration of praise and justification.
Vasari locates the pictorial qualities that the "good and true" painter
of his generation should strive to achieve in the *Last Judgment*, both as
a demonstration of Michelangelo's mastery and the futility of trying
to emulate it – "the true Last Judgment and the true Damnation and
Resurrection."[44] Even the most able and inspired artists would despair
before this painting, says Vasari, as they try to grasp the enormity of
Michelangelo's achievement and divine inspiration. Vasari's position
is, of course, also institutionally and politically motivated, but it is
equally grounded in the visual evidence of the painting itself as was
Aretino's. Each argument rests on ideologically divergent ideals about
the purposes and effects of art for which the *Last Judgment* was now
the *exemplum*.

Vasari's exaltation of Michelangelo and the primacy of Tuscan
painting is taken up by Ludovico Dolce in *L'Aretino* (1557), the well-
known fictional dialogue in which the interlocutors "Aretino" and
"Giovanni Fabrini," (a reference to the Florentine *letterato* who occu-
pied the Chair of Rhetoric in Venice), devote most of their discussion

to the relative merits of Raphael and Michelangelo's styles with respect to ideals of physical beauty in which the *Last Judgment* figures prominently. While Michelangelo's *ingegno* and unsurpassed mastery of the figure are acknowledged and supported in the *paragone*, the style of Raphael is ultimately preferred for its greater grace, delicacy, variety, and visual beauty. Dolce also addresses the relative merits of various literary styles (particularly that of Petrarch) and devotes the very end of the dialogue to the "overlooked" genius of Titian and the values of Venetian painting. It is important to keep in mind, however, that Dolce is not specifically a Counter-Reformation critic. Elizabeth Cropper has insightfully characterized Dolce's dialogue as "not essentially moralizing. He rather seeks to problematize the issue of judgment by emphasizing the role of affection in the perception, possession, imitation, and reception of beauty."[45] Although Dolce's critique of the *Last Judgment* is not his primary subject, it nonetheless informs part of the critical debate and inspired several of Vasari's revisions to his *Life* of Michelangelo in the 1568 edition of the *Lives*.[46]

As a man of letters himself, Dolce had known the real Aretino in Venice and based his critique of the *Last Judgment* on an interpretive reading of Aretino's letters and, for Fabrini's perspective, Vasari's *Lives*. In setting his treatise in the form of a dialogue, Dolce gave the real Aretino (d. 1556) a voice as a commentator on his own critical position and lent authority to the argument he presents as author of the dialogue in being able to argue from both sides – what the rhetoricians called, *ad utrimquem partem* (to both sides equally).

In elaborating on Aretino's position about decorum, audience, and Michelangelo's license as they were expressed in his letters, Dolce also added some important new points regarding Michelangelo's use of poetic techniques and their consequent effect on the viewer, issues that Gilio would pursue assiduously in his later dialogue. Fabiano, in defending Michelangelo against the fictional Aretino's claim that Raphael is superior in narrative invention and decorum, at one point remarks, "I venture to say, that his stupendous *Last Judgment* embodies in its arrangement certain allegorical meanings of great profundity which few people arrive at understanding." Aretino retorts that if that were in fact the case, then he would deserve praise, but certain "ridiculous things" in the *Last Judgment* belie Michelangelo's intention to have "imitated those great philosophers who shrouded beneath the

veil of poetry supreme mysteries of human and theological philosophy so that they would not be grasped by the masses; as if they did not wish to cast pearls before swine."[47] After outlining the "ridiculous things" with which he claimed Michelangelo violated decorum in representing the sacred subject – Christ without a beard, figures of the blessed embracing, figures dragged down by their genitals – Aretino adds,

> It is none too commendable to me that . . . only men of learn-ing should understand the profundity of the allegories hidden behind them. . . . Similarly, I wish to say that if Michelangelo does not want anyone to understand his inventions, apart from a small number of intellectuals, then I, who am not one of the few intellectuals, leave thinking about them to him.[48]

Dolce, here feigning concern for the uninformed masses as Aretino had done, reinforces the sentiment that the *Last Judgment* was not only inaccessible, but also that it could mislead the untutored viewer. He also recommends censure of the nudes, citing laws that "forbid the publication of indecent books," and "how much more should pictures of the same kind be banned."[49]

Fabiano then argues forcefully on Michelangelo's behalf in a clever allusion to one of Petrarch's sonnets, pointing out that "Healthy eyes, sir, are not corrupted or scandalized by seeing the things of Nature represented in painting; nor do diseased eyes look at anything with sound understanding. And you can understand that if this work did indeed set so bad an example, it would not be tolerated."[50]

These remarks (among others) by Dolce's interlocutors were pre-scient of the final session of the Council of Trent in 1563, which issued decrees on sacred imagery in general and "corrections" to be made to Michelangelo's *Last Judgment* in particular.[51] In responding to ac-cusations of idolatry within the Church, the old argument from the second Council of Nicaea was invoked about how the faithful should worship the saints represented and not the images themselves. Reli-gious imagery should therefore instruct the masses in articles of faith and persuade them to follow the example demonstrated by saints in cultivating piety. Reformers at the Council of Trent adopted a partic-ularly hard line in this decree, fearing that further scandal and unrest

could seriously weaken the Church's already tenuous institutional authority.

With the continued controversy surrounding the *Last Judgment* and its significance in the politics of the Counter-Reformation and as a symbol of the papacy, the timing was right to make it an example of the new policy of the council and a demonstration of its authority. Indeed, it is a remarkable fact that the painting survived at all given the considerable pressure from within the curia to have it replaced throughout the century. Furthermore, although Daniele da Volterra's censures of the nudes and repainting of Saints Blaise and Catherine made the *Last Judgment* the most spectacular pictorial casualty of the Counter-Reformation, it was also unquestionably the power of Michelangelo's art – the very qualities critics found so objectionable and dangerous and supporters extolled as the most profound and meaningful achievement – that ultimately saved the work from destruction. Even Carlo Borromeo, renowned for his conservatism, could not consent to treat it like any other painting that would have been required to be destroyed in any other context.[52]

Gilio, writing twenty-three years after the *Last Judgment* was unveiled, was the first to address the broader implications of the council's decree on sacred imagery, particularly in the context of its new administrative requirement that bishops become involved in the oversight and evaluation of artistic projects. Much of Gilio's dialogue is devoted to a detailed critique of the *Last Judgment* as concerned its genre, decorum, style, and theological accuracy, on which he based his arduously specific recommendations for the painting of sacred imagery in general. Gilio's failure to acknowledge the value of art and the artist's imagination as topics have made him largely an anathema among many art historians who readily cast him as a conservative prude. The unfortunate consequence of this characterization, however, has been to gloss over the important contribution of Gilio's dialogue in shaping a new kind of Counter-Reformation criticism where a work of art was evaluated in terms of its textual or historical literalism, that is, in terms of its adherence to an orthodox version of the "truth." Appreciating the "profundity of art" as a value in Michelangelo's painting was of little interest or purpose to Gilio. However ill-motivated we may define Gilio's purposes and lack of aesthetic understanding with respect

to the *Last Judgment*, he argued the conservative position persuasively and in a more sophisticated and informed manner than anyone had before him.[53]

Gilio's criticism and the charges he levels against Michelangelo make the most sense when read within the foundation he establishes for his argument, which is based on a distinction he outlines between three distinct genres of painting and their literary parallels. Although this generic distinction was discussed and analyzed by Charles Dempsey more then twenty years ago and a thorough reading of Gilio makes clear that it is the theoretical foundation for his entire critique, art historians have paid suprisingly little attention to its larger significance within Gilio's argument.[54] A few pages into the dialogue, one of Gilio's interlocutors outlines the distinction between pure "history" painting (for which the *Last Judgment* is cited as the exemplar, as well as sacred themes in general), pure "poetic" painting (for which Raphael's *Loggia di Psiche* is the exemplar), and "mixed" painting, which combines history and poetry (for which Vasari's *Sala dei Cento Giorni* and Salviati's *Sala dei Fasti Farnesiani* are the exemplars). The pictorial examples that Gilio cites are mentioned for their subjects only since each painter is then accused of having violated decorum in each work, some more egregiously than others, based on the license they believed was granted to them through the legacy of Horace's *Ars poetica* and the well-known Renaissance dictum "ut pictura poesis."[55]

Throughout the dialogue, Gilio also carefully defines and reiterates the qualities that comprise the three genres, namely, the "vero," that which actually happened or was true; the "finto" (fictitious), that which did not necessarily happen even though it could have, making it "verosimile"; and the "favoloso" (fabulous), that which does not exist nor ever could. Thus, history painting represents the "vero"; poetic painting, the "finto" and "favoloso"; and mixed painting combines elements of all three. Furthermore, Gilio defines the "mixed" genre, which is the most extensively discussed of the three, as the "epic" based on an analogy with Virgil's *Aeneid*.[56] In addition to the conventions appropriate to each genre, the painter must also understand how to use them properly with respect to location and context. This condition is particularly important with respect to sacred history, which is for the instruction of the ignorant and is by definition more absolute in

its "truth" than secular history, which, by contrast, is interpretively variable.

It is on the basis of this definition of genre and the rules of decorum dictated for each that Gilio dissects and censures Michelangelo's *Last Judgment*. Michelangelo was guilty, among other things, of using the wrong genre – that is, the epic, "mixed" genre (that Raphael, Vasari, and Salviati used in their secular, courtly frescoes) where he should have painted in the genre of "true" history and thus, he introduced elements belonging to the poetic genre, the "finto" and "favoloso," into a sacred and immutable theme. The multitude of nude figures, their extreme postures, angels without wings inappropriately struggling like heroic athletes, personifications of the deadly sins among the damned, Charon's boat, among many other specific points, constituted an unwarranted violation of the historical theme to the extent that these poetic fictions overwhelmed the "truth."[57] This was especially egregious because Michelangelo "did so not out of ignorance, but in wanting to demonstrate to posterity the excellence of his genius and the excellence of the art that was in him."[58] In his desire to imitate the ancients in both the form and expression of his figures and in the genre in which he conceived the *Last Judgment* – things for which Vasari and his contemporaries saw the perfection and completion of the ideals of Renaissance art – Michelangelo was now guilty of having compromised the very faith to which he was so ardently dedicated.

> Michelangelo had wanted to imitate the ancients, who made their figures nude to demonstrate better the excellence of art in expressing the muscles, veins, and other parts of the body. But the ancients did not have a pure, chaste, and holy religion as we do, for consider that the religion of Jove was founded in rape, adultery, and incest; that of Priapus in the awefulness of his member; that of Venus in carnal lust; that of Cibele in ripping the genitalia from her Corybants.[59] . . . But Michelangelo, having to paint a most important article of our faith, should have imitated theologians and not poets, because theology and poetry are complete opposites.[60]

In a remarkable and far-reaching demonstration of cultural reversal through a literalist ideology, Gilio effectively dismantled some of the central ideals of Renaissance pictorial culture since Alberti, ideals that

Michelangelo had refined in a supremely powerful and unprecedented manner. For it was through the idealized human form expressing the movements of the soul and embellished with rhetorical and poetic conceits that the painter could amplify the subject through his invention and thereby not only enrich its essential meaning, but also persuade the viewer more effectively of its veracity. In understanding the painter's invention and poetic allusions, the viewer would arrive at a more profound discovery of meaning, thus elevating his own piety and the fame of the artist together. Nowhere, however, does Gilio suggest that Michelangelo is not a supreme artist or that he had not mastered the nude figure so completely that he had vanquished all others. Indeed, Gilio even emphasizes the need for painters to be learned in the sophisticated techniques and conventions of history and poetry so that they may know how to represent subjects with the decorum appropriate to a particular genre.[61] But the license that artists exercised in representing poetic ornament and personifications in sacred imagery, and which Michelangelo exemplified in the *Last Judgment*, carried with it the unacceptable danger that art would overwhelm the truth of the subject and thus corrupt the ignorant. Gilio appreciates that the mixed genre is appropriate for paintings in the "halls of cardinals and the pope" but that paintings in this genre "truly should not be put in churches nor among sacred things."[62] In the final analysis, art should not be flaunted for its own sake but should be marshalled into revealing the truth of its subject, and Gilio's dialogue established a new set of theological and ideological boundaries for acceptability and the manner in which audiences should understand and see painting. The disengagement of the bond between humanist culture and Christian purpose that had so clearly defined the culture of the papacy and Church in Rome during the earlier decades of the sixteenth century was now codified.

It is perhaps fortunate that Michelangelo did not live to know of Gilio's criticisms, for it seems that he had already been deeply affected by the controversy surrounding the *Last Judgment* – his letters and poetry written during the later years of his life increasingly reveal him questioning his art and expressing uncertainty about his salvation. Even Vasari remarked in his *Life* of Michelangelo that "no one should think it strange that Michelangelo loved solitude, for he was deeply in love with his art, which claims a man with all his thoughts for itself

alone." This observation is reflected in one of Michelangelo's most well-known sonnets, which he sent to Vasari in 1554, the subject of which contrasts an uncertain search for spiritual solace with the frustrated recognition of a life spent devoted to art:

> The voyage of my life at last has reached,
> across a stormy sea, in a fragile boat,
> the common port all must past through, to give
> an accounting for every evil and pious deed.
>
> So now I recognize how laden with error
> was the affectionate fantasy
> that made art an idol and sovereign to me,
> like all things men want in spite of their best interests.
>
> What will become of all my thoughts of love,
> once gay and foolish, now that I'm nearing two deaths?
> I'm certain of one, and the other looms over me.
>
> Neither painting nor sculpture will be able any longer
> to calm my soul, now turned toward that divine love
> that opened his arms on the cross to take us in.[63]

In the 1568 edition of the *Lives*, Vasari prefaced his earlier 1550 discussion of the *Last Judgment* with a lengthy preamble that reaffirmed, almost as a manifesto, the value and achievement of Michelangelo's art in terms that were no doubt calculated to respond, in part, to the critiques of Dolce and Gilio:

> It is enough for one to see that the intention of this extraordinary man has been to refuse to paint anything except the perfect and best proportioned forms of the human body in the most diverse attitudes; and not only this, but similarly the expressions of the passions and joys of the soul. Being satisfied to have surpassed all of his fellow artists in that area, he showed the way of the grand manner in painting nudes and how great his understanding was in the difficulties of *disegno*. And finally, he showed the way to achieving facility in this art in its principal purpose, which is the human body. And in devoting himself only to this goal, he left to one side the seductive charm of colors, clever inventions, and the novel fantasies of certain minute and delicate refinements that many other painters, and perhaps not without reason, have not entirely neglected. For some artists, not so well grounded in *disegno*, have sought with a variety of tints and shades of color, with

most unusual, various, and novel inventions, in short, with this other way of painting, to make themselves a place among the best masters. But Michelangelo, always standing firmly in his profound knowledge of art, has shown to those who understand well enough how they should achieve perfection.[64]

In defending Michelangelo's exclusive concentration on the nude figure in motion as the highest province of painting (Dolce defined that exclusivity as Michelangelo's limitation, quipping "the man who sees a single figure of Michelangelo's sees them all"), Vasari placed himself in the awkward position of having to contrast this achievement with the "other way of painting," which was of course the more universal style of the School of Raphael and the artists of Vasari's own generation.[65] Michelangelo's style was inimitable, for he had surpassed the ancients, moderns, and Nature herself, and seeking to imitate his style alone would, as Vasari warned, only result in a second-rate art devoid of meaning. But mastery of *disegno* in theory and practice could also be attained by the artist who understood the foundation of Michelangelo's achievement and who, with judgment and *ingegno*, could thereby achieve his own perfection.

Michelangelo conceived an epic historical subject in an appropriately epic style and genre, much as his contemporaries (Raphael, Vasari, Salviati, Perino del Vaga, among others) did with regularity in the grand, epic history paintings they created throughout the courts of Florence and Rome, where rhetorical and poetic figures (incidents of the "fictitious" and "fabulous") routinely amplified and enriched the meaning of a subject. Gilio and others called for a more static and literal representation of the *Last Judgment* rather than the visual enactment Michelangelo envisioned, where psychological terror, confusion, and ineffable bliss appear in sensate, idealized form in a profoundly individual and, in the final assessment, theologically appropriate, manner. Each figure articulates a unique, expressive intensity that only the heroicism of the idealized, imagined body could communicate, and observers are compelled to acknowledge the uncertainty of their own fate. It was also, perhaps, the intimately private vision of Michelangelo's struggle between the love of his art and his intense uncertainty about the salvation of his soul presented as a grand, public discourse that equally stirred the critics in their responses to the painting – but this is also what helped to save it.

Although the urgency expressed in many sixteenth-century commentaries eventually subsided, damage continued to be inflicted on the fresco itself through interventions made well into the middle of the eighteenth century, seventeen of which were removed during the restoration completed in 1994. When the *Last Judgment* was unveiled after this restoration, Pope John Paul II celebrated Mass beneath the painting (as had Pope Paul III) and was quoted in newspapers worldwide in his reaction to the newly cleaned fresco. An uneasy defensiveness characterized many of the pope's remarks, as if it were still necessary to justify Michelangelo's invention and the heroic nudes, or perhaps mollify those critics who claimed that the pope himself was too conservative: "We remain dazzled by the splendor and the fear," noting that Michelangelo had the "great courage" to "transfer visible, corporeal beauty even to the invisible Creator."[66] In his homily, the pope alluded to the censure of the painting during the Counter-Reformation in stating that, "The Sistine Chapel . . . is the sanctuary of the theology of the human body . . . in rendering homage to the beauty of mankind created by God as man and woman . . . it also expresses the hope of a transfigured world," and further, "When you remove it from this dimension it becomes an object that can easily be debased, because only before the eyes of God can the human body remain nude and uncovered while fully conserving its splendor and beauty."[67]

But of course, everyone did not perceive the newly cleaned fresco in this manner. A staff writer for the Religious News Service noted that some of the press coverage "expressed surprise that Pope John Paul II was not embarrassed by the huge number of naked bodies of both sexes displayed in Michelangelo's monumental painting – especially since the restoration process had removed some of the loincloths added after the painter's death."[68] (One might have offered the observation that many substantially "naked" bodies were, in fact, also quite visible before the restoration.) This writer then added, with much the same "scrupulous" candor as Biagio da Cesena, "Personally, I think Michelangelo's nudes look like people who have spent too much time in health clubs and are not all that erotic, indeed perhaps not all that human. But the issue is not what the naked bodies look like, but that they are naked at all."

And so it continues.

NOTES

1. Paul III's supposed response has been repeated in several modern art-historical studies on the *Last Judgment*. See, for example, L. Goldscheider, *Michelangelo – Paintings, Sculptures, Architecture* (London: Phaidon, 1963), 20; H. Hibbard, *Michelangelo* (New York: Harper & Row, 1974), 252; and most recently, Valerie Shrimplin, *Sun-Symbolism and Cosmology in Michelangelo's Last Judgment* (Kirksville, MO: Truman State University Press, 2000), 97. The first, and likely private, unveiling was October 31, 1541, on the eve of All Saints for which Paul III delivered a papal vespers. See also P. Barocchi, *Giorgio Vasari – La vita di Michelangelo nelle redazioni del 1550 e del 1568*, 5 vols. (Milan: Ricciardi, 1962), vol. 3, 1406–7.

2. There were of course other remarks published in anticipation of the finished fresco. Barocchi, *La vita*, provides the most extensive collection of critical and scholarly sources from the sixteenth through the twentieth centuries. R. De Maio (*Michelangelo e la Controriforma* [Rome-Bari: Laterza, 1978; reprint, Florence: Sansoni, 1990]) references a wealth of archival citations, many of which have yet to be fully explored or discussed.

3. For an important study on the question of style see P. Sohm, *Style in the Art Theory of Early Modern Italy* (New York: Cambridge University Press, 2001).

4. On the principles of *disegno* and Vasari's role in the founding of the Accademia del Disegno, see Karen-edis Barzman, "Perception, Knowledge, and the Theory of 'Disegno' in Sixteenth-Century Florence," in *From Studio to Studiolo – Florentine Draftsmanship under the First Medici Grand Dukes*, ed. Larry J. Feinberg (Oberlin/Seattle: Allen Memorial Art Museum 1991), 37–48, and eadem, *The Florentine Academy and the Early Modern State – The Discipline of Disegno* (New York: Cambridge University Press, 2000). On Varchi's *Due lezzione*, see L. Mendelsohn, *Paragone – Benedetto Varchi's 'due lezzione' and cinquecento Art Theory* (Ann Arbor: UMI Research Press, 1982).

5. On this point, see the revisionary and provocative analysis by C. Dempsey, "Mythic Inventions in Counter-Reformation Painting," in *Rome in the Renaissance – The City and the Myth*, ed. P. A. Ramsey (Binghamton, NY: Center for Medieval and Early Renaissance Studies, 1982), 55–75.

6. Vasari/Barocchi, vol. I, 70–80. All translations, unless otherwise noted, are mine. For the sake of economy I have regretfully not included the texts in their original language, but refer the reader to the edition and passage I have consulted.

7. For Gilio's text see, Giovanni Andrea Gilio, *Dialogo nel quale si ragiona degli errori e degli abusi de'pittori circa l'istoria* (1564), in *Trattati d'arte del cinquecento* (Bari: Laterza, 1961), ed. Paola Barocchi, vol. II, 1–115. See also Barocchi's very useful critical notes, 521–43. The quotation cited is from the dedication.

8. The critical commentary on the *Last Judgment* is extensive, for which see Vasari/Barocchi, vol. III. For the purposes of this essay, I address only some of the more prominent and polemical examples.

9. The transcriptions most often cited are those in E. Steinmann, *Die Sixtinische Kapelle*, 2 vols. (Munich: F. Bruckmann, 1905); E. Steinmann and H. Pogatscher, "Dokumente und Forschungen zu Michelangelo," *Repertorium für Kunstwissenschaft* 29 (1906): 487–8; Vasari/Barocchi, vol. III; and Redig de Campos (1964).

B. Barnes (*Michelangelo's "Last Judgment"* – *The Renaissance Response* [Berkeley: University of California Press, 1998]), presents an engaging discussion of the genesis of the painting and the question of audience, both intended and actual. Her analysis of reproductions of the *Last Judgment* in the sixteenth century and their role in shaping a wider audience and critical responses to the painting is an important one.

10. The *Last Judgment* was discussed in the twenty-fifth session of the Council of Trent in 1563 with a final decree made on 21 January 1564: "Picturae in capella Apostolica cooperiantur, in aliis autem ecclesiis deleantur, si quae aliquid obscenum aut evidenter falsum ostendant, iuxta decretum secundum in sess. 9 sub Pio." [The paintings in the Apostolic chapel are to be covered; however, in other churches, such paintings are to be destroyed if anything obscene or evidently false is shown, following the decree according to session 9 under Pope Pius.] See Vasari/ Barocchi, vol. III, 1377, who cites from L. Pastor, *Geschichte der Päpste...* (Frieberg: Herder, 1925), vol. V, 786, n. 4. The passage cited here is verified by a manuscript copy in the Vatican Library, where it appears as tenth in a list of thirty-three directives from the last session at Trent. The manuscript, which cites Borromeo as presiding (Pro exequendis decretis Concilij Coram Revmo Borromeo), is in the hand of Cardinal Giovanni Morone, a friend of Michelangelo's and papal legate to Trent. See Biblioteca Apostolica Vaticana Borg. Lat. 61, 318–321 (318v). A. Boschloo (*Annibale Carracci in Bologna* – *Visible Reality in Art after the Counil of Trent*, 2 vols. [The Hague: Government Publishing Office, 1974]), provides an excellent brief summary of the decrees of Trent with respect to sacred imagery. See vol. I, 133–41, especially. On the eighteenth-century corrections, see *Michelangelo* – *The Last Judgment* – *A Glorious Restoration* (New York: Abradale, 2000), 174–77, and on the restoration in general, see *The Last Judgment* – *The Restoration*, 2 vols. (New York: *Rizzoli*, 1999).

11. R. De Maio, 1990, 29.

12. For Vasari's comments on Biagio, see Vasari/Barocchi, vol. I, 74–5 and vol. III, 1297–8 for Domenichi's "Facezia." See also R. de Campos (1964), 27–8. The "Pasquinata" is included in *Pasquinate Romane del Cinquecento (Testi e Documenti di Letteratura e di Lingua VII)*, 2 vols., eds. V. Marucci, A. Marzo, and A. Romano (Rome: Salerno, 1983), vol. I, n. 462. The third stanza describes Biagio: "Il coglion di Cesena come pazzo/sta con li muorti per suo mal governo,/tutt'ascosto in certo cantonazzo." As this sonnet reveals, some of the primary objections voiced early on by conservative critics had also found their way into a more popular discourse.

13. Ludwig von Pastor first published Sernini's letters relating to Paul III in his *Geschichte der Päpste...*, vol. V, 838–49. Although not a complete record, Pastor includes thirteen letters from 18 December 1539 through 14 October 1542, some written hastily and only a day apart. On Sernini's mention of the "resurrection" in 1534, see *Michelangelo e la Sistina* – *La tecnica, il restauro, il mito* (Rome: Palombi, 1990), 47–8. On the *Last Judgment* and the theme of the resurrection, see M. Hall, "Michelangelo's Last Judgment: Resurrection of the Body and Predestination," *Art Bulletin* 58 (1976): 85–92.

14. The original transcription is from Pastor (1925), vol. V, 842–3 (November 19, 1541).

15. See Rudolf and Margaret Wittkower, *The Divine Michelangelo: The Florentine Academy's Homage on His Death in 1564. A Facsimile Edition of "Esequie del Divino Michelangelo Buonarroti," Florence, 1564* (London: Phaidon, 1964).

16. Petrarch had reintroduced the epistolary genre as a form of humanist inquiry based most especially on the example of Cicero's familiar letters. The familiar letter became one of the most flexible and popular forms in Renaissance literature. For a good discussion of the genre, see A. Quondam, *Le "Carte messaggiere": retorica e modelli di communicazione epistolare per un indice dei libri di lettere del cinquecento* (Rome: Bulzoni, 1981).

17. The poem to which Martelli refers is reproduced in Vasari/Barocchi, vol. III, 1258. Martelli's letter, along with Anton Francesco Doni's from 1543 and all five of Aretino's, are conveniently collected with annotations in *Il Carteggio di Michelangelo*, vol. IV, eds. P. Barocchi & R. Ristori, (Florence Sansoni, 1979). My thanks to Professor Ted Emery for his helpful suggestions in translating the Martelli and Doni letters.

18. See Barzman (1991). In Barzman's astute discussion of Varchi's and Vasari's reformulation of Aristotelian concepts, she observes that "Varchi initially provided the discursive foundation for the theory of 'disegno' as a process of cognition . . . Varchi drew heavily upon the authority of Aristotle . . . for an audience that was clearly acquainted with Aristotelian theories of knowledge. . . . (38) Following the paradigm of human cognition laid out in book 6 of Aristotle's *Nicomachean Ethics*, Varchi placed the arts in the lower part of universal reason, defining them as the reasoned consideration of how things come to be that are not necessary (the products of art can either be or not be) and whose origin is not in themselves (like the objects of nature) but in their maker" (39). Vasari elaborated Varchi's framework for *disegno* as a "process of cognition involving the apprehension of universal knowledge" in describing *disegno* in the introduction to the 1568 edition of the *Lives* as a "complex intellective process that combined the acquisition of universal knowledge with the ability to suggest with line that which is inaccessible to sight" (40). Barzman's argument is further developed in her book, *The Florentine Academy and the Early Modern State* (see n. 5).

19. Ariosto first published the epithet "il divino" in reference to Michelangelo. The term was similarly applied to many others during the sixteenth century, including Bembo, Titian, Raphael, and Aretino.

20. Doni's letter to Michelangelo was published in four editions of his *Lettere Familiare:* 1544, 1545, 1546, and 1552. See Barocchi/Ristori (1979), vol. IV, 160–3.

21. Barocchi/Ristori, 1979, vol. IV, 160–3.

22. K. Frey, *Giorgrio Vasari – Der Literarische Nachlass* (Hildesheim/New York: G. Olms, 1982), vol. I, 148, doc. LXIX. See also Vasari/Barocchi, vol. III, 1260, and A. Chastel, *Chronique de la peinture italienne à la Renaissance 1280–1580* (Fribourg: Office du Livre, 1983), 275, for partial transcriptions of the letter. Pitti has obviously reversed his reference to the two faces here.

23. The identification of the skin as Michelangelo's self-portrait has been accepted since F. La Cava made the argument in 1925 based on a comparison with known portraits of Michelangelo. See *Il volto di Michelangelo scoperto nel Giudizio Finale* (Bologna: N. Zanichelli, 1925). See Barnes (1998, 105–107) for a discussion of

Saint Bartholomew, the skin, and an analogy to the myth of Apollo and Marsyas with reference to Dante.

24. Michelangelo's complex and deep religiosity in relation to his art and issues of Christian reform is well documented and discussed in the scholarly literature. For the most recent and thought-provoking study, see A. Nagel, *Michelangelo and the Reform of Art* (New York: Cambridge University Press, 2000). The theme of spiritual uncertainty is a virtual leitmotif in Michelangelo's poetry and in a great many of his letters, a theme that noticeably increases from the time Michelangelo was working on the *Last Judgment* through the last years of his life. See J. Saslow, *The Poetry of Michelangelo – An Annotated Translation* (New Haven: Yale University Press, 1991), and Barocchi/Ristori (1979). On the issue of self-portraiture, F. Hartt proposed an identification of another image of Michelangelo wearing a stonecutter's cowl in the right lunette behind the corbel that was revealed during the restoration. See F. Hartt, "Michelangelo in Heaven," *Artibus et Historiae* 13 (1992): 191–209. See also, Nagel (2000, 195–8) for an engaging analysis of the portrait skin.

25. Of the many useful studies on Aretino see, for example, C. Cairns, *Pietro Aretino and the Republic of Venice: Researches on Aretino and His Circle in Venice, 1527–1556*, 2 vols. (Florence: Olschki, 1985), and *Pietro Aretino nel cinquecento della Nascita (Atti del Convegno di Roma-Viterbo-Arezzo, Toronto, Los Angeles, 1992)*, 2 vols. (Rome: Salerno, 1995). On the *Last Judgment* letters specifically, see, most recently, Barnes (1998, 74–88). See also N. Land, *The Viewer as Poet: The Renaissance Response to Art* (University Park, PA: Pennsylvania State University Press, 1994), esp. chap. 6.

26. The five letters and Michelangelo's one response are collected in Barocchi/Ristori (1979, vol. IV). For Aretino's letters on art in general, see the standard edition by E. Camesasca, *Lettere sull'arte di Pietro Aretino*, 3 vols. (Milan: Milione, 1957–1960).

27. See Barnes (1998) for the most recent and valuable version of this argument. See also idem, "Aretino, the Public, and the Censorship of Michelangelo's *Last Judgment*," in *Suspended License – Censorship and the Visual Arts*, ed. Elizabeth C. Childs (Seattle: University of Washington Press, 1997), 59–84.

28. Later letters to other addressees and passages in Aretino's subsequent poetry confirm his continued personal and critical admiration for Michelangelo and the *Last Judgment*.

29. Aretino's various corrections and revisions to the letters throughout several editions, including those bearing a date prior to the famous 1545 invective but subsequently printed in editions after 1545 without substantive changes in tone or content, make clear Aretino's idea of a unified discourse. See Barocchi/Ristori (1979, vol. IV) for the textual apparatus.

30. See Barnes, 1998, n. 24. See R. Klein and H. Zerner, *Italian Art 1500–1600 Sources and Documents* (Englewood Cliffs, NJ: Prentice Hall, 1966), 56–8, for a complete English translation of the 1537; see 122–4 for the 1545 letter.

31. See Barocchi/Ristori, 1979, vol. IV, 87. In the 1551 edition of Aretino's *Lettere scritte al signor Pietro Aretino da molti signori*, where Michelangelo's letter was also reprinted, it is not insignificant that his signature was changed from simply, "Michelagnolo Buonaruoti," to "Il sempre vostro Michelagnolo Buonaruoti," thereby supporting Aretino's attempt to demonstrate both Michelangelo's

indebtedness to him and the hubris he endured in not having received a drawing or further responses to his other letters.

32. Barocchi/Ristori 1979, IV, 88.

33. Ibid. 91, 181–2.

34. See Barnes (1998, 80–1) for a discussion of discrepancies in the date for the published version and the provenance of the manuscript version.

35. See Barnes, 1998, 81–2.

36. This last reference, a personal stab on Aretino's part, no doubt alludes to Gherardo Perini and Tommaso Cavalieri as recipients of Michelangelo's so-called presentation drawings, gifts he made as gestures of deep friendship and love. See E. Cropper, "The Place of Beauty in the High Renaissance and Its Displacement in the History of Art," in *Place and Displacement in the Renaissance*, ed. Alvin Vos (Binghamton: Center for Medieval and Early Renaissance Studies, 1994), 159–205, esp. 195–203, for an important reevaluation of the function and character of the presentation drawings in Renaissance culture and art-historical discourse.

37. Barocchi/Ristori, 1979, 218–19. See Barnes (1998, 80–4) for a discussion and partial translation. For a complete English translation of the 1550 letter, see *Aretino – Selected Letters*, trans. G. Bull (Middlesex, England: Penguin, 1976), 226–8.

38. Vasari/Barocchi, vol. III, 1259.

39. The ancient topos of selective imitation as a means for creating a figure more perfect than Nature alone could create, drawn from the artist's imagination but based in the visible world, is not only central to Vasari's definition, but it also informs the justification in the argument for Michelangelo creating figures in a manner similar to that of divine generation. The issue of the *bella maniera* in relation to stylistic paradigms in the sixteenth century is a complex and important one. For an insightful discussion of this problem and the issue of beauty, see E. Cropper, "The Place of Beauty in the High Renaissance."

40. L. Domenichi, *La nobiltà delle donne* (Venice: Giolito di Ferrarii, 1548), 28.

41. Much has been written about Michelangelo and Dante and the *questione della lingua*. Among the many relevant sources, see, for example, Varchi's discussion of Dante and Michelangelo in the *Lezzione* (Barocchi, 1961, vol. I), and Lionardo Salviati's *Orazione di Lionardo Salviati nella morte di Michelangelo Buonarroti* (Florence: Giunti, 1564), which is devoted almost entirely to a discussion of Dante. On the *questione della lingua*, see especially C. Dionisotti, *Gli umanisti e il volgare fra quattro e cinquecento* (Florence: Le Monnier, 1968), and A. De Gaetano, *Giambattista Gelli and the Florentine Academy: The Rebellion Against Latin* (Florence: Olschki, 1976).

42. Vasari/Barocchi, vol. I, 76. The line Vasari quotes from Dante is *Purgatorio*, XII.67. Astute sixteenth-century readers would have also recognized a further meaning in Vasari's reference, as Canto XII begins with a lengthy ekphrastic description of an image of Purgatory in which the line immediately preceding Vasari's quotation reads: "What master was he of brush or of pencil who drew the forms and lineaments which there would make every subtle genius wonder?" (*The Divine Comedy – Purgatorio*, trans. Charles S. Singleton [Princeton: Princeton University Press, 1977], 125).

43. Vasari/Barocchi, vol. I, 78–80.

44. Vasari/Barocchi, vol. I, 80.

45. Cropper, 1994, 177.

46. On Dolce, see P. Barocchi, *Trattati d'arte del cinquecento* (Bari: Laterza, 1960), vol. I; Mark Roskill, *Dolce's "Aretino" and Venetian Art Theory of the Cinquecento* (New York: New York University Press, 1968); and Cropper, 1994.

47. Roskill, 1968, 165.

48. Ibid., 167.

49. Ibid., 163.

50. Ibid. See also Cropper (1994, 174–7) for a thoughtful analysis of Dolce's reference to Petrarch's "crooked eye" metaphor and the perception of beauty as a function of love, which can deceive the eye.

51. See n. 9 for the text dictating that the figures in the *Last Judgment* be "covered," with subsequent payment to Daniele da Volterra.

52. See n. 9 for the directive requiring the painting to be corrected but not destroyed.

53. The full title of Gilio's dialogue is more revealing of his purpose: *Dialogo nel quale si ragiona degli errori e degli abusi de'pittori circa l'historie con molte annotazioni fatte sopra il Giudizio di Michelagnolo et altre figure, tanto de la nova, quanto de la vecchia Capella del Papa. Con la dechiarazione come vogliono essere dipinte le sacre imagini.*

54. See Dempsey, 1982.

55. Barocchi, 1961, vol. II, 15. Gilio's critique of Horace as a theoretical justification for the painter's license is woven throughout his discussion, for which see R. Lee, *Ut Pictura Poesis: The Humanistic Theory of Painting* (New York: Norton, 1967).

56. Barocchi, 1961, vol. II, esp. 88–92, 98–102, and Dempsey, 1982, 64–5.

57. Ibid., 1961, vol. II, 54

58. Ibid., 55.

59. Ibid., 79.

60. Ibid., 87.

61. See ibid., 81–115.

62. Ibid., 114.

63. Translated by Saslow, 1991, n. 285, 476–7.

64. Vasari/Barocchi, vol. I, 74–5.

65. For a discussion of the "universal" style and Vasari's generation, see M. Schlitt, "*Lavorando per pratica* – Study, Labor, and Facility in Vasari's Life of Salviati," in *Francesco Salviati e la Bella Maniera* – *Actes des colloques de Rome et de Paris (1998)*, eds. C. M. Monbeig Goguel, Philippe Costamagna, and Michel Hochmann (Rome: École Française de Rome, 2001), 91–105, and idem, "The Rhetoric of Exemplarity in Sixteenth-Century Painting: Reading 'Outside' the Imagery," in *Perspectives on Early Modern and Modern Intellectual History* – *Essays in Honor of Nancy S. Struever*, eds. J. Marino and M. Schlitt (Rochester, NY: University of Rochester Press, 2001), 257–82.

66. *The Atlanta Constitution*, April 9, 1994, sec. A, p. 16; *Chicago Sun-Times*, April 9, 1994, 15.

67. *The Guardian*, April 9, 1994, foreign page, 13.

68. Andrew M. Greeley, *Star Tribune Minneapolis*, May 27, 1994.

A CEREMONIAL ENSEMBLE: MICHELANGELO'S *LAST JUDGMENT* AND THE CAPPELLA PAOLINA FRESCOES

Michelangelo's frescoes in the Cappella Paolina, the *Conversion of Paul* and the *Crucifixion of Peter*, were completed in 1550 (Figs. 29, 30).[1] These works marked the end of Michelangelo's career as a painter, and from this moment his primary public persona became that of architect-in-charge at New Saint Peter's. Michelangelo was proud of his late frescoes despite vociferous critiques and threats to repaint some of the more offending areas.[2] In 1555, as part of his efforts to discredit Antonio da Sangallo's design for New Saint Peter's, Michelangelo claimed that "There would be this further inconvenience: the addition of the circle of structures superimposed on the plan of Bramante would require the razing of the Cappella Paolina, the halls of the Segnatura and the Ruota and many others; not even the Sistine Chapel, in my opinion, would escape."[3] Certainly Michelangelo was appealing to the reigning Pope Julius III's desire to maintain the venerated ceremonial core of the Papal Palace, but equally compelling must have been his desire to preserve the spaces in which his work had a prominent role.[4] Just as the late *Pietàs*, intended for his own tomb, have been understood as a kind of last will and testament, the *Last Judgment* and the Cappella Paolina frescoes also bore personal significance.[5]

The initial expressions of discontent with the *Last Judgment* (Fig. 2) surfaced immediately and are first recorded in a letter written by the Mantuan envoy to the papal court, Nino Sernini, to Cardinal Ercole Gonzaga on 19 November 1541, just nineteen days after the unveiling.[6] The letter informs Cardinal Gonzaga of the general appearance and reception of the fresco. The negative response evidently did not dissuade

FIGURE 29. *Conversion of Paul*, Pauline Chapel, Vatican (Photo: Art Resource).

Pope Paul III who clearly wanted to leave his own mark on the palace and was undeterred in his pursuit of Michelangelo. In fact, even before the completion of the Sistine altar wall, Paul III was already scheming to have Michelangelo fresco his newly completed private chapel, the Cappella Paolina (Fig. 31).[7]

The Cappella Paolina is adjacent to the Cappella Sistina and is counted among the main ceremonial rooms of the *piano nobile* of the Vatican Palace (Fig. 32). It was built by Antonio da Sangallo the Younger between 1537–38 and 1539 as a southern extension from the Sala Regia, the main audience hall of the papal residence. The construction was part of Paul III's larger renovation of the ceremonial core of the palace. His work involved restructuring the Sala Regia,

FIGURE 30. *Crucifixion of Peter*, Pauline Chapel, Vatican (Photo: Art Resource).

reconstructing a new Scala del Maresciallo, and rebuilding the Cappella Paolina at a new location. The Paolina replaced the medieval *Capella parva*, destroyed to make room for the new Scala del Maresciallo, which served as the new ceremonial entrance to the Vatican Palace from the east.[8]

In rebuilding the chapel Sangallo struggled to overcome several design issues, foremost among them the need to harmonize its smaller dimensions with the vast ceremonial spaces of the Cappella Sistina and Sala Regia. To minimize the discrepancies in scale and to provide as much natural light as possible because the chapel was hemmed in on three sides, Sangallo raised the vault to the highest possible elevation. This increased the volume of the space and enhanced its lighting, allowing the insertion of three thermal windows, one on each wall and a third above the altar.[9]

FIGURE 31. View of the Pauline Chapel, Vatican (Photo: Vatican Museums).

As a result, the chapel has grandeur and majesty comparable to the adjoining rooms, and the visitor scarcely notices how small the chapel truly is. Its length, excluding the chancel, is a mere 16.5 meters, and its width is only 10 meters, whereas the vault is approximately 14 meters high (the much larger Sala Regia has a vault that is approximately 18 meters high).[10] The difficulty of the Cappella Paolina's proportions for any decorative scheme is compounded by the high socle, which rises over 4 meters and was designed to accommodate elaborate wooden benches.[11] For Michelangelo the inherent problems of the site in fact were quite different from those he faced in the Cappella Sistina. Instead of contending with the unprecedented size of areas to be painted as he did in the Sistina, Michelangelo dealt with walls that are large only with respect to the tall and narrow proportions of the space; the frescoes measure 6.25 by 6.61 meters.

The Cappella Paolina inherited the primary functions of its predecessor, which were threefold. The Paolina served as the papal Sacrament Chapel, thus it was where the consecrated Host was stored

and displayed to be venerated at various times throughout the liturgi-
cal calendar. As the conclave chapel it was where the cardinals would
gather to cast their votes to elect a pope. It was also the Singers' Chapel,
where daily masses were sung and Divine Offices were performed.[12] In
the sixteenth century, the chapel was the pope's private chapel, as it is
today. It did not have the same public audience as the Cappella Sistina.[13]
It was accessible to the public only on special occasions, to observe
the Easter Sepulchre on Holy Thursday and, later in the century, to
view the apparatus set up for the Devotion of the Forty Hours.[14] Even
on these occasions, public entry was not permitted. Visitors proba-
bly remained at the door and only peered into the sacred space. The
English cleric Gregory Martin describes the throngs of pilgrims who
anxiously seized the opportunity to enter the palace to observe the
Easter Sepulchre during the Holy Year 1575.[15] The restricted access
of the chapel is also indicated in guide books, which often mention
the chapel as the locale of the last two paintings by Michelangelo
yet frequently misidentify their subjects or are completely silent about
the decoration in this regard. Already by the seventeenth century, the
frescoes were so obscured from the soot of candles and lamps for spe-
cial celebrations that those allowed to visit the space complained the
frescoes were virtually illegible.[16]

This situation stands in dramatic contrast with the Cappella Sistina,
where the laity often entered the chapel and which had what might
be considered a semipublic function. The area reserved for the laity
was defined by a large chancel screen still in place.[17] Even if one
did not gain entrance to the area reserved for church officials, the
Last Judgment could easily be seen from the farthest reaches of the
chapel (Fig. 1). The power of this image, which rises to a height of
17 meters, is unarguable; its scale is overwhelming as is the manner in
which it literally envelopes anyone who enters the space. The Paolina
frescoes on the other hand could only be glimpsed from oblique angles
at the entrance, and only the most privileged visitors were allowed
full access.

In addition to several subsequent decorative campaigns, the
Cappella Paolina has undergone major structural changes since
Michelangelo completed the frescoes. The most dramatic occurred
at the beginning of the seventeenth century when Maderno's new
nave and façade of New Saint Peter's necessitated walling up all but
the one window above the *Crucifixion of Peter*. To provide additional

FIGURE 32. Plan, *piano nobile*, Vatican Palace, indicating the ceremonial rooms and the original location of the *Capella Parva* and Scala del Maresciallo, in relation to New Saint Peter's.

light, Maderno inserted a lantern in the barrel vault of the newly built extension of the Paolina chancel.[18]

Two weeks before the official unveiling of the *Last Judgment*, on 12 October 1541, Cardinal Alessandro Farnese wrote to the bishop of Sinigaglia, Marco Vigerio, reiterating that Pope Paul III would liberate Michelangelo from the obligation of the tomb of Pope Julius II because the pope intended him to paint his new chapel.[19] Sernini also mentions Paul III's intentions in his letter of 19 November, noted earlier, stating specifically in his closing remarks that "They say that N. S. [Pope Paul III] wants Michelangelo to paint the other small chapel that he had built."[20] Evidently just two weeks after the unveiling of the *Last Judgment*, the services of Michelangelo had been retained;

once again Paul III wasted no time in realizing his newest decorative project.[21]

Michelangelo did not welcome the task of painting the Cappella Paolina and stalled to the best of his ability as he did with the Sistine altar wall. A year later, in October 1542, he wrote to his friend Luigi del Riccio that he was under great pressure to begin painting but would be delayed for at least four to six days because the rough underplaster (arriccio) was not yet dry enough to begin.[22] One can infer from the remainder of the letter that the underlying problem that most vexing to Michelangelo was his contractual obligations to complete the Julius II tomb had not been rescinded. He had complained bitterly about painting the Last Judgment under similar conditions and was not anxious to begin another monumental fresco cycle with this outstanding obligation, especially at his advanced age of sixty-seven.[23] Regardless of these impediments, and despite his desperation and overwhelming sense of burden and guilt, work in the chapel was begun sometime in November 1542.[24]

The first fresco to be executed, the Conversion of Paul, is on the left as one enters, and the Crucifixion of Saint Peter decorates the right wall opposite.[25] The identity of the author of the narrative program has eluded scholars and is further complicated by Giorgio Vasari's contradictory texts. In the first edition of the Lives, published in 1550, he describes the frescoes as representing the Conversion of Paul and Christ Giving the Keys to Saint Peter, rather than the Crucifixion of Peter. The text is corrected in the second edition, published in 1568.[26] When, and if, the program was changed remains a topic of scholarly debate.[27] Although the pairing of the "Conversion" with the "Giving of the Keys" is more common because it refers explicitly to the founding of the papacy, I argue here that the combination of Paul's conversion with Peter's crucifixion was specifically chosen with respect to the particular functions of the Cappella Paolina and its functional and ceremonial connection with the Cappella Sistina. In addition, I suggest that the Last Judgment had specific meaning for Michelangelo and Pope Paul III, as did the pair of frescoes in the Cappella Paolina. These works must be understood within their thematic and ceremonial context and in relation to the personal desires of the aging patron and artist.

The accessibility of the Cappella Sistina and the Cappella Paolina certainly speaks to the relative notoriety of the frescoes. The private nature

of the Cappella Paolina undoubtedly affected the amount of criticism the frescoes received. Steinberg has argued that the silence surrounding the Paolina frescoes, following the unveiling, was due to an "embarrassment" for what was perceived as the great decline of the master who was once revered as divine.[28] More likely the silence was the result of the limited audience. The covering up of several nude figures in the *Last Judgment* including the repainting of Saints Catherine and Blaise by Danielle da Volterra was well known and a subject of much debate.[29] Several of the nude angels that appear in the *Conversion of Paul* were also provided drapery, as was the figure of Saint Peter, yet the alterations go unmentioned in the contemporary sources.[30] Surely it is the private nature of the chapel that explains why the Paolina frescoes did not become a cause célèbre as Bambach aptly describes the escalating discontent surrounding the *Last Judgment*.[31] This is especially clear as the negative criticisms were gaining momentum in the mid-1540s, precisely when Michelangelo was embarking on the second Paolina fresco.[32]

Despite growing dissent pertaining to the Sistina altar wall, the pope certainly did not object to Michelangelo's work and eagerly awaited its completion.[33] He visited the Paolina on 13 October 1549, just days before he died, climbing ten or twelve steps of a temporary ladder to get a better look at the work, and in obvious anticipation of its completion.[34] Yet the frescoes have been derided as Michelangelo's least successful works and perhaps for this reason, combined with their inaccessibility, have received relatively little attention in the Michelangelo literature.[35]

Although the figure style of these frescoes has been considered different from that of the *Last Judgment*, perhaps a better understanding of the physical and ceremonial context will reveal that Michelangelo created a fresco cycle in response to the peculiarities of the viewing space, while conveying meanings relevant to the primary functions of the chapel for the papal conclave and the Sacrament. As Wallace accurately noted, the frescoes are "ill served by photographs," which reproduce the images from an ideal point of view, that is, a ninety-degree angle from the wall surface, a viewpoint that would never be realized by any visitor.[36] The size and configuration of the chapel dictates that the frescoes are nearly always seen from a relatively steep angle from below, and when seen in situ the peculiarities of the composition are visually corrected. Rather, the Paolina frescoes should be

understood as supreme examples of Michelangelo's ability to manipu-
late a composition to accommodate perspectival constraints inherent
in the space.

The changes Michelangelo incorporated in the scale of the figures
on the Sistine Ceiling are well known, but more significant for this
discussion are the changes, evident in the numerous *pentimenti* in the
Last Judgment, which were implemented to "alter the figure's positions
and sense of movement, [and were] . . . undertaken for dynamic and
perspectival reasons."[37] The compositions of the Paolina frescoes are
further steps toward implementing compositional elements specifically
to engage the perspective of the viewer.[38] Analogous to the Sistine altar
wall fresco, Michelangelo does not use traditional methods to mark,
define, or measure space. Again, as Wallace has observed, "the paint-
ings disobey conventional rules of composition, ground planes appear
oddly tilted, there are unexpected shifts in scale, figures are cut off ar-
bitrarily, and many exhibit peculiar proportions."[39] Critics have taken
issue with these aspects of the compositions, while others criticize the
barren landscape or have described the figures as ponderous, blocklike
forms.[40] Recently Paul Joannides described these late works as, "if
not actively ugly, consciously different from anything he had painted
hitherto."[41] Instead of trying to understand the Paolina frescoes in a
context of a stylistic development or simply acceding to Lomazzo's
disdainful assessment of them as the epitome of a progressive decline,
these frescoes must be reassessed within the physical context of the
chapel.[42]

When seen in situ, and much like the Sistine altar wall, the il-
lusionistic space is created by the scale and placement of the figures
themselves, and all disjunctions disappear. The forms in the Paolina
frescoes do not move within an airless environment nor do they float
within an undefined space. Instead, they move within an environ-
ment that is both measurable and immeasurable, a contradiction that
heightens the spectator's involuntary response to the consequences of
the scenes depicted. When viewed in the chapel the figures that are
larger in scale project forward as the figures in the distance recede.

Because of the much larger decorative field of the *Last Judgment*
and the increased viewing distance afforded by the dimensions of the
Sistina, the sense of continuous movement into and out of depth (most
obviously in the figural groups of the Elect and apostles to either side

of Christ; Fig. 7) is more pronounced. The recessive spatial envelope in which they move parallels that of the deep limitless landscape below. These groups are perceived as an endless stream of figures that press forward, and the apostles are led by Saint Peter to Christ's left and Saint John the Baptist to his right. Saint Peter's and Saint John's location, just to the side and in front of Christ also explains their posture. John looks back toward Christ, while Peter's upper body twists to present the papal keys.[43] Each steps forward while his upper body turns back to look imploringly at Christ, a device that intensifies the sense of viewer involvement.

Visually, Saints John and Peter are meant to project beyond the painted space into the space of the chapel, which explains why they are slightly larger in scale than Christ.[44] Contrary to convention, Michelangelo did not define his illusion according to the frontal plane of the fresco. There is not a predetermined perspectival system that he superimposed onto the design to create an illusionistic space, but instead he designed "an architecture of figures" that move in a loosely defined ellipse extending into the limitless space behind Christ.[45] The spatial illusion is enhanced by the gradual cant of the wall, which projects approximately twenty-four centimeters at the apex. This device was certainly implemented to increase legibility of the upper reaches of the fresco when viewed from below, but also was very likely intended to enhance the perspectival effect so vividly revealed when the fresco was cleaned.[46] It is the overwhelming scale and illusionism that creates the sense that the image is inescapable, a force that all who experience the fresco respond to involuntarily.

For the purpose of this discussion, I will demonstrate that there are three primary viewpoints with an infinite number of subsidiary views.[47] The first is from the entrance, where the frescoes would be seen by the majority of the laity. The second view is from a seated position along one of the lateral walls, as during the papal conclave, and the third viewpoint is from the altar. After a successful election the pope-elect would be seated on the altar to receive the first obeisance from the cardinalate. Thus, the walls would be seen by the pope-elect from a slightly raised position. In each of these cases, however, the frescoes are seen from oblique angles and at a close range. Michelangelo was fully cognizant of these circumstances when designing the compositions.

In the *Last Judgment*, the complicated figural groupings and spatial construction of swirling bodies that recede into infinite space to either side of Christ, yet simultaneously push forward, can be understood fully only when the fresco is viewed from a distance and in its entirety. By contrast, the close viewing range of the Paolina frescoes dictated that the compositions not be populated with figures that recede into immeasurable space, as the spatial relationships of the forms would not be perceived or understood. Although initially this seems counterintuitive, when one understands the narrow arrangement of the chapel and the constraints that it imposed, this makes perfect sense. Thus, the forms are confined to the foreground and shallow middle ground to maintain maximum legibility. The result is that Michelangelo has created powerful religious narratives that overwhelm the viewer in much the same way as the *Last Judgment*. Just as Sangallo's design for the chapel successfully mitigated the relatively small size of the space, Michelangelo's images are a brilliant solution to the demands of the site. Through the manipulation of the scale of the figures, which are larger than lifesize, and the illusionism of their setting, the frescoes communicate a sense of grandeur far more expansive than their actual dimensions.[48]

In the *Conversion*, the placement of Christ and Saint Paul to the left of the central axis of the composition has repeatedly been criticized. Yet seen from the entrance to the chapel this "asymmetry" is visually corrected; the main figural group is shifted toward the center of the composition and serves to direct the viewer's attention to the far distant corner of the composition. Here we glimpse Damascus, Paul's ultimate destination. The figure of Christ hovers above, dispensing his message to Paul, who lies prostrate below, as he points in the direction of Damascus. If the fresco was designed to be seen sequentially, as Wallace argues, then, like Paul's attendants, the viewer would progress in the direction of the altar as if walking toward Damascus.[49]

Accounts of Paul's conversion appear in three passages of the Acts of the Apostles, and although the accounts vary slightly, they describe the event as both frightening and bewildering.[50] Michelangelo's visualization effectively conflates these passages. The figures disperse in what can be understood as fear and panic, others stand dumbfounded looking upward at the source of the blinding light, and still others shield their ears or almost defiantly confront what they do not understand.[51]

When seen from the oblique angle of the entrance the figures coalesce to create a logically composed group. The heavenly and earthly realms are divided by an open landscape. It is not a desolate area, but a forum within which the intensity of the drama is given physical form and sensate power. Michelangelo has created an image that, like the Sistine altar wall, overwhelms the space of the viewer, who is both dwarfed by the presence of the vision and simultaneously drawn into it. To the far right, two figures, seen from the back, climb from the space of the chapel, thus merging the real and illusionistic spaces, creating the sense that the audience is both participant and witness to the momentous event.

Despite the vast, limitless space of the *Conversion* fresco, Michelangelo nevertheless pushes his forms forward to create an inescapability and psychological impact so powerful as to imply that the figures are within the space of the chapel. Christ, above, is dramatically foreshortened and lunging forward, as is the horse, which gallops in the opposite direction away from Saul. The contrasting foreshortening catapults these figures forward. In 1953, Magi published the discovery of *pentimenti* that reveal the horse originally leapt laterally, toward the center of the composition, and thus moved in a direction parallel to the picture plane.[52] Michelangelo subsequently modified this motion in a direction contrasting that of Christ. The combined foreshortening and dramatic movement into and out of depth effectively intensifies the immediacy and violence of the event.

Extreme foreshortening is found throughout the *Last Judgment* and Michelangelo's use of this device in the Paolina was a strategic move that also may have had multilayered meanings.[53] Not only was foreshortening a theme of artistic theoretical discourse, but Michelangelo may also have been consciously countering criticisms levied many years earlier by demonstrating his virtuoso skill as a painter. His arch rivals, Bramante and Raphael, questioned his ability as a painter, particularly his skill at foreshortening.[54] According to contemporary sources they masterminded Michelangelo's receipt of the commission to paint the Sistine ceiling with the twofold goal of thwarting progress on the Julius II tomb and thus securing progress on New Saint Peter's and with the hopes of his failure at the task resulting in ultimate humiliation and ruin. Bramante artfully baited the pope, claiming, "Holy Father [Julius II], I believe that he does not have spirit enough, because he has

not painted many figures, and mostly the figures [in the ceiling] are set high and in foreshortening, and that is a different thing from painting on ground level."[55] Although Raphael and Bramante had been dead for more than two decades when he embarked on the Paolina frescoes, it was not like Michelangelo to relinquish a criticism or forget a challenge. Evidently this was the case here; Michelangelo's response to this subterfuge is clearly expressed by Condivi who dismisses his detractors as envious emulators and asserts Michelangelo's triumph claiming, "to the admiration and amazement of the world, . . . [the ceiling] brought him so great a reputation that it set him above all envy."[56]

The *Crucifixion of Peter* is similarly dominated by figures that, although less violent in their physical actions, literally seem either to emerge from, or encroach on, the viewer's space.[57] The soldiers to the far left who, with their backs to the viewer, climb up into the illusionistic space are contrasted to the group of four cowering women in the right foreground, who seem to pause in their forward motion and look back at the figure of Peter. In each case their lower bodies are cropped by the frame, as if they extend into the space of the chapel. The diagonal of the cross is surrounded by figures that climb up and back on the left and descend on the right, a circular motion that counters the reverse motion of the raising of the cross. The ill ease inherent in the violent action of the *Conversion* is similarly created in the *Crucifixion* by the large scale of the figures with respect to the plane of the wall. Their slow, continuous, deliberate motion creates an overall sense of compression and underscores their inescapable presence. They form a steady stream of pilgrims that climb to the site of Peter's crucifixion identifiable as Montorio.[58]

Saint Peter, contrary to tradition, is not represented in the inverted position, but at the more dramatic moment when his executioners are hoisting the cross into position.[59] The urgency of the moment, conveyed by Peter's extraordinarily large physical presence, is matched only by his expression; he confronts the viewer with intense glaring eyes.[60] The expressive intensity of this figure was recognized by Giovanni Andrea Gilio who criticized the omission of narrative details, yet praised Peter's emotive power and recognized the poignancy of the image:

> If you look at his pose, you consider the effort exerted by a man turned upside down, which you can see in his eyes and

in the twisting of his chest, which seems tormented from the pain of death. It is assumed that this new way of working will bring delight to the eyes of the viewer and beauty to the work, more than the atrocity of the nails, ropes and chains.[61]

The overarching similarities of Michelangelo's Sistina and Paolina frescoes make perfect sense when it is understood that the chapels are linked thematically as well. As patron of both, Pope Paul III obviously subscribed to Michelangelo's late figure style, but when the connection between the functions of the spaces, and the themes of the frescoes are understood as an ensemble, it becomes clear why Paul III insisted that Michelangelo paint the Paolina.[62] For example, it is well-known that the Sistina functioned as the Capella papalis and the pope heard mass here on special feasts including the Sundays throughout Lent.[63] Easter is the culmination of Lent, the forty-day period preceding the Sunday commemorating Christ's Resurrection. Lent is a time of penance, a theme that is found throughout the decorations of the Sistina sponsored by Pope Sixtus IV. The Christological and Mosaic frescoes that decorate the lateral walls correspond to themes and readings of the Roman liturgy of the Lenten season and, as demonstrated by Lewine, can be divided into three units, with the entrance wall frescoes forming a fourth unit that corresponds to the subsequent liturgy between Easter and Pentecost.[64]

Before Michelangelo's interventions the altar wall was decorated with the Nativity and the Finding of Moses and with an altarpiece illustrating the Assumption of the Virgin, to whom the chapel is dedicated. This triumvirate marked the beginning of the cycle, which concluded on the entrance wall with scenes of the Resurrection and Ascension of Christ. Together the entrance and altar wall explicate a theme of Salvation, and during the fifteenth and sixteenth century the Assumption of the Virgin was understood to "foretell the bodily resurrection of all Christians."[65]

The iconographic-theological connection between Sixtus IV's decoration of the altar wall and Michelangelo's *Last Judgment* is explicit. Barnes argues that "just as Christ's Resurrection and the resurrection of the dead at the Last Judgment were theologically analogous themes, so too was the Assumption of the Virgin."[66] Indeed, the iconographic changes to the Last Judgment implemented under Pope Paul III emphasized themes of Christ's Passion and Resurrection.

The elaborations involved the expansion of the fresco to include the lunettes, where Michelangelo added angels carrying instruments of the Passion. These are juxtaposed with the images of the Crucifixion of Haman and the Brazen Serpent, both typological images of Christ's Passion. It deserves to be emphasized that the most prominent instruments of the Passion, the crucifix on the left and the column on the right, also are set at dramatic diagonals that visually converge on the figure of Jonah painted in the severy at the center. Jonah, who remained in the belly of the whale for three days, was a common typology for Christ's Resurrection.[67] By adding the instruments of the Passion, the connections between the Old Testament prefigurations of Christ's death and resurrection were inextricably linked.

Michelangelo had painted the scenes of Genesis on the ceiling decades earlier, yet it was under Paul III that these thematic connections were consolidated. During the time Michelangelo was involved with the Sistine altar wall, Pope Paul III's new Cappella Paolina was designed and built. Although it has not been previously noted, it is logical to assume that Paul III's iconographic modifications to the Last Judgment were intended to underscore the liturgical-ceremonial connection between the Cappella Sistina and the pope's new Cappella Paolina, the Sacrament Chapel and future site of the Holy Week celebrations. The decorations relate directly to the functions of the two chapels for Holy Week, a connection obvious to any privileged participant or observer.

On Holy Thursday mass would be celebrated in the Cappella Sistina after which the consecrated Host would be brought to the Cappella Paolina and stored in the tabernacle symbolizing Christ's Sepulchre. This ceremony was part of a long tradition and had assumed all of the symbolism of Christ's death and burial.[68] There was no consecration on Good Friday, thus the Host would be retrieved and brought back in procession to the Sistina for the mass of the Presanctified Host.[69] The chapels were used as subsidiary spaces for the celebrations surrounding the most holy days of the liturgical calendar, and the decorative embellishments were elaborations on these themes.[70]

To be saved, all Christians must repent for their sins. Penance was the means to spiritual healing, and Saint Paul, who was "lifted up into the third heaven" (2 Cor. 12:2) – that is, brought into the presence of God and thus reborn as a follower of Christ – was the supreme example

of the penitential saint. His experience was followed by three days of blindness and fasting, an ordeal likened to Christ's entombment. Paul was subsequently "resurrected" through baptism by Ananias (Acts 9:1–9). The obligation of sufficient penance was requisite for baptism as demonstrated by the preparation of catacumens throughout the Lenten period.[71] The association of baptism and Easter was first recognized by Saint Paul and repeated throughout his writings.[72]

Throughout the last decades of his life, Michelangelo was preoccupied with his mortality and salvation, a theme repeatedly expressed in his poetry. In a madrigal dated circa 1534–42, precisely when he was working on the *Last Judgment* and perhaps beginning the *Conversion* fresco, he speaks of his soul and his desire for salvation:

> My eyes, desirous of beautiful things
> and my soul, likewise, of its salvation
> have no other means to rise to heaven but to gaze at all such
> things[73]

He returns to this same theme in several other writings, among them a quatrain of ca. 1545, the year it is believed he completed the first Paolina fresco:

> The soul is not unworthy to expect
> Eternal life, where it will find rest and calm[74]

Michelangelo was well versed in the writings of Saint Paul and Pauline theology on justification and the immortality of the soul. According to Francesco de Hollanda's *Dialogos em Roma* (1538), Hollanda met on Sundays with, among others, Michelangelo and Vittoria Colonna at the Theatine church of San Silvestro al Quirinale first to hear a lecture on the Epistles of Paul by Frate Ambrogio da Siena (Ambrogio Catarino Politi) and subsequently discuss their import.[75] These discussions certainly informed Michelangelo's understanding of Pauline theology and his conception of the Cappella Paolina frescoes, which have been understood as testimonials of his profound faith.[76]

The programmatic choice of the *Conversion of Paul* undoubtedly had personal meaning for Pope Paul as his name saint and to whose devotions he was especially attached.[77] What has remained perplexing however is that Saul/Paul in the *Conversion* is not a portrait of the reigning pope, but a likeness of the artist.[78] The identity of Michelangelo

with Paul has long been recognized and understood as a further example of the artist's repeated self-identification with Saint Paul.[79] This association was based on a mimetic similitude, Michelangelo's own turning toward God and personal conversion, which was fostered by his growing friendship with Vittoria Colonna.[80] Like Saint Paul, Michelangelo repented his earlier ways, and the *Conversion* has been understood as a visual manifestation of his own penance and desire for salvation.[81]

Unlike earlier religious narrative in which the artist's self-portrait is included as one of the subsidiary characters, here Michelangelo has represented himself as a main protagonist.[82] This was an extraordinarily bold gesture. How could he justify so prominent an inclusion of his self-image? It was not a veiled likeness, as the flayed skin of Saint Bartholomew in the *Last Judgment* (Fig. 28), but an unmitigated self-statement. The flayed skin was probably recognized by contemporaries as self-referential, and it has been understood by subsequent scholars in a variety of ways.[83] The question remains, however: why do the likeness of the skin and the saint not match? Posèq has called this a "contradiction" and suggests that it might have devotional significance: "the flayed skin may be seen as a visible metaphor of his concept of the mortal body being a 'leather pelt' which imprisons the soul and is cast off in the afterlife" and relates this to Michelangelo's well-known verse of flaying to liberate the soul.[84] Just as poignant perhaps is Posèq's subsequent observation pertaining to Bartholomew's role as "guardian of the doubting and the agnostics . . . [and how] Michelangelo may have identified with the saint's spiritual anguish." Posèq concludes, "but one wonders why he was permitted to include such a very personal avowal in a doctrinal representation."[85] Certainly this self-reference and Michelangelo's identification with Bartholomew can be understood as a heightened "prayer for redemption" whereby "the outwardness of Michelangelo, his ugliness would be thrown off, and his inward spiritual self resurrected, pure and perfected" as well as a personal avowal.[86] But unlike the flayed skin, in the image of Saint Paul all ambiguity of identity is gone: it is a self-likeness. Michelangelo's "prayer for redemption" has been transformed into a plea for salvation. He is proclaiming his own conversion and personal piety while simultaneously referring to his repentance for past sins.

Michelangelo himself espoused the sanctity of the artist, stating that "to imitate in some degree the venerable image of Our Lord [and all sacred images], it is not enough to be a painter, a great and skilful [sic] master; I believe that he must further be of blameless life, even if possible a saint, that the Holy Spirit may inspire his understanding."[87] Thus, Michelangelo did not obscure his identity, but instead prominently displayed himself as the fallen, repentant Saul, before he became Saint Paul. To include himself in this way Michelangelo had to break with Renaissance tradition and represent Saul as old, not young, and bearded, not clean shaven. The digression from recent tradition, most notably Raphael's tapestry of the same subject for the Cappella Sistina, was criticized by contemporaries and subsequent viewers alike. Steinberg argues that Michelangelo consciously reverted to a Florentine, medieval tradition whereby the saint is represented old and in civilian dress.[88] This obviously was a decision which both facilitated and justified his self-representation. By reverting to past Florentine tradition Michelangelo may have also been making reference to his own Florentine heritage as well as a variety of other symbols inherent in the bearded visage.

During the fifteenth century and first decades of the sixteenth century, beards were recognized as a sign of sinfulness and associated with Eastern clergymen, and therefore symbolic of the split between Constantinople and Rome. Julius II, Michelangelo's revered patron, maintained a beard from approximately January 1511 until early 1512, and it bore a host of political and ecclesiastical implications, foremost among them penitential connotations.[89] It was not until 1515 that beards became fashionable among Renaissance gentlemen and only in 1531 that Clement VII proclaimed that priests no longer needed to shave; thus followed two centuries of unshaven pontiffs.[90] Clement VII had grown a beard while incarcerated during the Sack of Rome as a symbol of his "grief, shame and mortification."[91] With respect to the tradition of representing Paul beardless, Michelangelo's immediate predecessors were conforming to contemporary attitudes and the iconographic implications of facial hair; a clean-shaven Paul symbolized "innocence and humility."[92] Michelangelo would have been familiar with the attitudes of his two previous papal patrons toward beards and may have invoked these meanings when he chose to represent himself as the bearded Paul. He, like his esteemed patrons Julius II

and Clement VII, also wanted to show his penance, grief, and shame, and the *Conversion* fresco provided a perfect opportunity to fashion his identity as a penitent.

There is little dissension as to the identification of Saul as Michelangelo, yet those who espouse this notion have not addressed fully the question of how Michelangelo was permitted to include himself in this way. Perhaps Posèq's query, "How was Michelangelo permitted to include such a personal avowal?" should be asked instead with respect to the *Conversion of Paul*. To begin, we must assume that Paul III recognized and accepted Michelangelo's self-representation when he visited the chapel in 1545, presumably to view the completed *Conversion* fresco.[93] Thus, the image must have had special meaning, not only for Michelangelo, as Barolsky suggests, but perhaps also for the pope.[94] Beyond this, numerous hypotheses to explain its inclusion can be proposed, but without further documentation, this will remain a topic of scholarly debate.[95] For example, on the most basic level, Michelangelo was leaving his self-likeness for posterity, as a kind of signature. Or Paul III may have granted Michelangelo this liberty as a means of placating the artist who did not want to paint the chapel. Another possibility might be that the self-likeness was a means to validate the divinity of Michelangelo and, by extension, that of his patron – a divinely inspired artist working under the aegis of a divinely inspired patron.[96] We have to remind ourselves that Michelangelo believed the artist must be "if possible a saint," and Pope Paul III was elected "per viam Spititus Sanctus" – that is, through the agency of the Holy Spirit, thus he, too, was divinely chosen.[97]

Although this extraordinarily bold self-reference might be considered as bordering on hubris, it should also be pointed out that Michelangelo took the secondary position. He has represented Pope Paul III as Saint Peter, which is similar to the image of Saint Peter in the *Last Judgment* (Fig. 15) in both physiognomy and urgent expression.[98] By representing Pope Paul as Saint Peter, Michelangelo made the primacy and papal succession absolutely explicit. Upon election the new pope inherited the papal charge to convert and spread the word of God with unwavering faith and willingness for self-sacrifice even martyrdom, notions clearly expressed by the images chosen.

Saint Peter's original investiture with the power to absolve or condemn sinners (bind and loose) is clearly expressed in the *Last Judgment*

by the gold and silver keys which he, on the final day, re-presents to Christ. Peter's role as spiritual leader would have also been understood by those who entered the Cappella Paolina, which was the site of papal elections. This notion is especially poignant when it is remembered that Peter's last action as pope, that is, just before his martyrdom, was to choose his successor, conferring on him the *cathedra Petri* saying, "I deliver to you the same power of binding and loosing that Christ relinquished to me; scorn and hold in contempt all matters of the flesh and of fortune, and as befits the good shepherd preach the salvation of the human race."[99] Peter looks beseechingly to anyone who enters the chapel. His penetrating stare is a constant and ever-vigilant reminder imploring the College of Cardinals gathered below to elect his successor to choose wisely, and similarly urges the newly chosen pope to continue his legacy.

The iconographic substitution of the Crucifixion for the Giving of the Keys has been associated with the "more somber and penitential mood of the Counter-Reformation Rome," and it is argued that the site-specific connotations of the locale of Peter's crucifixion at Montorio "served as a powerful reminder that the Church gained its foundations through suffering and martyrdom."[100] Stinger also claims that the fifteenth and the beginning of the sixteenth century was marked by greater confidence and that the theme of martyrdom receded; "in its place emerged emphasis on the Apostle as heroic spiritual leader." Michelangelo's image of Peter, however, emphasizes the duality of Peter as both martyr and heroic spiritual leader. His heroism is clearly expressed by the powerful scale and pose of his muscular body, which turns and confronts the viewer. Saint Peter is actively asserting and claiming his presence and role as leader, even at the moment of his crucifixion.

Peter's Crucifixion also relates to the function of the chapel as the Sacrament Chapel. As mentioned earlier, the Easter celebrations were a central focus of the liturgical calendar and embraced ceremonies that involved both papal chapels. Resurrection symbolism is inherent in the *Last Judgment* and a culmination of the iconographic program of the walls and vault. Easter is the time during the liturgical calendar when baptisms are performed, as baptism was recognized as a reenactment of the Passion, death, and resurrection of Christ. Saint Basil in his homily "De Spirito Sancto" quotes Saint Paul, writing: "There is

only one death for the world, and one resurrection of the dead, of which Baptism is the figure."[101] Gregory Nazianzus in his "Oration on the Holy Light" clarifies that there are five types of baptism:

> Moses baptized but it was in water, . . . John also baptized; but this was not like the baptism of the Jews, for it was not only in water, but also "unto repentance." . . . Jesus also baptized, but in the Spirit. This is the perfect Baptism. I know also a Fourth Baptism – that by Martyrdom and blood, which also Christ himself under went; – and this one is far more august than all the others, inasmuch as it cannot be defiled by after-stains. Yes, and I know of a Fifth also, which is that of tears, . . . received by him who washes his bed every night and his couch with tears.[102]

Just as Paul's conversion represents the penitential state before baptism, Peter's crucifixion would have been understood as a form of baptism and thus perfectly suited for the Sacrament Chapel. The combination of these images, to either side of the Paolina altar where the consecrated Host was "buried" for the Easter triduum, would have conveyed a powerful message. It was for this very reason that popes would come and pray for hours before the Host, as one chronicler noted, "bathing themselves in tears," a clear reference to their personal penance-baptism and hoped-for salvation.

The interrelation of these chapels and Michelangelo's frescoes must be reiterated. Viewers who witnessed Paul's Conversion and Peter's Crucifixion were forced to contemplate inescapable mandates. The poignant meaning of these frescoes as a pair would have been underscored and reinforced both visually and physically by the ceremonial procession and "burial" of the consecrated Host on Holy Thursday and again when the Host was brought to the Sistina on Good Friday for the mass of the Presanctified Host. The placement of the consecrated Host beneath the *Last Judgment* foretold of the resurrection and our salvation. Understanding this chorus of images and ceremonies and how they worked together to create an unrivaled ensemble makes the anecdote of Paul III falling to his knees before the *Last Judgment* a worthy visceral response, whether real or not, to such potent sensate art and ceremony.

NOTES

1. The most accessible discussions and reassessments of the fresco cycle include Charles De Tolnay, *The Final Period* (Princeton: Princeton University Press, 1971), 70–8, 135–47; Leo Steinberg, *Michelangelo's Last Paintings. The Conversion of Paul and the Crucifixion of Peter in the Cappella Paolina, Vatican Palace* (New York: Oxford University Press, 1975); Fritz Baumgart and Biagio Biagetti, *Gli Affreschi di Michelangelo e Lorenzo Sabbatini e Federico Zuccari nella Cappella Paolina in Vaticano* (Vatican City: Tipografia Pogliglotta Vaticana, 1934), who also gather the known documents. For the architecture, see Christof L. Frommel, "Antonio da Sangallos Cappella Paolina. Ein Beitrag zur Baugeschichte de Vatikanischen Palastes," *Zeitschrift für Kunstgeschichte* 27 (1964): 1–42, and more recently Margaret Kuntz, "Designed for Ceremony: The Cappella Paolina at the Vatican Palace," *Journal of the Society of Architectural Historians* 62 (2003): 228–55.

2. Ascanio Condivi, *The Life of Michelangelo*, 2d ed., trans. A. S. Wohl, ed. H. Wohl (University Park: Pennsylvania State University Press, 1999), xi, 87. It has long been held that Condivi's account was written under Michelangelo's guidance and certainly reflects his views. Condivi praises the Paolina frescoes, stating, "both [frescoes are] stupendous works, not only in the representation of the events in general but also in each figure in particular." Lisa Pon, "Michelangelo's *Lives*: Sixteenth-Century Books by Vasari, Condivi, and Others," *Sixteenth Century Journal* XXVII (1996): 1015–37. For the repainting done after Michelangelo's death, see Fabrizio Mancinelli, "The Painting of the *Last Judgment*: History, Technique, and Restoration," in *Michelangelo the Last Judgment. A Glorious Restoration* (New York: Abrams, 1997), 157–86.

3. Robert Clements, *Michelangelo. A Self-Portrait* (New York: New York University, 1968), 42–3.

4. Kuntz (2003, 233ff) for the veneration for the ceremonial rooms in relation to the designs for the chapel.

5. Jack Wasserman, *Michelangelo's Florence Pietà* (Princeton: Princeton University Press, 2003); Alexander Nagel, "Observations on Michelangelo's Late Pietàs," *Zeitschrift für Kunstgeschichte* 56 (1996): 538–72; idem, "Gifts for Michelangelo and Vittoria Colonna," *Art Bulletin*, LXXIX (1997): 647–68; these topics are revisited in a broader context in idem, *Michelangelo and the Reform of Art* (New York: Cambridge University Press, 2000).

6. For the full text of this letter, see Baumgart and Biagetti, 1934, 72; see Barnes (1998, 78–80) for a partial translation and analysis in the context of criticism. The *Last Judgment* was unveiled to the pope on the Eve of All Saints, 31 October 1541.

7. For the chronology of construction, see Kuntz (2003, 243ff).

8. Margaret Kuntz, "Antonio da Sangallo the Younger's Scala del Maresciallo: A Ceremonial Entrance to the Vatican Palace," in *Pratum Romanum Festschrift für Richard Krautheimer zum 100. Geburtstag*, ed. R. Colella (Wiesbaden: Dr. Ludwig Reichert Verlag, 1997), 233–245.

9. Kuntz, 2003, 238–9.

10. The dimensions presented here are approximate. For their importance, see Kuntz, 2003, 241ff.

11. Both the Cappella Sistina and Sala Regia have a similarly high socle, but a completely different visual effect is created because of the scale of the rooms.

12. Kuntz, 2003, 231–3; the chapel served a variety of other functions as well.

13. For the audience in the Cappella Sistina, see John Shearman, *Raphael's Cartoons in the Collection of Her Majesty the Queen and the Tapestries for the Sistine Chapel* (London and New York: Phaidon, 1972); Neils K. Rasmussen, O.P., "*Maiestas Pontificia. A Liturgical Reading of Etienne Dupérac's Engraving of the Capella Sixtina* from 1578," *Analecta Romani Istituti Danici* 12 (1983): 109–48; Barnes, 1998, 1–4, 87–8.

14. Kuntz, 2003, 231ff. For the most concise history of the Devotion of the Forty Hours, see Mark Weil, "The Devotion of the Forty Hours and Roman Baroque Illusions," *Journal of the Warburg and Courtauld Institutes* 37 (1974): 218–48.

15. Gregory Martin, *Roma Sancta*, ed. G. Brunner Parks (1581; reprint, Rome: Edizioni di storia e Letteratura, 1969), 237: "the B. *Sacrament* with the traine of men and women following the same, above 30000 persons. . . . The Companie of the B. Trinitie upon holy Thursday with 8000 Pilgrims, [went] to visite the Sepulcher of S. Pauls Chappel in the palace; and so of al other Companies, Religions, Nations, Hospitals, Scholes, with Christian shewes and representations of great edification"; and 89, for the annual visit of the Confraternities. In 1741, Charles Dickens experienced tremendous frustration when he waited for hours in the Sala Regia to see the Easter apparatus in the Paolina, only to have the door to the chapel quickly shut; passage quoted in Kuntz, "Cappella Paolina," 243.

16. Richard Lassels, *The Voyage of Italy . . . in Two Parts* (Paris: Du Moutier, 1670), 50: "In the Paulina is seen a reare picture of the crucifying of S. Peter by Michel Angelo. The roof of it also was rarely painted by Federico Zuccari, but the smoke of the candles upon Maundy Thursday, when this Chappel serves for the Sepulcher, hath so defaced these pictures, that a farre worse hand would have served there."

17. Because of the growing number of attendees to the papal chapel, the chancel screen had to be moved, to enlarge the *sanctum sanctorum*; Shearman (1972), 4, 27; Rasmussen (1983), 109–48, for an explanation of the seating arrangement of the *capella papalis* as illustrated by the Brambilla print of 1575.

18. Margaret A. Kuntz, "Federico Zuccari, Gregory XIII, and the Vault frescoes of the Cappella Paolina," *Römisches Jahrbuch der Bibliotheca Hertziana* 32 (1997/1998): 221–9; idem., "Maderno's Façade for St. Peter's Why First?" *Zeitschrift für Kunstgeschichte* (forthcoming), for Maderno's alterations to the Cappella Paolina necessitated by the construction of the nave and façade of New Saint Peter's.

19. Carl Frey, "Zur Baugeschichte des St. Peter," *Jahrbuch der Preuss. Kunstsammlungen* XXXIII (1913): 147; Baumgart and Biagetti (1934), 72ff, for this and other relevant documents. The ratification of the final contract for the Julius II tomb was only issued in 1542 after Michelangelo petitioned the pope on 20 July 1542, and a final contract was drawn on 20 August 1542. Michelangelo was never liberated fully from the burden of this obligation as the letter from Annibale Caro to Antonio Gallo of 1553 suggests. Caro pleads that Gallo speak to the duke of Urbino on Michelangelo's behalf (John Addington Symonds, *The Life*

of Michelangelo, 2d ed. [Philadelphia: University of Pennsylvania Press, 2002], 2, 75–8); Steinberg (1975), 14. For a detailed account of the tomb project see Charles De Tolnay, *The Tomb of Julius II* (Princeton: Princeton University Press, 1970), passim.

20. Baumgart and Biagetti, 1934, 72.

21. Perhaps the earliest payment associated with the Paolina decorations is from 19 November 1541 for the installation of scaffolding, presumably for preparation of the walls; Archivio di Stato di Roma Camerale I, Tes. Seg. vol. 1290, f.38b.

22. Baumgart and Biagetti, 1934, 73–4.

23. Edith Balas ("Michelangelo's Double Self-Portrait in His Vatican Fresco "The Conversion of Paul" (a Hypothesis)," *Arte Christiana* 82 [1994]: 6) notes that "When he passed the age of 50 in 1525 and his rivals (Leonardo, Bramante, and Raphael) had long since died, he already felt old and tired. Michelangelo was referring wishfully to *la mia propria morte* 48 years before his death." See also Steinberg, (1975) 14.

24. Michelangelo's bitterness and sense of persecution due to the conflicting demands of the heirs of Pope Julius II and Pope Paul III regarding the Paolina are best expressed by a letter written to Monsignore Aliotti (some time before 24 October 1542): "I am stoned every day, as if I had crucified Christ. . . . It is borne upon me that I lost the whole of my youth, chained to this Tomb, contending, as far as I was able, against the demands of Pope Leo and Clement. . . . But to return to the painting. It is not in my power to refuse Pope Pagalo [Paul] anything. I shall paint ill-content, and shall produce things that are ill-contenting" (Baumgart and Biagetti, 72). Several authors cite this passage to suggest that the aesthetic failure of the frescoes was intentional on the part of the artist.

25. Contrary to most scholars, Creighton Gilbert has argued that the *Crucifixion of Peter* was the first of the two frescoes to be painted ("The Usefulness of the Comparison between the Parts and the Set: The Case of the Cappella Paolina," in *Actas del XXIII Congresso International de Historia del Arte* (Granada: Universidad de Granada, 1973), vol. III, 519–31. Carmen Bambach (*Drawing and Painting in the Italian Renaissance Workshop: Theory and Practice, 1300–1600* [New York/London: Cambridge University Press, 1999], 1ff, esp. 7–8), who, based on an analysis of Michelangelo's fresco technique in the Paolina, infers that the *Conversion* was the first of the two frescoes to be executed.

26. Giorgio Vasari, *Le vite de' più eccellenti pittori, scultori et. architetti italiani, da Cimabue insino a' tempi nostri* (Nell'edizione per i tipi di Lorenzo Torentino Firenze 1550) (Turin: Giulio Einaudi, 1986), 910; Giorgio Vasari, *La vita di Michelangelo*, ed. Paola Barocchi (Naples/Milan: Riccardo Ricciardi, 1962), vol. I, 81, with extensive commentary that summarizes the documents and literature to date (Vasari/Barocchi, vol. III, 1407–20, and esp. 1415–16, for the literature surrounding the change in program). This question is beyond the scope of this discussion. Although Condivi (1999, 87) records the correct subjects of the Paolina frescoes, he does not mention any changes in program. See n. 27.

27. See, for example, De Tolnay (1971, 135): "it is likely that the original program, Conversion and Delivery of the Keys, stems from Paul III; however, the transformation of the program of the second fresco into a Crucifixion of St. Peter may

go back to the artist, who used the historic scene to give the subject a symbolic and autobiographic connotation"; Steinberg, 1975, 45–6. More recently Paul Joannides, *Michelangelo and His Influence. Drawings from Windsor Castle* (London: Lund Humphries, 1996), 184: "Although this change must have been approved by the pope, it may have been prompted by Michelangelo himself, increasingly preoccupied with death." These are just three of many varying opinions.

28. See n. 35.

29. Mancinelli, 1997, 173–2.

30. Bambach (1999, 9–10 and n. 34) notes that the sources are silent concerning the repainting of the Paolina figures. De Tolnay (1971, 242) suggests that a drawing in the Louvre is a study, showing where draperies, indicated in a darker wash, would be added.

31. Bambach, 1999, 9. See Schlitt, this volume, for the critical responses to the *Last Judgment.*

32. See Schlitt, this volume.

33. To my knowledge it has gone unremarked that Paul III remained silent in the debates surrounding the *Last Judgment.*

34. This account is from a letter from the Florentine Ambassador Serristori to Cosimo I de' Medici from 13 October 1549; Baumgart and Biagetti, 1934, 77, and as cited by Vasari/Barocchi, vol. II, 1962, 1410. It was not unusual for a pope to inspect a work in progress. Julius II climbed the scaffold to view the ceiling; Condivi, 1999, 57.

35. For a concise summary of the dissatisfaction, see William Wallace, *Michelangelo. The Complete Sculpture, Painting, Architecture* (Hong Kong: Hugh Lauter Levin, 1998), 198: "Despite the importance of the chapel and its patron, Pope Paul III, the Pauline frescos have often been considered among Michelangelo's least successful works, products of his declining abilities in old age." Wallace alludes to what might be the cause for this dissatisfaction: "Yet Michelangelo's frescoes have been ill served by reproduction. They were meant to be seen along the walls of the long, narrow chapel: the oft-remarked oddities of these two frescos are greatly exaggerated when they are seen from the 'ideal' frontal view of most photographs. Michelangelo purposefully adjusted the arrangement and proportions of his figures so they would appear correct – as successive parts of an unfolding narrative – from a number of different viewpoints, mostly oblique." These statements are a synopsis of Wallace's "Narrative and Religious Expression in Michelangelo's Pauline Chapel," *Artibus et Historiae* 19 (1989): 107–22; Steinberg, 1975, 17ff, for the historiography and his characterization of the lack of commentary surrounding the unveiling of these frescoes as "embarrassed silence" and the revival of interest in these last two frescoes at the beginning of the twentieth century as part of a reevaluation of the aesthetics of the second half of the sixteenth century spurred by the emergence of contemporary abstract art.

36. Wallace, 1989, passim.

37. Mancinelli (1997, 163–4) discusses the more sophisticated perspectival nature of Michelangelo's changes to the *Last Judgment.*

38. Steinberg, 1975, 40–1: "The *Conversion* fresco is conceived in a like spirit: less an object of contemplation, than a bid to manipulate our response, to reach out,

to persuade, to involve. In the aggressiveness of its Christian summons, in its predatory encroachment on the spectator's space, it again transcends Michelangelo's former aestheticism."

39. Wallace, 1998, 198.

40. See for example Johannes Wilde (*Michelangelo* [Oxford: Oxford University Press, 1978], 170ff); see De Tolnay, 1971, 145–7; Steinberg, 1975, especially chap. 2, "The Fame of the Frescoes" and 19, "Raphael's exemplary narrative pictures had harmonized depth of space with dramatic action: free-moving figures populate a receptive ambience. But in Michelangelo's frescoes this mutual accommodation is ruptured: in the *Crucifixion of Peter* by a coalescing of space and figures together; in the *Conversion* by an arbitrary discontinuity – men miraged against a waste desert that seems resistant to penetration of occupancy."

41. Joannides (1996, 185 ff) concludes that "this awkwardness was due neither to lack of competence nor lack of physical control. . . . The style of the Pauline Chapel, then, is deliberate"; see also his discussion of the influence of the Pauline Chapel on later artists.

42. Gian Paolo Lamozzo, *Idea del Tempio della Pittura* (Milan, 1590), 53, as cited in Steinberg, 1975, 17. Marcia Hall (*After Raphael: Painting in Central Italy in the Sixteenth Century* [New York: Cambridge University Press, 1999], 178) accurately observes that "The chapel has not found a place in the sequence of stylistic developments that art historians describe. . . . Michelangelo's shift in style is not so abrupt as at first glance it appears. It was anticipated in the lowest zone of the *Last Judgment* and it surely resulted in part from the thinking of the artist as he pondered that subject."

43. The prominent inclusion of the papal keys dispels any ambiguity concerning Peter's identity, whereas the identity of the second figure has always been a subject of discussion. Condivi (1999, 87) recognizes him as Saint John, whereas Vasari/Barocchi (vol. I) views the figure as Adam. This debate has continued. See, for example, Howard Hibbard, *Michelangelo* (New York/London: Harper and Row, 1974), 247; Mancinelli, 1997, 170; and Barnes, 1998, 34, to cite just three examples.

44. Jack M. Greenstein ("'How Glorious the Second Coming of Christ': Michelangelo *Last Judgment* and the Transfiguration," *Artibus et Historiae* 20 [1989]: 35) discusses Saint John and Saint Peter as "paired in symmetry around Christ" and in n. 4 discusses their relative size in comparison to the figure of Christ, concluding that they are the largest in the fresco. He argues their importance within the iconography of the fresco but does not question their spatial relationship to the figure of Christ.

45. Mancinelli (1997, 168 and 164) for the change in the figures for perspectival purposes as noted earlier.

46. Loren Partridge ("Michelangelo's *Last Judgment*: An Interpretation," in *Michelangelo, the Last Judgment. A Glorious Restoration* [1997]: 11ff) for diagrams and a complete account of the structural changes to the altar wall. He dismisses Vasari's explanation that it would reduce the accumulation of dust and dirt and argues the changes were made for aesthetic reasons. He also (pp. 144–6) relates the cant in the wall to the increased corporeality of the figures and the Fifth

Lateran Council of July 1511, which stated that "resurrection was a process of enfleshing individual souls, of embodying unique spirits." Mancinelli (1997, 162) suggests it was more likely for "its optical effect" but does not develop this idea further. Altarpieces were frequently canted forward for greater legibility; see, for example, the altars throughout the Gesù, Rome.

47. Wallace (1989, passim), to my knowledge, is the first to completely reassess the frescoes with respect to the role of the viewer. He notes the cinematic aspects and has thoroughly explored the sequential viewing of the frescoes when walking through the space.

48. Ibid. (112, 115) for the oft-noted inconsistent proportions of some of the figures and their function with respect to the various viewpoints for the frescoes. Proportional manipulation is beyond the scope of this discussion, but it should be remembered that throughout Michelangelo's artistic career he manipulated proportions for a variety of reasons, among them visual effect. The best-known example is the David.

49. Ibid. (1989, passim, and 107, 111): "Michelangelo's originality lies in the fact that he takes advantage of the viewer's movement through space and past the frescoes. His narrative unfolds in space as well as over time."

50. Acts of the Apostles 9:1–9; 22:6–10; 26:12–16.

51. I am referring specifically here to the white-bearded figure at the right edge of the fresco. The figure just behind Saint Peter in the *Last Judgment* shares inarguable physiognomic similarities to the figure in the Cappella Paolina. For his identification in the *Last Judgment* see De Tolnay, 1971, 115.

52. Filippo Maggi, "Nuovi aspetti michelangioleschi della Paolina," *Ecclesia* XII (1953): 584–9.

53. Vasari praised foreshortening because it demonstrated extraordinary artifice in addition to its success as a means to distinguish the heavenly from the earthly realm, whereas Gilio, in his treatise on painting, criticized the foreshortening of Christ in the *Conversion*, only to debate its use in the subsequent dialogue with the fictitious character Silvio Gilio, who argues that it demonstrates the "agility of the glorious body." For Giovanni Andrea Gilio's text, *Dialogo nel quale si ragiona degli errori e degli abusi de'pittori circa l'istoria* (1564), see Paola Barocchi, *Trattati d'arte del cinquecento*, ed. Paola Barocchi (Bari: Laterza, vol. II, 44–6); Barnes (1998, 90–2, and n. 61) for Leonardo's warning against foreshortening because it provokes the ignorant.

54. Rona Goffen, *Renaissance Rivals: Michelangelo, Leonardo, Raphael, Titian* (New Haven: Yale University Press, 2002), passim, for an intriguing discussion of sixteenth century rivalries.

55. This passage is from a letter of 10 May 1506 written by the Florentine mason Piero Rosselli in which he recounts the dinner conversation where Bramante both secured the idea of Michelangelo to paint the Sistine ceiling and criticized his ability, as quoted in Goffen, 2002, 216. The anecdote is also told by Condivi, 1999, 39.

56. Goffen, 2002, 216; Condivi, 1999, 39. Envy was a common topos in the sixteenth century; Beverly Louis Brown, "The Black Wings of Envy: Competition, Rivalry, and Paragone," in *The Genius of Rome 1592–1623*, exh. cat. (London: Royal

Academy of Arts, 2001); Patrizia Cavazini, "The Porta Virtutis and Federigo Zuccari's Expulsion from the Papal States: An Unjust Conviction?" *Römisches Jahrbuch der Bibliotheca Hertziana* 25 (1989): 167–77.

57. Paul Barolsky ("Pontormo, Michelangelo, Caravaggio," *Source* XIX [2000]: 12–15) has made similar observations with the goal of illustrating that Pontormo's *Road to Cavalry*, Certosa di Val d'Ema, is a likely source for Michelangelo's conception. Important for this discussion is the growing change in attitude toward Michelangelo's last frescoes.

58. Philipp Fehl, "Michelangelo's *Crucifixion of St. Peter*: Notes on the Identification of the Locale of the Action," *Art Bulletin* 53 (1971): 327–43.

59. Ibid., 332f, for depictions of this theme in association with Old Saint Peter's and the identification of the protagonists. See also Jacobus de Voragine, *The Golden Legend Readings on the Saints*, trans. William Granger Ryan (Princeton: Princeton University Press, 1993), vol. I, 345.

60. Fehl (1971, 340, n. 65) notes, "Michelangelo, in turning the head of Peter so that it affects every step taken in the Pauline Chapel may perhaps also have been conscious of the immensity of the affairs affecting the future of the church which were to be transacted in the chapel." Fehl is referring to papal elections. Wallace (1989, 115) observes "his penetrating stare remains fastened on us through the entire course of our passage from the entrance to altar."

61. Barocchi, *Trattati 1961*, vol. II, 95; Barnes (104) discusses this passage in the context of metaphor and "The omission [of narrative details] itself causes them [the viewer] to look at other details (the eyes, the twist of the chest) and, in doing so, to imagine more vividly the suffering of the saint. This new participation causes delight (even though the viewer might share the martyr's anguish). The unusual manner ornaments the subject, not by making it pretty or innocuous, but by riveting the viewer's attention."

62. Barnes (1998, 39ff and esp. 53–4) argues, "It is probably best to see both Clement VII and Paul III as facilitators, who allowed the idea [the image of the *Last Judgment*] to be brought to completion" and concludes "his means, not that they hired him to express his inner-most feelings in a completely unrestrained manner, but that they hired him to articulate a known subject in a manner consistent with his previous work." Paul III's role with respect to the Paolina cannot be questioned, yet how much influence Michelangelo had on the choice of subjects is beyond the scope of this discussion.

63. Barnes (1998, 48) cites the papal master of ceremonies Paris de Grassis, who notes that the pope heard mass there forty times a year.

64. Carol Lewine (*The Sistine Chapel Walls and the Roman Liturgy* [University Park: Pennsylvania State University Press, 1993], 5–6) for a concise summary, and passim for a full discussion of these ideas. See also Leopold Ettlinger, *The Sistine Chapel before Michelangelo: Religious Imagery and Papal Primacy* (Oxford: Oxford University Press, 1965), passim. Barnes (1998, 48), based on Lewine, notes the importance of Easter for the Sistina but does not explore this further.

65. Lewine, 1993, 101; Ettlinger, 1965; John O'Malley, *Praise and Blame in Renaissance Rome: Rhetoric, Doctrine, and Reform in the Sacred Orators of the Papal Court, c. 1450–1521* (Durham, NC: Duke University Press, 1979), 120.

66. Barnes (1998, 65–9) for the connection of these themes in relation to the pose of the Virgin which, "reflects other images in the chapel, and, . . . incorporates another aspect of the Virgin's cult, her Assumption."

67. Barnes (1998, 58) notes the changes made under Paul III and recognizes that Michelangelo "tie[d] them closely to the ceiling frescoes. For example, the axes of the cross and column suggest a visual parallel with the vertical elements in the Crucifixion of Haman and the Brazen Serpent. These two scenes, painted by Michelangelo some thirty years earlier, depict typological equivalents of the Passion, and they frame Jonah, whose resurrection after three days in the belly of a whale foretold Christ's Resurrection. In a similar way the angels frame the figure of Christ, whose Resurrection holds the promise of salvation and provides a model for the resurrection of the dead at the Last Judgment." Barnes does not comment on these changes in connection with the celebrations of Holy Week or the Cappella Paolina; see subsequent discussion.

68. This was among the functions transferred to the Cappella Paolina from the *Capella parva*. The ceremony is documented throughout the accounts of the masters of ceremonies. For the years 1539 and 1540, see Bibliotheca Apostolica Vaticana (hereafter B.A.V.) Barb lat. 2799, fol. 542v, 582r ff, and Vat. Lat., 8417, fol. 20r ff, for the sixteenth century in general. The Holy Thursday celebration commemorates the institution of the Blessed Sacrament at the Last Supper. Following Mass the pope would deliver the Benediction and Bull, *In cena domini*, and in imitation of Christ, would perform the *mandatum*, the washing of the feet of twelve poor citizens. It was also on this day that the *Chrism*, used for Baptism, confirmation, and Holy Orders, was blessed and that the consecration of the churches and altars was performed.

69. Kuntz, 1999, 221ff. It was only under Pope Paul IV in 1556 that the celebration of a true Easter Sepulchre, which commemorated the actual death of Christ on Good Friday, was introduced in Rome; *Decreta Authentica Congregationis Sacrorum Rituum ex actis Eiusdem Collecta Eiusque auctoritate promulgate sub auspiciis SS, Domini nostri Leoni Papae XIII*, Rome, vol. V, 433: "Imo etiam Romae hic ritus Ss. Sepulchri introductus est: nam in vita Pauli PP. IV (1555–1559) legimus: 'Quibus maxime feriis ascerbissimam Christi Domini necem recolit Christiana respublica, *Sepulchrum in Vaticanas aedes invexit'*." The Friday burial existed previously outside of Rome, ibid., 429f and 433; K. Young, "The Dramatic Associations of the Easter Sepulchre," *University of Wisconsin Studies in Language and Literature* 10 (1920): passim.

70. De Tolnay (1971, 101–2) did not recognize the theme of the Resurrection in the Last Judgment and notes that on Holy Saturday "the Choir sang twelve prophecies chosen for the story of the Creation through the last of the Prophets. . . . From the readings given on the Saturday of Passion Week it becomes clear that the Creation of the World, the forebearers of Christ, and the Prophets themselves could have become the only possible subjects of the paintings of the ceiling to complete the existing cycles. The whole culminated in the Easter message: the Resurrection of Christ. Therefore it also becomes clear on the basis of the liturgy that the resurrection of Christ should have been painted on the altar wall as a finale and that the Last Judgment does not fit in this pattern. The Last Judgment would have been more fitting as decoration for a funerary chapel than for a palace chapel."

71. Charles L. Stinger (*The Renaissance in Rome* [Bloomington: Indiana University Press, 1985], 150) suggests that in the fifteenth century, "penance – rather than baptism or the Eucharist – tended, in effect, to become the central Christian sacrament." The distinction between Baptism and the Sacrament of Penance was clarified at the sixth session of the Council of Trent, 13 January 1547 ("Decree Concerning Justification"). Chapter XIV, "The Fallen and Their Restoration," explicitly states, "For on behalf of those who fall into sins after baptism, Christ Jesus instituted the sacrament of penance when He said: *Receive ye the Holy Ghost, whose sins you shall forgive, they are forgiven them, and who sins you shall retain, they are retained.* . . . the repentance of a Christian after his fall is very different from that at this baptism, and that it includes not only a determination to avoid sins and a hatred of them, or a *contrite and humble heart*, but also the sacramental confession of those sins, at least in desire, to be made in its season, and sacerdotal absolution, as well as satisfaction by fasts, alms, prayers and other devout exercises of the spiritual life, not indeed for the eternal punishment, which is, together with the guilt, remitted wither by the sacrament or by the desire of the sacrament" (*The Canons and Decrees of the Council of Trent*, trans. and introduced by Rev. H. J. Schroeder, O.P., [Rockford, IL: Tan Books, 1978], 39).

72. See, for example, 1 Cor. 6:11; 1 Cor. 12:13; Col. 2:12–13; Rom. 6:3–11; for these themes see Jean Danièlou, S. J., *The Bible and the Liturgy* (Notre Dame: University of Notre Dame Press, 1956), 43–4 and 46ff, for additional texts. Baptism was recognized as the reenactment of the passion, death and resurrection of Christ, the recreation of man in the image of God.

73. James Saslow (*The Poetry of Michelangelo. An Annotated Translation* [New York: Yale University Press, 1991], 239, madrigal #107) explains, "The theme has a long tradition in Italian lyric poetry, from Buinicelli onward, and also recalls Plato's theory of love and beauty descending from above and the mind ascending to them." Paul Barolsky, *Michelangelo's Nose, a Myth and Its Maker* (University Park: Pennsylvania University Press, 1990), 31ff, for the platonic associations.

74. Saslow, 1991, 403 (no. 238); see also 136 (no. 51), a *Canzone* dated ca. 1528: "Now I am dying, in great danger,/ for my short span of time has gotten less, . . . / Now that time is changing and sloughing off my hide,/ death and my soul are still battling,/ one against the other, for my final state./ And if I'm not mistaken/ (God grant that I may be),/ I see, Lord, my eternal penalty/ for having, though free, poorly grasped or practiced truth,/ and I don't know what I can hope for"; and 484 (no. 290), a sonnet of ca. 1555, or later, and usually associated with the drawing of the crucified Christ for Vittoria Colonna, "Your thorns and your nails and both of your palms,/ and your benign, humble, and merciful face, promise to my unhappy soul the grace of deep repentance and hope of salvation./ May you holy eyes not look upon my past/ with justice alone, nor likewise your pure ear,/ and may your stern arm not stretch out to it./ May your blood suffice to wash and cleanse my sins,/ and the older I grow, the more may it overflow/ with ever-ready aid and full forgiveness." These are some of the many examples demonstrating that, as he aged, he became more vehement in his pleas. For drawings as gifts, see Nagel, 1997, 647–68; idem, 2000, chap. 6.

75. *Francisco de Hollanda Dialogos em Roma (1538): Conversations on Art with Michelangelo Buonarroti*, ed. Grazia D. Folliero-Metz (Heidelberg: Universitätsverlag C. Winter, 1998), esp. 72. Ambrogio Catarino Politi was papal preacher to Paul III

during the later 1530s and authored an extensive critique of the text *Beneficio di Cristo*, generated by the Viterbo circle centered around Cardinal Pole and the larger group known as the *Spirituali*. For the most concise and accessible discussion of the debates surrounding justification and the complicated theological underpinnings of the religious climate at this time, see Mayer, this volume.

76. See following notes.

77. The most prominent display of his devotion was Paul III's annual celebration of the Feast of the Conversion at St. Paul's Outside the Walls.

78. Joanna Woods-Marsden (*Renaissance Self-Portraiture: The Visual Construction of Identity and the Social Staus of the Artist* [Yale University Press: New Haven, 1998], 254) notes that Michelangelo "never created a conventional self-likeness, even within the context of a wider narrative – the Nicodemus who supports Christ's body in the Florentine *Pietà*, and the flayed skin of St. Bartholomew in the *Last Judgment*, for instance, should surely be understood as self-referential rather than as self-portraiture." By contrast, he was "one of the most sophisticated self-fashioners of the Italian Renaissance, and . . . he consciously went to great lengths to forge a glorified image of self for contemporaries and posterity."

79. Steinberg, 1975, 39; Hibbard (1974, 275), on the other hand, identifies Paul "perhaps as an idealized reference to the bearded Pope." Michelangelo's identification with Saint Paul is thoroughly discussed by Barolsky (1990, 37–52, see esp. 39): "Even if the image is not an explicit self-portrait, the departure from convention here is indicative of Michelangelo's identification in old age with the saint. The association is, however, even deeper, for it is evocative in the spiritual sense of Saint Paul's preaching on the death of the old man as the prelude to rebirth. In the image of Saint Paul in old age, in which Michelangelo participates imitating it in the deepest sense, Michelangelo illustrates Paul's putting off the old man, being reborn in the light of Christ. Making the saint's metaphor literal, Michelangelo makes Saint Paul's conversion his own."

80. *Vittoria Colonna: Dichterin und Muse Michelangelos*, (Kunsthistorisches Museum, Vienna), ed. Sylvia Ferino-Pagden (Milan: Skira Editore, 1997), passim.

81. De Tolnay, 1971, 71: "They [the frescoes] are conceived not only as historical events but as confessions by the artist. They gave Michelangelo an opportunity to visualize his own conversion and his conciousness of the collective guilt which he shared with all humanity." Steinberg, 1975, 37–41: "The work [Conversion] is rhetorical in the sense that it engages the viewer; and it is, like the *Last Judgment*, confessional in that the artist projects himself passionately into his subject, even to the point of portraying himself in its hero. The painting becomes a synthesis of private penance, apostolic fervor, and art. . . . His self-projection into the role of Saul is a petition."

82. Woods-Marsden, 1998, 43–62, for the "artist as witness to holy stories."

83. De Tolnay, 1971, 114, 118–19; a contemporary noted the discrepancy between the face of the saint and the skin. The identification of Michelangelo with the skin is suggested by a print by Nicolo Beatrizet (1562) in which the artist's name is engraved adjacent to the skin as a kind of "legend"; Barnes, 1998, 105–6, 155. Schlitt, this volume, recognizes this as Michelangelo's "profound spiritual uncertainty and complex personal identity." See also Nagel, 2000, 195–6: "It is also generally agreed that the saint bears the features of Aretino. It is reasonable

to assume that Michelangelo, even before finishing the fresco had advance notice that he was going to be flayed alive by Aretino"; see following notes.

84. Avigdor Posèq ("Michelangelo's Self-Portrait on the Flayed Skin of St. Bartholomew," *Gazette des Beaux Arts* c XXIV [1994]: 2, 5) concludes, "if St. Bartholomew grasps a skin which is not his own, and if the face on the skin is Michelangelo's, then he is not Michelangelo"; Steinberg, 1975, 41. See Hall, this volume.

85. Posèq, 3. I return to the later question later.

86. Barolsky, 1990, 31. This connection was made amply by Steinberg, 1975, 39.

87. Francisco de Hollanda, 1998, 111; he continues, "For often badly wrought images distract the attention and prevent devotion, at least with persons who have but little; while those which are divinely fashioned excite even those who have little devotion or sensibility to contemplation and tears and by their austere beauty inspire them with great reverence and fear." Barolsky (1990, 40) elaborates, "Hollanda protests that when one hears the Epistles of Saint Paul, he prefers to listen to frate Ambrogio; but, even so, the parallel between the frate's sermons and Michelangelo's discourses has been established. The relation is not fortuitous or inappropriate, since it is based on the fact that for Michelangelo art is a spiritual exercise."

88. Steinberg, 1975, 25: "Raphael's historically more correct treatment commended itself to the authorities – to the detriment of the Paolina version. . . . Michelangelo makes no secret of his attachment to precedent. He seems, on the contrary, to make his quotations as conspicuous as possible." Shearman, 1972, 45ff, for Raphael's tapestry.

89. Mark J. Zucker, "Raphael and the Beard of Pope Julius II," *Art Bulletin* 59 (1977): 525–30, and postscript 532; Loren Partridge and Randolf Starn (*A Renaissance Likeness. Art and Culture in Raphael's Julius II* [Berkeley and London: University of California Press, 1980], 43–46) discuss many of these points, as well as the significance of the beard as a sign of papal succession.

90. Zucker, 1977, 532.

91. Ibid., 532.

92. Ibid., 525.

93. Baumgart and Biagetti, 1934, 76–7, according to the diary of Master of Ceremonies Ioannes Franciscus Firmanus on 12 July 1545 after attending mass in the Cappella Sistina the pope: "ivit ad videndum cappellam seu pictures factas per dominum Michaelemangelum."

94. See nn. 79 and 81.

95. The following hypotheses are just some of the many ideas surrounding this complex yet unresolved issue. This self-reference must be explored more fully within the context of Michelangelo's self-fashioning, for which Woods-Marsden notes he "was one of the most sophisticated self-fashioners of the Renaissance," as in n. 78 to the present chapter.

96. The notion of the divine artist was not unique to Michelangelo; see Goffen, 2002, 46, 120, 446, 456, with bibliography.

97. G. Catalanus, *Sacrarum caeremoniarum, sive Rituum ecclesiasticorum Sanctae Romanae Ecclesiae libri tres ab Augustino Patricio ordianti et a Marcello . . . primum editi . . . comentariis aucti,* (Rome: Doricus, 1750–1), 63ff.

98. Hall, this volume, notes the likeness and questions the meaning of Peter's gesture and expression.

99. Stinger, 1985, 190.

100. Ibid., 189, whose discussion is based on Steinberg (1975, 42–55) and Fehl's (1971, 327–343) convincing identification of the outcropping in Michelangelo's fresco as Montorio.

101. The passage continues: "This is why the Lord who orders our life has established the covenant of Baptism, containing the figure of death and life, the water effecting the image of death, the Spirit communicating the pledges of life. It is by three immersions and as many invocations that the sacrament of Baptism is carried out. So that the image of the death may be reproduced and so that, by communication of the knowledge of God, the soul of the baptized may be illuminated"; Danièlou (1956, 46 and 44ff) for the symbolism of baptism based on Pauline theology.

102. *A Select Library of Nicene and Post-Nicene Fathers of the Christian Church*, 2d ser., eds. Philip Schaff and Henry Wace (Grand Rapids, MI: Church Eerdmans, 1983–6), vol. VII, 358.

SELECTED BIBLIOGRAPHY

Armenini, Giovanni Battista. *De' veri precetti della pittura*. 1586. English translation: *On the True Precepts of the Art of Painting*. Translated and edited by Edward J. Olszewski. Renaissance Sources in Translation. New York: Burt Franklin, 1977.

Barnes, Bernadine. "The Invention of Michelangelo's 'Last Judgment.'" Ph.D. diss., University of Virginia, Charlottesville, 1986.

Barnes, Bernadine. "A Lost *Modello* for Michelangelo's *Last Judgment*." *Master Drawings* 26 (1988): 239–48.

Barnes, Bernadine. "Metaphorical Painting: Michelangelo, Dante, and the *Last Judgment*." *Art Bulletin* 77 (1995): 65–81.

Barnes, Bernadine Ann. *Michelangelo's Last Judgment: The Renaissance Response*. Berkeley: University of California Press, 1998.

Barolsky, Paul. *Michelangelo's Nose: A Myth and Its Maker*. University Park: Pennsylvania State University Press, 1990.

Barolsky, Paul. "From Grotesque to Vision: The Journey of the Poetic Imagination in Michelangelo's Art." *Source* 23 (1997): 79–94.

Barzman, Karen-edis. *The Florentine Academy and the Early Modern State – The Discipline of Disegno*. New York: Cambridge University Press, 2000.

Barzman, Karen-edis. "Perception, Knowledge, and the Theory of 'Disegno' in Sixteenth-Century Florence." In *From Studio to Studiolo – Florentine Draftsmanship under the First Medici Grand Dukes*. Edited by Larry J. Feinberg, 37–48. Oberlin and Seattle: Allen Memorial Art Museum, 1991.

Barocchi, P., and R. Ristori, eds. *Il Carteggio di Michelangelo*. Florence: Sansoni, 1979.

Borghini, Raffaello. *Il riposo*. Facsimile of 1584 edition with bibliography and index. Edited by Mario Rosci. 2 vols. Gli storici della letteratura italiana, no. 13. Milan: Edizioni Labor, 1967.

Boschloo, A. W. A. *Annibale Carracci in Bologna – Visible Reality in Art after the Counil of Trent.* 2 vols. The Hague: Government Publishing Office, 1974.

Bynum, Caroline. *The Resurrection of the Body in Western Christianity, 200–1336.* New York: Columbia University Press, 1995.

Calì, Maria. *Da Michelangelo all'Escorial: momenti del dibattito religioso nell'arte del cinquecento.* Turin: Einaudi, 1980.

Camesasca, Ettore. *Lettere sull'arte di Pietro Aretino.* 3 vols. Milan: Milione, 1957–60.

Canons and Decrees of the Council of Trent. Original text and translation by H. J. Schroeder. 2nd ed. Rockford, IL: Tan Books, 1978.

Chastel, André. *The Sack of Rome, 1527.* Translated by Beth Archer. Princeton: Princeton University Press, 1983.

Condivi, Ascanio. *The Life of Michelangelo.* Translated by Alice Sedgwick Wohl; edited by Hellmut Wohl. 2nd ed. University Park, PA: The Pennsylvania State University Press, 1999.

Cropper, Elizabeth. "The Place of Beauty in the High Renaissance and Its Displacement in the History of Art." In *Place and Displacement in the Renaissance.* Edited by Alvin Vos, 159–205. Binghamton, NY: Center for Medieval and Early Renaissance Studies, 1994.

De Hollanda, Francisco. *Four Dialogues on Painting.* 1548. Translated by Aubrey F. G. Bell. Oxford: Oxford University Press, 1928.

De Maio, Romeo. *Michelangelo e la controriforma.* Bari: Laterza, 1978.

Dempsey, Charles. "Mythic Inventions in Counter-Reformation Painting." In *Rome in the Renaissance: The City and the Myth.* Edited by P. A. Ramsey, 55–75. Binghamton, NY: Center for Medieval and Early Renaissance Studies, 1982.

De Tolnay, Charles. *The Final Period.* Vol. V of *Michelangelo.* Princeton: Princeton University Press, 1943–60.

De Vecchi, Pierluigi. *Pittore.* Vol. I of *Michelangelo.* Milan: Jaca, 1984.

De Vecchi, Pierluigi. "Michelangelo's Last Judgement." In *The Sistine Chapel. The Art, the History, and the Restoration,* 176–207. New York: Crown-Harmony, 1986.

Di Napoli, Giovanni. *L'immortalità dell'anima nel Rinascimento.* Turin: Società Editrice Internazionale, 1963.

Freedberg, S. J. *Painting in Italy 1500–1600.* 3d ed. New Haven: Yale University Press, 1993.

Frey, Karl. *Giorgio Vasari – Der Literarische Nachlass.* Hildesheim and New York: G. Olms, 1982.

Gilio, Giovanni Andrea. *Dialogo nel quale si ragiona degli errori e degli abusi de' pittori circa l'istorie.* Camerino, 1564. Vol. 2 of *Trattati d'arte del cinquecento fra manierismo e controriforma.* Edited by Paola Barocchi, 3–115. Bari: Laterza, 1960–2.

Goffen, Rona. *Renaissance Rivals: Michelangelo, Leonardo, Raphael, Titian.* New Haven: Yale University Press, 2002.

Goldberg, Victoria L. "Leo X, Clement VII, and the Immortality of the Soul." *Simiolus* 8 (1975/6): 16–25.

Greenstein, Jack M. "'How Glorious the Second Coming of Christ': Michelangelo's *Last Judgment* and the Transfiguration." *Artibus et Historiae* 20 (1989): 33–57.

Hall, Marcia B. "Michelangelo's *Last Judgment*: Resurrection of the Body and Predestination." *Art Bulletin* 58 (1976): 85–92.

Hall, Marcia B. *Color and Meaning: Practice and Theory in Renaissance Painting.* New York: Cambridge University Press, 1992.

Hall, Marcia B. *After Raphael: Painting in Central Italy: 1520–1600.* New York: Cambridge University Press, 1999.

Hall, Marcia B. *Michelangelo. The Frescoes of the Sistine Chapel.* New York: Abrams, 2002.

Hartt, Frederick. "Michelangelo in Heaven." *Artibus et Historiae* 13 (1992): 191–209.

Hibbard, Howard. *Michelangelo: Painter, Sculptor, Architect.* 1975. Reprint, London: Octopus, 1979.

Hirst, Michael. *Michelangelo and His Drawings.* New Haven: Yale University Press, 1988.

Jedin, Hubert. *Il Concilio di Trento.* 5 vols. Translated by G. Cecchi and O. Niccoli. Brescia: Morcelliana, 1973.

Jedin, Hubert, ed. *Riforma e Controriforma.* Vol. 6 of *Storia della Chiesa.* Milan: Jaca Book, 1985.

Joannides, Paul. "'Primitivism' in the Late Drawings of Michelangelo: The Master's Construction of an Old-age Style." In *Michelangelo's Drawings.* Edited by Craig Hugh Smyth in collaboration with Ann Gilkerson, 245–62. Studies in the History of Art, no. 33. National Gallery of Art, Washington, DC. Center for Advanced Study in the Visual Arts, Symposium Papers, XVII. Hanover, NH: University Press of New England, 1992.

Joannides, Paul. *Michelangelo and His Influence: Drawings from Windsor Castle.* Exh. cat. Washington, DC: National Gallery of Art, 1996.

Klein, Robert, and Henri Zerner. *Italian Art, 1500–1600: Sources and Documents,* 122–4. Sources and Documents in the History of Art series, edited by H. W. Janson. Englewood Cliffs, NJ: Prentice-Hall, 1966.

Kuntz, Margaret. "Designed for Ceremony: The Cappella Paolina at the Vatican Palace." *Journal of the Society of Architectural Historians* 62 (2003): 228–55.

La Cava, F. *Il volto di Michelangelo scoperto nel Giudizio Finale.* Bologna: Zanichelli, 1925.

Lee, Rensselaer W. "*Ut pictura poesis*: The Humanistic Theory of Painting." *Art Bulletin* 22 (1940): 197–269. Reprint, New York: Norton, 1967.

Mancinelli, Fabrizio, Giancarlo Colalucci, and Nazzareno Gabrielli. "The *Last Judgment*: Notes on Its Conservation History, Technique, and Restoration." In *The Sistine Chapel: A Glorious Restoration*. New York: Abrams, 1992.

Mancinelli, Fabrizio, Giancarlo Colalucci, and Nazzareno Gabrielli. "Michelangelo: Il giudizio universale." *Art Dossier*, no. 88 (March, 1994).

Mendelsohn, Leatrice. *Paragone: Benedetto Varchi's "due lezzione" and Cinquecento Art Theory*. Ann Arbor: UMI Research Press, 1982.

Michelangelo e la Sistina: La tecnica, il restauro, il·mito. Exh. cat. Rome: Fratelli Palombi, 1990.

Nagel, Alexander. *Michelangelo and the Reform of Art*. New York: Cambridge University Press, 2000.

Paleotti, Gabriele. *Discorso intorno alle imagini sacre e profane*. Bologna, 1582. Vol. 2 of *Trattati d'arte del cinquecento fra manierismo e controriforma*. Edited by Paola Barocchi, 117–503. Bari: Laterza, 1960–2.

Partner, Peter. *Renaissance Rome, 1500–1559. A Portrait of a Society*. Berkeley: University of California Press, 1976.

Partridge, Loren W. *Michelangelo: The Sistine Chapel Ceiling, Rome*. The Great Fresco Cycles of the Renaissance. New York: George Braziller, 1996.

Partridge, Loren W. *Michelangelo, The Last Judgment: A Glorious Restoration*. With texts by Fabrizio Mancinelli and Giancarlo Collalucci. New York: Abrams, 1997.

Pastor, Ludwig von. *Geschichte der Päpste*. Frieberg: Herder, 1925.

Posèq, Avigdor. "Michelangelo's Self-Portrait on the Flayed Skin of St. Bartholomew." *Gazette des Beaux-Arts* 124 (July–Aug 1994): 1–14.

Redig de Campos, D. *Il giudizio universale di Michelangelo*. Milan: A. Martello, 1964.

Roskill, Mark W., ed. *Dolce's "Aretino" and Venetian Art Theory of the Cinquecento*. Monographs on Archaeology and the Fine Arts, no. 15. New York: College Art Association, 1968.

Saslow, James M. *The Poetry of Michelangelo. An Annotated Translation*. New Haven: Yale University Press, 1991.

Scavizzi, Giuseppe. *The Controversy on Images from Calvin to Baronius*. Toronto Studies in Religion, no. 14. New York: Peter Lang, 1992.

Shearman, John. "The Chapel of Sixtus IV." In *The Sistine Chapel. The Art, the History, and the Restoration*, 22–91. New York: Crown-Harmony, 1986.

Shrimplin-Evangelidis, Valerie. "Sun-Symbolism and Cosmology in Michelangelo's *Last Judgment*." *Sixteenth Century Journal* 21 (1990): 607–44.

Shrimplin, Valerie. "Hell in Michelangelo's *Last Judgment.*" *Artibus et Historiae* 15 (1994): no. 30, 83–107.

The Sistine Chapel. The Art, the History, and the Restoration, 22–91. New York: Crown-Harmony, 1986.

Steinberg, Leo. *Michelangelo's Last Paintings. The Conversion of St. Paul and the Crucifixion of St. Peter in the Cappella Paolina, Vatican Palace.* New York: Oxford University Press, 1975.

Steinberg, Leo. "Michelangelo's *Last Judgment* as Merciful Heresy." *Art in America* (November/December 1975): 49–63.

Steinberg, Leo. "A Corner of the *Last Judgment.*" *Daedalus* (spring 1980): 207–73.

Steinberg, Leo. "The Line of Fate in Michelangelo's Painting." *Critical Inquiry* 6 (spring 1980): 411–54.

Steinmann, Ernst. *Die Sixtinische Kapelle.* 2 vols. Munich: Bruckmann, 1901–5.

Summers, David. *Michelangelo and the Language of Art.* Princeton: Princeton University Press, 1981.

Taja, Agostino. *Notizie delle pitture antiche e moderne del Palazzo Apostolico Vaticano.* Biblioteca Apostolica Vaticana, Vat. Lat. 9927.

Varchi, Benedetto. *Orazione Funerale di M. Benedetto Varchi Fatta, e recitata da Lui pubblicamente nell'esequie di Michelangelo Buonarroti in Firenze, nella Chiesa di San Lorenzo.* . . . Florence: Giunti, 1564.

Vasari, Giorgio. *La vita di Michelangelo nelle redazioni del 1550 e del 1568.* 5 vols. Edited by Paola Barocchi. Milan: Riccardo Riccardi, 1962.

Vasari, Giorgio. *Le vite de' più eccellenti pittori, scultori ed architetti nelle redazioni del 1550 e 1568.* Edited by Rosanna Bettarini and Paola Barocchi. (Best English version: *The Lives of the Painters, Sculptors and Architects.* Translated by A. B. Hinds. 4 vols. 1927. Rev. edition, edited with introduction by William Gaunt. New York: Dutton, 1963.)

Wallace, William. "Narrative and Religious Expression in Michelangelo's Pauline Chapel." *Artibus et Historiae* 19 (1989): 107–22.

Wallace, William E., ed. *Michelangelo. Selected Scholarship in English. Volume 4: Tomb of Julius II and Other Works in Rome.* New York: Garland, 1995.

Wilde, Johannes. *Michelangelo. Six Lectures.* Edited by John Shearman and Michael Hirst. Oxford Studies in the History of Art and Architecture. Oxford: Oxford University Press, 1978.

Wittkower, Rudolf, and Margaret Wittkower. *The Divine Michelangelo: The Florentine Academy's Homage on His Death in 1564. A Facsimile Edition of "Esequie del Divino Michelangelo Buonarroti." Florence, 1564.* London: Phaidon, 1964.

Wind, Edgar. *Pagan Mysteries in the Renaissance.* New Haven: Yale University Press, 1958.

INDEX